*With Pen and Pencil
on the Frontier
in 1851*

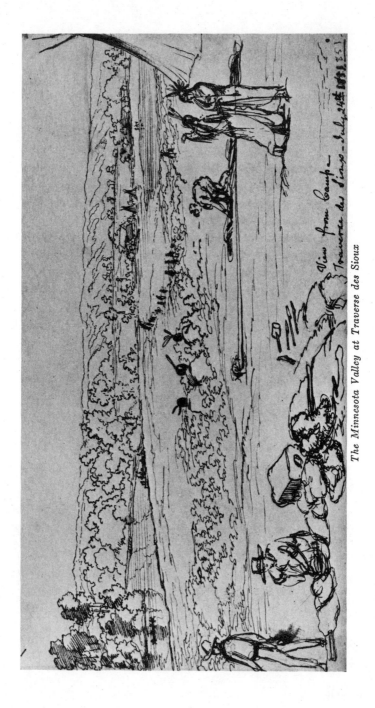

The Minnesota Valley at Traverse des Sioux

With Pen and Pencil on the Frontier in 1851

THE DIARY AND SKETCHES OF FRANK BLACKWELL MAYER

Edited with an introduction and notes
by BERTHA L. HEILBRON

MINNESOTA HISTORICAL SOCIETY PRESS • ST. PAUL • 1986

Borealis Books are high-quality paperback reprints of books chosen by the Minnesota Historical Society Press for their importance as enduring historical sources and their value as enjoyable accounts of life in the Upper Midwest.

Part 1 was first published in 1932 by the Minnesota Historical Society.

Part 2 was first published in *Minnesota History* 22 (June 1941): 133-56.

Unless otherwise noted, all sketches in this book are reproduced from Mayer's sketchbooks in the Edward A. Ayer Collection at The Newberry Library and are reproduced with permission.

Minnesota Historical Society Press, St. Paul 55101

International Standard Book Number 0-87351-195-6
Manufactured in the United States of America
10 9 8 7 6 5 4 3 2 1

Library of Congress Cataloging-in-Publication Data

Mayer, Frank Blackwell, 1827-1899.
With pen and pencil on the frontier in 1851.

"Part 1 was first published in 1932 by the Minnesota Historical Society; part 2 was first published in Minnesota history 22 (June 1941)"—T.p. verso.
"Borealis books"—T.p. verso.
Includes bibliographical references and index.
1. Mayer, Frank Blackwell, 1827-1899—Diaries.
2. Indians of North America—Minnesota—Social life and customs. 3. Frontier and pioneer life—Minnesota.
4. Minnesota—Description and travel—To 1858. 5. Pioneers—Minnesota—Diaries. I. Heilbron, Bertha L. (Bertha Lion), 1895-1972. II. Title.

| F606.M387 | 1986 | 977.6'04 | 86-717 |

ISBN 0-87351-195-6 (pbk.)

Contents

Illustrations

Foreword

RANK BLACKWELL MAYER'S journal of 1851 records the
adventure of a lifetime. His grand tour of mid-
nineteenth-century America was an ambitious circuit
of half the settled nation, heightened by encounters with
a broad sampling of American types: rivermen and writers,
innkeepers and fellow travelers, Yankees, Southerners,
and, of greatest interest to Mayer, Indians. On his return
from Minnesota Territory to his native Baltimore, the 23-
year-old artist wrote of "having been absent 170 days, 115
of which had been consumed in travelling 5903 miles 4768
of which was executed by steamboats 674 by Railroad, 361
by stage waggon [sic] or on horseback, and 100 by canal."
Less precisely tabulated were the people and places he had
seen, but his on-the-spot sketches and equally vivid diary
entries enabled Mayer to return in his mind to the Min-
nesota frontier for the rest of his life.[1]

This Borealis reprint edition makes Mayer's diary and
drawings once again available to modern readers. Part 1
consists of the 1932 edition of *With Pen and Pencil on the
Frontier in 1851: The Diary and Sketches of Frank Black-
well Mayer*, edited by the late Bertha L. Heilbron and here

[1] Frank Blackwell Mayer, "Memoranda &c Vol. 3," 53, original in the
posession of the American Museum of Natural History, New York, typed
copy in Mayer Papers, Minnesota Historical Society (MHS).

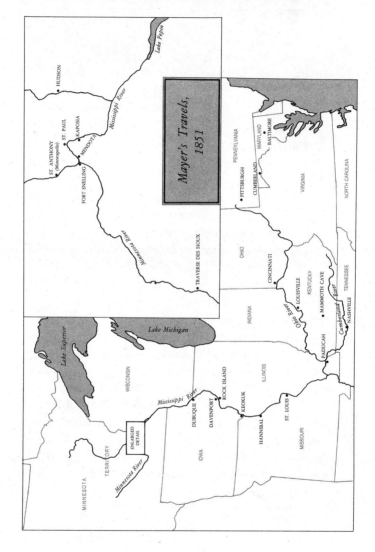

reprinted with her indispensable introduction to the artist and his Minnesota enterprises. The part of the diary describing the actual treaties of Traverse des Sioux and Mendota, however, was lost at the time of the book's publication. Part 2, Heilbron's "Frank B. Mayer and the Treaties of 1851," was first published in 1941 in *Minnesota History*; it explains the manuscript's reappearance and includes a key portion of Mayer's diary. The publication of these two pieces in a single volume constitutes a book that will interest readers as a travel narrative, an eyewitness account of a critical treaty signing, and a candid personal view of the development of an artist in mid-nineteenth-century America.

Although the 1851 western journal forms a self-contained narrative, it is part of a more extensive series of Mayer diaries. A surviving diary from the years 1847 to 1854 indicates that Mayer had considerable experience in capturing his impressions in words as well as pictures. The entries reveal an educated, perceptive, earnest young man, eager for experience of the wide world. Mayer's mind was nurtured on the momentous deeds of Columbus, the Pilgrims, and the founding fathers of the American republic; his position of librarian of the Maryland Historical Society afforded a few brushes with great men of his day like Henry Clay and Daniel Webster. In April 1851 he wrote, "I hope henceforth to combine the acquisition of knowledge with its application," and within weeks he was on his way West.[2]

[2]Frank Blackwell Mayer, "Journal," 1847–54, p. 105, original in private possession, microfilm copy in MHS.

As insightful and open to new experiences as the young artist may have been, he by no means traveled without preconceptions. Mayer frequently referred his real-life experiences to his knowledge of art and literature, as if seeking validation from the opinion of past ages. To one whose reading had been wider than his travels, Phidias, Raphael, and Shakespeare were handy touchstones. Much of the freshness in Mayer's diary derives from the juxtaposition of reader and traveler in his observations: "In riding to Nashville I saw a woman & child nearly exactly in the position of Raphaels 'Madonna della sedulla' — sitting at a cottage door — also a rattle snake on the road side" (p. 67). His perceptions of Indians were particularly constrained by classical allusions, but he was quick to adopt such imagery regardless of race: "A boathand from the steamer is a model for Hercules — a Sioux warrior for Mercury or Mars" (p. 99). In describing individuals, Mayer relaxed his comparative pontifications for more balanced insights.

The same is true of Mayer's drawings. Some are generalized contour sketches which denote poses and actions. "No better *'life-school'* could be conceived" than the lacrosse game Mayer witnessed at Traverse des Sioux (p. 157), and he covered pages with small drawings of the players (p. 152, 153). Drawings like the view of Kaposia (p. 112) are more carefully composed, with shading and perspective creating a sense of depth in the landscape and three-dimensionality in the residences. Other drawings, such as an Indian pipe or the saddle and gear of a Fort

Snelling dragoon, are studies in detail of objects — visual annotations for future use in studio work (p. 48, 134). The portraits are among the most accomplished and highly finished of Mayer's Minnesota drawings. Michel Renville, Iron Leg, Good Thunder, and A. S. H. White are individuals whose spirit and bearing are alive in Mayer's portrayals (p. 93, 120, 155, 162). That Little Crow deeply impressed Mayer is clear, both in the artist's accounts of their meetings and in a splendid drawing in which Mayer rendered expression and textures with particular care (p. 119).

The entries from Mayer's 1851 diary that Heilbron did not publish trace his return to Baltimore along a northerly route. As he had done on his westward journey, he recorded his travels by canal boat and lake steamer, describing the scenery and industry along the route and noting his impressions of cities like Chicago, Detroit, and Buffalo. Mayer found Niagara Falls disappointing in grandeur, for "Drawings and descriptions had mislead [*sic*] me into an idea of greater extent and height." He felt no need to comment on an encounter with a fellow observer of the falls: "While meditating on the sublimity of the 'thunder of waters' I was interrupted by 'I guess the water-power 'bove here's purty valuable h'aint it', and turning, I behold one of [']*those practical Yankees*' 'calculatin' 'the *use* of the Falls of Niagara." Mayer also described an art collection in Albany and a visit to relatives near the Hudson River — episodes that echo his experiences on the westward trip. In

this symmetry and in the final, summarizing paragraph of the 1851 diary (which is quoted on p. 223), readers may detect a formality that belies the spontaneity of mere travel notes.[3]

For Mayer, the drawings and diary were a means to an end. He attempted to sell the sketches, to see the diary into print, and to secure a commission for a mural of the treaty signing, but his efforts were unsuccessful. "The sketches from life remain simply as memoranda of scenes which must soon exist only in tradition or in the artist's memory," he wrote in the 1870s, trying to sell the records of his journey.[4]

Fortunately for Mayer's fame and for twentieth-century readers, Bertha Lion Heilbron (1895–1972) carried through the artist's hopes for a book long after his death. An editor of the quarterly journal *Minnesota History* and author of dozens of articles and several books, Heilbron was particularly aware of the potential of artworks and photographs in the practice of history. Her thorough studies of artists like Mayer, Seth Eastman, Henry Lewis, and Edwin Whitefield established an art-historical lineage for Minnesota. Her articles on panoramas, which she aptly styled the "moving pictures" of the nineteenth century, still serve as basic references for the study of that intriguing art form. Indefatigable in her research — as her footnotes to this volume attest — she also published notes on two additional Mayer collections: a group of water colors at

[3]Mayer, "Memoranda," 37, 38.
[4]Mayer to James Lennox, 187-, copy in Mayer Papers.

Goucher College, Baltimore, and an album of drawings at the New York Public Library.[5]

In the decades after Heilbron's work on Mayer was published, the artist's presence in mainstream art-historical literature was minimal. Recent articles by Jean Jepson Page, however, have helped to revive Mayer's stature, offering an overview of his career, a discussion of the portraits from his Minnesota trip, and an interesting portrayal of Mayer as local historian, antiquarian, and muralist of Maryland history. Two other articles have scrutinized facets of Mayer's career. Mary Ellen Sigmond analyzed the artist's use of drawings in the creation of a painting — in this case, a French wedding scene. And John C. Ewers included Mayer among his case studies of "Artists' Choices," noting Mayer's work as a collector of Indian artifacts as well as a recorder of Indian life.[6]

[5]Heilbron, "The Goucher College Collection of Mayer Water Colors" and "Mayer's Album of Minnesota Drawings," *Minnesota History* 13 (December 1932): 408–14 and 26 (June 1945): 140–42. A four-page "Selected List of Published Books and Articles by Bertha L. Heilbron" is in the Heilbron Papers, MHS.

[6]Page, "Frank Blackwell Mayer," *The Magazine Antiques* 109 (February 1976): 316–23, "Frank Blackwell Mayer: Painter of the Minnesota Indian," *Minnesota History* 46 (Summer 1978): 66–74, and "Notes on the Contribution of Francis Blackwell Mayer and His Family to the Cultural History of Maryland," *Maryland Historical Magazine* 76 (September 1981): 217–39; Sigmond, "The Bride of Savoy," *Journal of the Walters Art Gallery* 39 (1981): 7–14; Ewers, "Artists' Choices," *American Indian Art* 7 (Spring 1982): 40–49. Mayer is mentioned in E. P. Richardson, *Painting in America* (New York: T. Y. Crowell, 1965), 252; Rena Neumann Coen, *Painting and Sculpture in Minnesota 1820-1914* (Minneapolis: University of Minnesota Press, 1976), 21–23; and Jessie Poesch, *The Art of the Old South: Painting, Sculpture, Architecture, and the Products of Craftsmen, 1560 to 1860* (New York: Knopf, 1983), 298–300.

Two recent directions in American art are especially relevant for Mayer's work. One is a strong scholarly interest in nineteenth- and early twentieth-century artists of the frontier — not just for their visual records of vanished scenes, but for their pictorial subjectivity as well. "For all the attempts to render an accurate view or produce a believable report," notes David C. Hunt of the Center for Western Studies at the Joslyn Art Museum, "the majority of the artists on the western frontier envisioned and perpetuated what we think of today as a romance: one that may well have been, in a personal sense, real enough to most of them." The second direction is the immensely popular phenomenon of contemporary Western art. A body of work like Mayer's can serve as an essential resource for Western artists devoted to period accuracy and atmosphere.[7]

In 1891 Mayer asked the legislature of Minnesota, "What would the states of New York, Massachusetts or Maryland not give for paintings from life of Hudson, Standish or Calvert, with their companions at the moment they founded these States?" He had full confidence in his ability to offer posterity his eyewitness account of "*the birth of a State.*" Though his plans to memorialize the Treaty of Traverse des Sioux in his own mural never came to fruition, his observations live on in words and pictures. Mayer's diary and drawings offer a fresher and truer account

[7]Hunt, *Legacy of the West* (Omaha: Center for Western Studies, Joslyn Art Museum, 1982), 33. The contemporary Western art movement is outlined in Mary Carroll Nelson, *Masters of Western Art* (New York: Watson-Guptill Publications, 1982), 8–10.

than could be given by a formal painting composed decades after the event. As the perceptions of a young man on a young frontier, they will continue to inform and amuse readers in this expanded new edition.[8]

THOMAS O'SULLIVAN

CURATOR OF ART
MINNESOTA HISTORICAL SOCIETY

[8]Mayer to the Honorable General Assembly of the State of Minnesota, February 11, 1871, copy in Heilbron Papers. The memorial proposes a painting of the Treaty of Traverse des Sioux, to be executed from Mayer's drawings of twenty years earlier.

Part 1

With Pen and Pencil
on the Frontier in 1851

Introduction

IN THE spring and early summer of 1851 the stage
was being set in two-year-old Minnesota Terri-
tory for a tremendous drama, part of the great
American epic of the retreat of the red man before
the ever advancing wave of white settlement. This
drama was to consist of three acts, which were to
find their settings at three widely separated points
in the vast frontier commonwealth — Traverse des
Sioux on the Minnesota River, Mendota at the junc-
tion of the Minnesota and Mississippi rivers, and
Pembina on the Canadian border. Although Min-
nesota Territory, which stretched from the Missis-
sippi, the St. Croix, and Lake Superior on the east
to the Missouri on the west, was established in 1849,
only a small triangle between the St. Croix and the
Mississippi was at that time white man's land; two
years later the rest of this great western empire was
still in the hands of the Indians, Sioux and Chippewa.
To extinguish the Indian title to much of the area,
treaties were negotiated at the places mentioned
above during the summer of 1851.

It is only with the first two acts of this Minnesota
drama that the present volume is in any way con-

nected. In these the red actors were Sioux Indians — members of the Sisseton and Wahpeton bands living in the Minnesota Valley, who met to treat at Traverse des Sioux, and of the Wahpekute and Mdewakanton bands of the Mississippi Valley, who gathered at Mendota. Chief among the white actors were the commissioners appointed by the president to negotiate the treaties — Alexander Ramsey, governor of Minnesota Territory, and Luke Lea of Mississippi, United States commissioner of Indian affairs. Indians by the thousands assembled for the treaties; probably there were not a hundred white men present at either. Yet by the terms of the agreements that were drawn up and signed at Traverse des Sioux and Mendota, much of what is now southern Minnesota and vast tracts of land in Iowa and Dakota — an area estimated at thirty-five million acres — became part of the white man's domain.[1]

Among those who were attracted to Minnesota in 1851 by news of the forthcoming treaties was a young artist of Baltimore, Frank Blackwell Mayer. He

[1] For a compact account of the treaties of 1851, see William W. Folwell, *A History of Minnesota*, 1:175–188 (St. Paul, 1921). "The Treaty of Traverse des Sioux in 1851, under Governor Alexander Ramsey, with Notes of the Former Treaty There, in 1841, under Governor James D. Doty, of Wisconsin," is the subject of an article by Thomas Hughes in *Minnesota Historical Collections*, 10:101–129 (part 1). Mr. Hughes has collaborated with Brigadier General W. C. Brown in the writing of a history of *Old Traverse des Sioux* which includes much material on the treaty (St. Peter, Minnesota, 1929). For a map showing the lands acquired by the treaties of 1851, see Folwell, *Minnesota*, 1:324.

went, not to participate in the negotiations, but to observe Indian life at first hand and to find subjects for his brush and pencil. It may be that he hoped to become a second Catlin or to follow in the footsteps of Charles Bodmer or Seth Eastman. He had long felt that "in his choice of subjects for illustration an artist should select those peculiarly illustrative of the history of his own country."[2] Where could one find distinctly American subjects better than among the red men of the West, who had not yet dropped their primitive mode of life? And how could one get in touch with the native Americans better than as a member of a government expedition? Such an expedition would afford protection and congenial companionship in regions that could not be reached conveniently by the independent traveler. As early as November 1, 1848, Mayer visited Washington to obtain an appointment as official artist to one of the government expeditions that were being sent into the West to explore new regions, establish forts, make surveys, or treat with the Indians. Interviews with a number of influential men and an application filed with the "office of the Topo-

[2] Mayer's Journal, 1847–54, p. 7. This manuscript journal, diaries of trips to Florida in 1852 and to Europe ten years later, some letters and other papers, a sketchbook, and a few drawings are among the Mayer Papers, in the possession of Mr. and Mrs. John Sylvester of Augusta, Georgia. Mrs. Sylvester is Mayer's stepdaughter. All the artist's papers that in any way relate to his western trip of 1851 have been placed at the disposal of the editor through the courtesy of Mr. and Mrs. Sylvester.

graphical bureau " failed to bring the desired appoint-
ment; positions as artists to western expeditions were
not plentiful. When, in the early months of 1851,
Mayer heard of the forthcoming Minnesota treaties,
he hurried to Washington to apply for any position
that might be open in connection with their nego-
tiation. Once more he was disappointed — he was
informed that all the positions had been filled. It
was then that he wrote in his journal: "I have de-
termined to undertake the trip at my own expense
as the intercourse with the Indians and others, &
the sketches I shall make will amply repay me for
any expenditure I shall make." While at Washing-
ton, Mayer was introduced to Captain Seth East-
man — a fortunate meeting, for this artist of Indian
life had served earlier as commandant at Fort Snell-
ing, and he was able to give his youthful colleague
much information and advice about travel in the
West and to furnish him with "many useful letters."[3]
Later, on May 2, Mayer met Governor Ramsey in
Washington, and that meeting resulted in a life-long

[3] Journal, 1847–54, p. 43, 102; Marcus L. Hansen, *Old Fort
Snelling, 1819–1858,* 62 (Iowa City, 1918). In 1851 Eastman was
engaged in preparing illustrations for Henry R. Schoolcraft's *His-
tory of the Indian Tribes of the United States.* In his journal,
Mayer remarks that Eastman's sketches " are bea[u]tifully drawn
and surpass his finished pictures " — a criticism that might well be
applied to Mayer's own work. It is interesting to note that Mayer
later contributed to Schoolcraft's work two illustrations based
upon the sketches made during his western travels. See *Indian
Tribes,* 6: 352, 385 (Philadelphia, 1857).

friendship.[4] During the journey to the West that followed his visits to Washington, Mayer recorded his impressions "with pen and pencil" in a series of sketchbooks and a diary. With a sure stroke he pictured the scenes and inhabitants — red and white — of the frontier; with a fluent pen he described all that he saw through the sensitive eye of the artist. Perhaps no other observer, with the exception of Catlin, has left so interesting a record in two mediums of the Indian life of the Middle West. Mayer's diary, illustrated with selections from his drawings, forms the substance of the present volume.

The artist and author whose work is published herewith was a member of a distinguished Baltimore family. His grandfather, Christian Mayer, emigrated from Württemberg in 1784 and engaged in the export business at Baltimore. His father, Charles F. Mayer, was a prominent lawyer; his mother, Eliza Blackwell, was the daughter of Captain Francis Blackwell, a commander in the merchant service. She named her first child, who was born on December 27, 1827, for her father, but he was generally

[4] Ramsey was in Washington on official business connected with the forthcoming treaties of Traverse des Sioux and Mendota. A letter from I. Morrison Harris of Baltimore to Ramsey, indorsed by the governor "May 2/51, Introducing Frank Mayer Esq an artist of Baltimore," is in the Ramsey Papers, in the possession of the Minnesota Historical Society. Harris informs Ramsey that Mayer's "family holds the highest social position, and his Father Chs. F. Mayer Esq. is one of the most eminent members of our Bar."

known as Frank, and he almost invariably signed
his name "Frank B. Mayer."[5] The boy grew up in
pleasant surroundings; his parents moved in cultured
circles; they entertained lavishly; and they frequently
played host to writers, artists, and prominent pro-
fessional people who chanced to visit Baltimore.
Frank is said to have inherited his taste for art from
his mother. Both parents seem to have encouraged
him in the development of his talent, for he was
allowed to study under a local artist of some fame,
Alfred J. Miller, who had visited the Rocky Moun-
tains in 1837 as a member of an expedition led by a
Scotch adventurer, Sir William Drummond Stewart.
Miller later prepared, from sketches made in the field,
a series of eighteen paintings of scenes and experi-
ences in the West.[6] It is more than likely that
Mayer's desire to join a western expedition was de-
rived from his teacher's tales of experiences as a
member of the Stewart expedition.

[5] Brantz Mayer, *Memoir and Genealogy of the Maryland and
Pennsylvanian Family of Mayer*, 36, 52 (Baltimore, 1878); Mantle
Fielding, *Dictionary of American Painters, Sculptors, and Engrav-
ers*, 233 (Philadelphia, 1926); *Sun* (Baltimore), July 29, 1899.

[6] In later years Mayer looked upon Miller's western sketches
as " among the best ever executed," and he remarked particularly
that the Indian sketches and paintings were " very valuable."
See Mayer's Journal, 1847–54, p. 185, 188. For some information
about Miller's adventures in the West and the Stewart expedition
of 1837, see Henry R. Wagner, *The Plains and the Rockies*, 70
(San Francisco, 1921). Four portfolios of Miller's sketches were
in the possession of Henry Walters of Baltimore in 1921. It is
interesting to note that Walters at one time also owned some of
Mayer's western drawings. See *post*, p. 21.

Mayer was not yet out of his teens when he began to support himself through his art. During the late summer of 1847 he was preparing a colored lithograph of General Taylor, which he sold to a Dr. Frost of Philadelphia on September 11 for fifty dollars — "my first earnings by my pencil." For some months he worked in Philadelphia, preparing illustrations, initial letters, and other designs for Frost's engravers. When Mayer left his first position on December 19 he felt that he had gained a "knowledge of the art of drawing on wood for engravers . . . general information on subjects connected with Typography & engraving, & the formation of *business habits*." Much of his later work of illustration must have been influenced by the training gained under Frost. During the winter he remained in Philadelphia, working for a time under an engraver for five dollars a week, and finally in April he returned to Baltimore. The summer of 1848 he spent at Pikesville, near Baltimore, resting, reading, studying botany and drawing, and recovering his health, which had been much impaired when he left Philadelphia.[7]

With the approach of autumn the young artist accepted a position as librarian of the Maryland Historical Society in Baltimore, an organization that his father and his uncle, Brantz Mayer, had helped to found in 1844. Despite his youth and lack of training, Mayer must have fitted well into his new

[7] Journal, 1847–54, p. 17, 22, 24, 28, 33, 34.

situation. He had the instincts of a collector; his habits, like those of his German forebears, were orderly; and he was deeply and sincerely interested in American history and in the past of his state and his city. The position gave him an assured income of a hundred and fifty dollars a year, and it left him with considerable leisure to pursue his profession. Such advantages notwithstanding, at the end of two years, on November 1, 1850, he resigned, feeling that the "further pursuit of my studies as an artist" had "become incompatible with the retention of that office." [8] The true cause of his resignation, however, seems to have been the fact that he had found another source of income. In April, 1849, Mayer made a contract with Sidney Drake, a publisher of Hartford, Connecticut, by which he agreed to furnish about a hundred illustrations for a work on Mexico by Brantz Mayer. The artist looked upon this task as a "tedious & unimproving work," but he rejoiced that it "put money in my pocket, ($450.) which will enable me to pursue my studies more advantageously in future." Young Mayer finished the Mexican drawings in February, 1850; within a month he began to take lessons in drawing from Ernest Fischer, a German artist then living in Baltimore. After giving up his work with the historical society he arranged

[8] Journal, 1847–54, p. 41, 45, 77; Brantz Mayer, *History, Possessions and Prospects of the Maryland Historical Society*, 1, 2 (*Fund-Publication*, no. 1 — Baltimore, 1867).

a studio in his home and determined to "Work hard," for, said he, "I *must* succeed."[9]

The money earned in illustrating his uncle's book also served another purpose for Mayer; it made possible a tour of the West at his own expense. With several hundred dollars at his disposal he was able, when he failed to secure a government appointment, to leave his native city on May 7, 1851, and to journey by railroad, stagecoach, and steamboat to the Minnesota country. At Fort Snelling, on June 29, he joined the commissioners who were bound for the scene of the treaty at Traverse des Sioux, a trading post and mission station near the site of the present city of St. Peter. In 1851 it consisted of "two log-buildings, used many years for the trading establishment of the Fur Company; three log buildings and two or three dilapidated stables" belonging to the resident traders, and the houses and schoolhouse of the mission. At this outpost of civilization Mayer had an opportunity to observe and mingle with thousands of Indians, many of whom had traveled to the treaty ground from the great buffalo plains to the west. According to one report the artist was very popular with the natives, since "next to paint-

[9] Journal, 1847-54, p. 50, 71, 74, 77. The first edition of Brantz Mayer's *Mexico; Aztec, Spanish, and Republican* appeared at Hartford in 1851. Most of the illustrations are unsigned, but a few bear the initials "F. M." This two-volume work, with Frank Mayer's illustrations, passed through several editions in the early fifties.

ing their own faces, the Indians seem to like to have their faces painted by others." Upon the conclusion of the negotiations at Traverse des Sioux, Mayer went down the Minnesota with the treaty-makers in a keel boat to Mendota, where he saw another gathering of natives and probably attended the signing of a second treaty on August 5.[10] The artist returned to Baltimore by way of the Great Lakes, Niagara Falls, Albany, and the Hudson River, apparently traveling in leisurely fashion during most of August, September, and part of October.[11]

After his western trip Mayer settled down to the life of an artist in his native city. His portraits and sketches had begun to attract attention, and he was becoming favorably known among his townsmen as a draughtsman; consequently he had "no fear of not gaining [a] livelihood" through his art. He illustra-

[10] Journal, 1847–54, p. 102; *News* (Baltimore), March 2, 1895; *Sun*, July 29, 1899; James M. Goodhue, in *Minnesota Pioneer* (St. Paul), July 17, 1851; Mayer to Knute Nelson, November 4, 1893, Minnesota Historical Society Archives. Goodhue was the editor of the *Pioneer;* he was present at the treaty negotiations and his reports of the proceedings at Traverse des Sioux, in journal form, appear in the weekly issues of his paper from July 10 to August 7. The last three installments are unsigned and are probably the work of William G. Le Duc. The journal is substantially reprinted in the *Minnesota Year Book for 1851,* 27–70, compiled by Le Duc, and in Hughes and Brown, *Old Traverse des Sioux,* 33–73. Mayer is mentioned at several points in this journal.

[11] The story of Mayer's journey to the West is covered in his diary and sketchbooks. His Sketchbook No. 45 contains a pictorial record of the return journey. A sketch made at Albany is dated September 15; one of the Hudson River palisades is dated

ted for his uncle a second work, *Captain Canot; or Twenty Years of an African Slaver.* Among the major works that he executed in the early fifties was a "portrait in crayon of Chief Justice Taney [which] is considered by himself and his family as the best likeness ever made of him." Mayer displayed his work at numerous local exhibitions; at one arranged by the Maryland Institute in 1852 he was awarded first premium for the best crayon drawings. He rented a room, furnished it as a studio, nailed his sign to the house door, and placed himself "before the public as an artist." He spent a winter in Florida and several summers at Pikesville; he purchased a horse and took long saddle trips into the country around Baltimore with his cousin Charles Mayer or with other friends and companions.[12]

In 1862 Mayer determined to leave Baltimore for that Mecca of American artists — Paris. There he entered the atelier of Charles G. Gleyre, a well-known

October 4. See pages 23, 45. References to the route followed on this journey occur in the table of contents for an autobiography to be entitled "Bygones & Rigmaroles," for which a few chapters were written in 1896. These items are among the Mayer Papers. A record of expenses of the return journey appears *post,* p. 207.

[12] Journal, 1847–54, p. 87, 104, 105, 119, 200, 220, 270. Brantz Mayer's *Captain Canot* was published at New York in 1854. According to Frank Mayer, the hero of the book was "Capt Canneau, formerly an African slave-trader and a man of adventurous fortunes, and daring but not over scrupulous character." He is said to have changed the spelling of his name to protect his brother, who was "tried friend & confidential physician to Napoleon III." A volume based on Brantz Mayer's work was published with illustrations by Miguel Covarrubias in 1928.

Swiss painter of historical subjects, and he also received instruction from the French artist, Gustave Brion. It was during this period that Mayer developed a style of painting figures that shows the obvious influence of Meissonier. He was constantly occupied with " orders from America," and his works were accepted and exhibited at the Paris salons of the late sixties. For one picture — " The Nineteenth Century " — he received five offers while it was on exhibit at the salon of 1869. Summers in Savoy, a sojourn in Holland, and a visit to the ancestral home of the Mayers at Ulm added variety to the artist's European life. His peaceful and pleasant residence abroad might have continued indefinitely, had not the Franco-Prussian War interfered. The discomforts, not to mention the dangers, of life in besieged Paris caused him, on October 27, 1870, to abandon his studio containing his furniture, paintings, and studies, and to " avail himself of the last opportunity afforded by diplomatic negotiation to leave the beleaguered city in company with a brother artist, a Herald correspondent and two friends." In a landau drawn by two horses, the party passed safely through the German lines and fled into Belgium. By way of Antwerp, London, Liverpool, and Ireland, the artist returned to America and Baltimore.[13]

[13] *News*, March 2, 1895; Mayer to Ramsey, September 6, 1869, Mayer Papers; Mayer to J. Fletcher Williams, February 7, 1871, Minnesota Historical Society Archives.

A short time later Mayer settled in the quaint old city of Annapolis, where he was destined to spend the remainder of his life. There in an old colonial house, which he dubbed the "Mare's Nest," he lived, painting, drawing, and writing. His surroundings reflected his antiquarian interests, for his studio was littered not only with easels, paint, and drawing materials, but also with curios collected in odd corners of the earth. His interest in local history doubtless led to his election in 1886 as vice president of the Ann Arundel County Historical Society. In 1883 he married Mrs. Ellen Brewer. He died at his Annapolis home on July 28, 1899.[14]

Many of Mayer's best works, including the great historical paintings of the "Planting of the Colony of Maryland" and the "Burning of the Peggy Stewart" that adorn the Maryland statehouse, were executed during the Annapolis period. Some historical drawings of special interest were prepared as illustrations for a *Memorial Volume* issued in connection with the celebration in 1880 of the one-hundred-and-fiftieth anniversary of the settlement of Baltimore. In 1872 photographic reproductions of thirty of Mayer's *Drawings and Paintings* were published in book form at Baltimore. The artist spent long hours pouring over old Maryland newspapers, he dipped

[14] *Herald* (Baltimore), April 5, 1896; *Sun*, July 29, 1899; Mayer to Williams, January 5, 1885 [*1886*], Minnesota Historical Society Archives.

into archives and family papers, he interviewed old residents of Annapolis and its vicinity. Sometimes he used the results of his researches in his pictures; sometimes he incorporated them into articles, a number of which appeared in *Harper's* and *Scribner's* magazines. His interest in the past of his locality is well reflected in these articles, in one of which he wrote: "Could we ransack the old garrets of Annapolis and unravel the threads of social history hidden in musty packages of family letters, we might weave many a woof of time and renew the life of the dead people whose ghosts still walk, they say, the old halls and chambers." Mayer furnished the material for a chapter on "Customs and Characters" in a *History of Annapolis* published in 1887.[15]

During much of the later part of his life Mayer continued to be interested in Minnesota — the frontier land that he had visited in 1851. That interest was stimulated and kept alive by the hope that some

[15] The subjects of Mayer's articles and the magazines in which they appeared follow: "Aunt Eve Interviewed," and "Old Baltimore and Its Merchants," in *Harper's New Monthly Magazine*, 46:509–517, 60:175–181 (March, 1873; January, 1880); "Old Maryland Manners," and "Signs and Symbols," in *Scribner's Monthly*, 17: 315–331, 18: 705–714 (December, 1878; September, 1879). Each of the articles is profusely illustrated by the author. See Elihu S. Riley, *History of Annapolis*, 122–146, for the chapter based on Mayer's notes. A paper dealing with the early German settlers of Maryland was read by Mayer before the Society for the History of the Germans in Maryland on October 21, 1890. Daniel W. Nead, *The Pennsylvania-German in the Settlement of Maryland*, 57 (Lancaster, Pennsylvania, 1914).

day he would be commissioned to paint a great historical picture of the signing of the treaty of Traverse des Sioux. His sketchbooks were crammed with drawings — actual portraits — of the commissioners and their retainers, newspaper correspondents, traders, half-breeds, Indians, and all the motley crowd that gathered at the little trading post on the Minnesota River to attend the making of the treaty. To supplement them, the artist had a vivid memory of the scene, with all its life and color. He had training and experience, his work had met with success. Who could be better qualified to perpetuate on canvas for the state of Minnesota one of the most important events in its early history? "An equally authentic record of early settlement cannot belong to any of the older states," argued Mayer. "What would we not give in Maryland for a picture or even sketch made on the spot of the Landing of Leonard Calvert and his Indian treaty in 1634? So in Minnesota, the Indians in another generation will be gone & the desire to see how the founders of the state looked will become a matter of great interest." The preparation of a painting of the treaty of Traverse des Sioux would give Mayer an opportunity to execute what "would be really an *original American* work of Art." He hoped to make it "*the* work" of his life, his "crowning effort." [16]

[16] Mayer to Ramsey, September 6, 1869, Mayer Papers; January 10, 1871; to Harwood Iglehart, August 19, 1884; to Williams,

The story of Mayer's attempts to obtain funds
for such a painting from the Minnesota legislature,
through the Minnesota Historical Society, or by pri-
vate subscription in Minnesota is a tale of unsuccess-
ful efforts and frustrated hopes. As early as 1869,
while he was still in Europe, Mayer conceived the
idea of preparing the Traverse des Sioux picture and
wrote about it to his old friend, Governor Ramsey,
who was then serving as United States senator from
Minnesota. He proposed to paint a canvas, about
six by twelve feet in size, for the sum of ten thousand
dollars. Ramsey called the matter to the attention
of the Minnesota Historical Society, but he expressed
grave doubts that the money could be raised. Short-
ly after Mayer's return to America, during the winter
of 1871, upon the advice of Ramsey the matter was
brought before the Minnesota legislature. Mayer
had printed, for distribution among members of the
legislature and the historical society, a memorial stat-
ing his qualifications and asking an appropriation of
ten thousand dollars for a painting of the treaty.
The memorial was presented to the legislature by no
less a person than Henry H. Sibley, pioneer fur-
trader, representative of the territory in Congress,
and first governor of the state. Mayer himself, again

January 5, 1885 [1886], Minnesota Historical Society Archives.
Most of the items cited from the Minnesota Historical Society
Archives and Executive Council Records and the Archives of the
Board of Capitol Commissioners were located by Mr. Donald E.
Van Koughnet, research and general assistant for the society.

on Ramsey's advice, made what he described as a "fatiguing journey" to St. Paul in order to appear in person before the legislature. But all his efforts were for naught; the Minnesota legislature of 1871 did not see fit to spend ten thousand dollars on an oil painting. Even after Mayer returned, disappointed, to the East, he still hoped that the money might be raised by private subscription. In addition to Ramsey, who promised to give "$100 or even $200 if necessary" for the cause, Mayer enlisted the interest of J. Fletcher Williams, secretary of the historical society, Henry M. Rice, Captain Russell Blakeley, and Edward D. Neill.[17] But the money was not forthcoming, and, in the summer of 1871, the matter was temporarily dropped.

Interest in Mayer's proposed painting was, however, to be revived. In the fall of 1880 members of the executive council of the Minnesota Historical Society decided to memorialize the legislature for a grant and in January, 1881, Mayer agreed to paint the pic-

[17] Mayer to Ramsey, September 6, 1869, Mayer Papers; Lewis Mayer to Ramsey, April 1, 1870, with Ramsey's indorsement; Mayer to Ramsey, January 10, 1871; Ramsey to Williams, January 17, 1871; Mayer to Williams, February 7, March 8, 27, April 21, 1871, Minnesota Historical Society Archives; Ramsey to Mayer, February 19, 1871; Williams to Mayer, March 21, April 24, May 17, 1871; Rice to Mayer, May 2, June 7, 1871, Mayer Papers; Minnesota, *House Journal*, 1871, p. 142, 164. On November 23, 1893, Mayer wrote to William R. Marshall: "I visited the Legislature once at Gov[r] Ramsey's suggestion but their preoccupation & my lack of a 'political pull' postponed action, & it has kept postponed ever since." Minnesota Historical Society Archives.

ture for eight thousand dollars. Some three years later he was ready to reduce the price to three thousand dollars. "This is very cheap for such a work but I am anxious to do it as one of the *completed projects* of my life," wrote the artist. A committee of the historical society was appointed to devise ways to raise the latter sum. During the session of 1885 a bill ordering the painting was introduced in the senate, but it failed to pass. In the hope that the money might be raised by private subscription, members of the historical society's committee asked Mayer to prepare a "rough sketch, or design of the picture, so as to give us some idea of what he proposes to execute." Victory seemed to be in sight at last. Mayer, much encouraged, spent three months working out in color a "study for the whole scheme of the composition." On January 5, 1886, he sent the sketch to Williams. He expressed the hope that it would "be understood that this is only a sketch," and that in the finished picture the figures would "be large enough to give the *likeness* of the individuals and the details of Indian costume." He asked that Williams "carefully guard this work that no one may make a drawing from it or 'steal my thunder.'" But even with the sketch before them, members of the executive council, after some deliberation, decided that they could not procure funds for the larger picture. It was then that Mayer, disheartened, offered to sell the sketch for two hundred

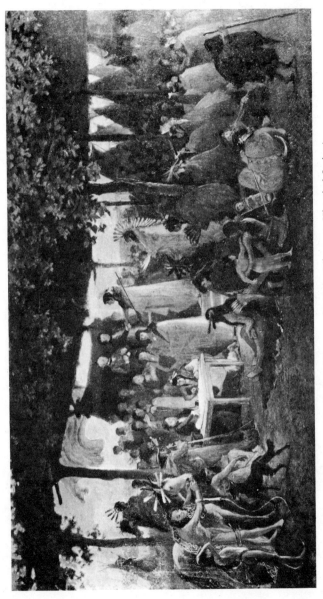

The Treaty of Traverse des Sioux (Minnesota Historical Society)

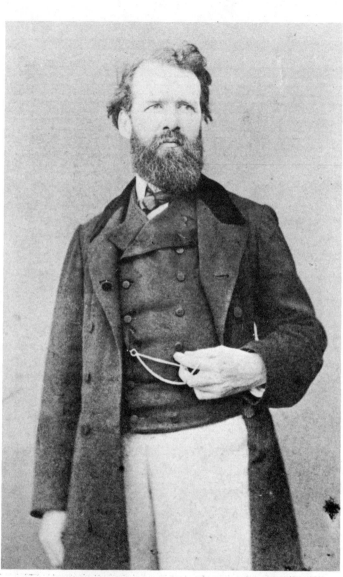

Frank Blackwell Mayer (Courtesy of Jean Jepson Page)

dollars. The offer was accepted by the executive council at its meeting of May 10, 1886.[18] Mayer's sketch in oil of the signing of the treaty of Traverse des Sioux still hangs in the museum of the Minnesota Historical Society. Mayer made one more feeble effort to obtain an order from the state for a large picture. In 1893, when he heard that Minnesota was about to build a new and magnificent capitol, he wrote to Governor Knute Nelson and proposed that he be allowed to develop his sketch to fill a "panel on the walls of your new state House."[19] But his proposal was premature. Ten years were to elapse before subjects for the paintings and murals in the Minnesota Capitol were assigned to some of America's most talented artists. By that time Mayer had died, and it remained for another artist — Frank D. Millet — to execute the picture that Mayer had so ardently longed to paint. The suggestion that a painting of the treaty be included among the Capitol decorations

[18] Minnesota Historical Society, Executive Council Minutes, September 13, 1880; January 17, 1881; October 13, 1884; February 9, April 13, 1885; April 12, May 10, 1886; Mayer to Williams, September 3, 1884; March 19, June 23, 1885; January 4, 5, March 5, April 17, 1886; January 31, 1887, Minnesota Historical Society Archives; Minnesota Historical Society, *Biennial Reports*, 1885, p. 16; 1887, p. 18.

[19] Mayer to Nelson, November 4, 1893; to Marshall, November 23, December 1, 1893; Nelson to Mayer, November 18, 1893; to Marshall, November 18, 1893, Minnesota Historical Society Archives; Minnesota Historical Society, Executive Council Minutes, December 11, 1893.

came from the historical society. When Cass Gilbert, the architect, commissioned Millet to paint the picture for four thousand dollars he specified that it should "in its general composition, follow a sketch which was made by Mr. Mayer . . . who was present at the time," and he furnished the artist with a photograph of Mayer's work. For the picture that now decorates the governor's reception room, Millet wisely adopted Mayer's design, though he changed the composition somewhat. Gilbert expressed himself as "very enthusiastic over the result." [20]

Another matter that Mayer made repeated attempts to push with the historical society was the sale to that organization of the diary and sketchbooks prepared during the journey of 1851. In 1871 he called Ramsey's attention to them and suggested that a "volume composed of the journal with watercolor drawings worked out from the sketches might be a very valuable contribution to the permanent records of the state and of the Historical Society." He offered to transcribe the journal and prepare the drawings for two thousand dollars. It was in 1884 that Mayer first suggested that the society publish his travel diary of 1851, "with the original drawings made at the time as illustrations." The photo-

[20] St. Paul Pioneer Press, June 24, 1903; Cass Gilbert to Channing Seabury, April 21, May 6, 12, November 16, 1904; to Frank D. Millet, May 6, 1904; Millet to Gilbert, July 12, 24, 1905. The letters cited are among the Archives of the Board of Capitol Commissioners, in the custody of the Minnesota Historical Society.

engraving process was being perfected at the time, and the artist found very pleasant the idea that his " drawings could be photographed *on the block* and so engraved of any size & be fac-similes of the originals." He suggested that the volume might be called " The Treaty of Traverse-des-Sioux — from the pen and pencil of an Eye-witness." Considerable interest in its possible publication was aroused among members of the society's executive council, and in 1887 Mayer was asked to send the journal and sketchbooks to St. Paul for inspection. He refused to risk sending the sketches, " as their loss would be absolute if accident befell them," but he did send three volumes of his manuscript diary, with suggestions for its illustration.[21] The society seems to have decided not only against its publication, but also against its purchase, for there is evidence that Mayer had the diary in his possession when he died in 1899. At that time he was engaged in preparing, for Henry Walters, a Baltimore collector of art works,

[21] Mayer to Ramsey, January 10, 1871; February 15, 1887; to Williams, February 11, 1871; September 3, 1884; January 14, 1885; March 5, April 17, 1886; January 31, April 21, 25, June 18, 1887, Minnesota Historical Society Archives. Mayer also attempted to interest the Wisconsin Historical Society and the Lennox Library of New York in the purchase or publication of the journal. The Smithsonian Institution offered to publish it, but could give the artist no remuneration. Mayer stated that he had had other opportunities to dispose of the diary, but he felt that " it certainly should belong to Minnesota." Mayer to the librarian of the Wisconsin Historical Society, September 20, 1882; to Williams, January 31, 1887; to Ramsey, February 15, 1887, Minne-

a series of water-color drawings based on his sketches. Thirty-one drawings were completed when the artist died. With them Walters seems to have acquired a transcript of the diary.[22] Fortunately the original diary and sketchbooks have been preserved. Shortly after Mayer's death they fell into the hands of that great collector of Americana and materials relating to the American Indian, Edward E. Ayer, and they are now in the Ayer Collection of the Newberry Library at Chicago. It is through the courtesy of this

sota Historical Society Archives; undated draft of letter to James Lennox, Mayer Papers.

[22] An account of the collection acquired by Walters, with reproductions of five water-color sketches, appears in the *Sun* for May 11, 1903. This newspaper announces that Walters had presented the drawings to Goucher College, and it includes a list of their titles. The donor had in his possession at the time "three volumes of carefully prepared notes on the Sioux and on the incidents of the journey" that Mayer made to Minnesota in 1851, and these he lent to the college. From them a transcript was "made to accompany and explain the collection of sketches." In 1932 the Goucher College authorities were unable to locate either the drawings or the copy of the "notes" that accompanied them. Some extensive quotations from these notes, published in the *Sun*, indicate that the volumes owned by Walters contained transcripts made by Mayer from his original diary. The artist had made certain minor additions to the text, and he had greatly improved the language. Walters died in 1931, leaving his art gallery to the city of Baltimore. According to its superintendent, Mr. James C. Anderson, Walters' copy of the Mayer diary was "caught in the Baltimore fire of 1904." A copy of a letter from Mr. Anderson was inclosed in a letter from Miss Katherine Jeanne Gallagher, professor of history at Goucher College, Baltimore, to the editor, March 3, 1932. Miss Gallagher has given freely of her time in an effort to locate any Mayer material that may exist in Baltimore.

library that the Minnesota Historical Society is privileged, after the lapse of a generation, to carry out Mayer's wish by publishing his diary with selections from his sketches.[23]

The Newberry Library has five of Mayer's sketchbooks, bearing the numbers from 40 to 44, and containing nearly five hundred pages of drawings. The first includes pictures of the Missouri frontier and Byrneham Wood, sketches made along the Mississippi, and a large number of drawings made at St. Paul and Kaposia. The others are made up of sketches executed for the most part at Fort Snelling, Traverse des Sioux, and Mendota. The last book in the series bears the date July 28, 1851, and is made up almost entirely of pictures drawn at Mendota. A sixth sketchbook, number 45, is among the Mayer Papers; this includes a few Minnesota sketches and a great number made during Mayer's return trip to the East. In addition to the sketchbooks, the Ayer Collection has about sixty-five separate drawings in pencil, a water-color sketch of a group of wigwams, and two Indian heads in oil by Mayer. Among the drawings are fourteen large ones, far more finished in style than other sketches in the collection. It may

[23] The bulk of the present narrative has never before been published. The portion of the diary dealing with Mayer's experiences at Traverse des Sioux from June 29 to July 18, comprising about a third of the text, is printed in Hughes and Brown, *Old Traverse des Sioux*, 79–96; and reproductions of a number of Mayer's sketches are among the illustrations in that volume.

be surmised that these were prepared as illustrations in the days when Mayer hoped to publish his diary through the Minnesota Historical Society.

The diary, which covers the dates from May 7 to July 18, 1851, is written in two small leather-bound notebooks and six unbound booklets of sixteen pages each. The booklets are lettered A to F and are paged separately in pencil.[24] The first bound volume is written on right-hand pages until the end of the book is reached; then it is reversed and carried back to the front. The second volume, the right-hand pages of which have been numbered in pencil, is written on right-hand pages only, except for the last portion, which is reversed and carried back to a page facing page 56. The text of this volume has been greatly elaborated by the addition of notes written on the left-hand pages. The fragments that make up volume 3 present a difficult problem. In 1887 when Mayer sent his diary to St. Paul for examination it was made up of three bound volumes. The last of these must at some later time have been taken out of the binding and separated into sections.

[24] A photostatic copy of the diary and photostatic or photographic reproductions of about a hundred and forty of Mayer's drawings are owned by the Minnesota Historical Society. The editor visited the Newberry Library in December, 1931, to examine the original Mayer diary and sketches. She wishes to acknowledge the courtesy and coöperation of Mr. George B. Utley, the librarian, and Mrs. Ruth L. Butler of the Ayer Collection, in placing these materials at her disposal.

Since the text ends abruptly, the question whether or not any portion of the original narrative is missing naturally arises. A list of proposed illustrations that once was at the end of volume 3 is lacking. More serious, however, is the fact that the last entry is dated July 18, the day that the treaty negotiations opened at Traverse des Sioux, although Mayer made scores of drawings later. Was the artist so busy with his pencil after that date that he had no time to write in his journal? Or has his word picture of the treaty negotiations been lost? In 1893 he himself asserted that he had "an accurate journal of all that transpired . . . on the *two* treaties of Traverse des Sioux and Mendota illustrated by sketches made on the spot." Once when Mayer felt that the value of his writings and sketches was not appreciated he wrote: "Perhaps if I did as the old Sibyl did and burnt them by degrees they would become of value." [25] Did he himself actually destroy part of his diary? It is a matter of regret that his accounts of the treaties of 1851, if they ever were written, are not available for publication in the present volume. On the other hand, it must be remembered that Mayer went to Minnesota to satisfy a visual craving — to see at first hand the natives, their villages, their costumes, their utensils, their dances,

[25] Mayer to Williams, April 17, 1886; April 21, 1887; to Ramsey, February 15, 1887; to Nelson, November 4, 1893, Minnesota Historical Society Archives.

their feasts, their ceremonies — rather than to learn
how the Great Father at Washington dealt with his
red children and bought their fertile prairies and
their rich woodlands for a few cents an acre. It is
just possible that the artist's overwhelming interest
in the natives accounts for the fact that the emphasis
in his diary is on Indian life and that the treaties
of 1851 are neglected.

In the editing of the diary, the original form has
been followed closely. Mayer's spelling, capitalization,
and punctuation have been reproduced throughout.
In the interest of readability, however, the narrative,
which in the original is not paragraphed, was broken
up into paragraphs and divided into chapters by
the editor, who also supplied the chapter headings.
Words or passages crossed out by the author are
omitted unless they contain significant information
not otherwise included, in which case they are in-
closed in brackets and followed by footnotes explain-
ing that Mayer intended to omit them. Brackets
with appropriate footnotes also have been used to
indicate material added in pencil or to inclose pas-
sages added by the diarist on pages facing the regular
text of the original diary. The editor is responsible
for the placing of such passages. Whenever possible,
the editor has supplied the full names of people men-
tioned in the diary, using brackets to indicate the
portions supplied. On the inside covers and the first
and last pages of the two bound volumes of the diary,

Mayer wrote lists of names and addresses and other bits of information that have no direct connection with the adjoining text. Such lists have been printed at the end of the narrative with accompanying footnotes to show their locations in the original diary.

BERTHA L. HEILBRON

MINNESOTA HISTORICAL SOCIETY
ST. PAUL

I

Down the Ohio to Cincinnati

Ｍ AY 7th 1851.[1] "Fare well" from Chris & Charly[2] and an agreeable conversation with Capt Hill of the army as far as Elicotts mills were the last links to bind me to home Elicotts mills and its neighborhood afford ample study for an Artist & indeed from this point until reaching Uniontown P[a] the scenery increases in interest, varying from the elegant and semicultivated hills of Elicotts Mills & Frederick county to the grandeur and wildness of the untouched Alleghanies. At the point of Rocks & Carroll's Manor we first see the Moun-

[1] At the foot of the page on the inside front cover of the first volume of the diary, is the following notation: "*Memoranda &c. Journey from Baltim[or]e to S[t] Paul's, Minnesota. May 7 to June 20[th] 1851.*" It evidently was written after the last entry was made in the volume.

[2] Charly and Chris probably were the artist's cousins, Charles Frederick and Christopher Lewis Mayer, the sons of Lewis C. Z. Mayer. In later life Charles became a successful and prominent Baltimore business man; from 1888 to 1896 he was president of the Baltimore and Ohio Railroad. See Journal, 1847–54, p. 148, 168; Mayer, *Genealogy*, 49, 51. Christopher is listed as the owner of several of Frank's paintings in the index to the latter's *Drawings and Paintings*.

tains forming grand & solemn lines of back ground
to the cultivated farms of Frederick [County]. The
windings of the Potomac through the thickly wooded
gorges of the mountains afford passages of great
beauty.

At Cumberland we took the stage[3] in company
with two women with children to watch, two young
women who carried individually a poodle & collec-
tively a large parrott in a correspondingly comber-
some cage An old gentleman, whose attentions to
the young ladies aforesaid can only be excused on
the ground of unexampled verdancy. [Want of self-
respect in those whom we are naturally induced by
their venerable appearance to respect leave[s] a
mingled feeling in the mind of contempt & sorrow.
As to the young women, it need only be said that loss
of modesty in women is loss of all that renders her
attractive especially if sensuality adds to our dis-
gust.][4] [Rev[d]][5] Mr Balentyne of Washington, & an
intelligent & educated man, & a merchant Mr Goss,
a fine specimen of the honest, frank & persevering
Western man completed our stages compliment.

The Narrows above Cumberland being the pas-
sage for Wills' creek thro' the mountain. This is

[3] Mayer traveled as far as Cumberland on the Baltimore and
Ohio Railroad, which was completed only to that place. Mayer to
Williams, April 21, 1887, Minnesota Historical Society Archives.

[4] The passage inclosed in brackets is crossed out with pencil in
the original.

[5] This word is added in pencil.

wild, grand & stupendous. The rocks on either side
rising to many hundred feet & crowned & interspersed
with pines & other trees. The great variety of tints
produced by the coming leaves mingled with the
sober masses of as yet leafless giants of the forest all
harmonized by the clear mellow tone of a golden
sunset, the mighty shadows cast by the riven moun-
tain & the magnificent repose of the whole scene
absolved all feelings of self in admiration of this
beautiful work of nature. Further on the mountains
increase in loneliness & wildness the marks of elemen-
tal strife being evinced in the decapitated tree tops
& shattered trunks. Many twisted & turned from
their wonted straitness 'ere they had acquired
strength to resist the violence of the storm. Added
to this was the mystical effect of the moonlight

The indistinct distinctness of moonlight has al-
ways something peculiarly mysterious and solemn in
it but when this is exhibited in such a theatre as
the mountains of alleghany present, the grand & mas-
sive mountain ranges the skeleton trees shattered by
the storm, interspersed with hardy pines of apalling
height. The rocks & twisted roots casting fantastic
& suggestive shadows. Shadows " of things unseen "
more evident than substance, altogether formed a
scene portentous & mystic The moon setting at one
o'clock[,] Starlight, & the chill of morning succeeded.
Day dawned gradually and beautifully & taking a
seat by the driver I enjoyed the perfection of trans-

portation thro' a most beautifully picturesque country.

Walking up Laurel Hill with my fellow travellers we looked *down into* forests unmutilated by the hand of man. The view from the summit is one of the most extensive probably in the country commanding a great extent of mountain view[,] Uniontown & Brownsville being seen beneath. Breakfasting at Uniontown we pass on to Brownsville thro' a cultivated & undulating country. In these places that effect of the general use of Bitumenous coal is apparent which renders Pittsburg & all places where it is used exclusively & in large quantities so disagreeable a place of residence investing everything & insinuating itself into every crevice and spot no matter how retired or secured, it constitutes an atmosphere of dirt & dust.

The Monongahela river is elegant in its scenery without possessing the grandeur of the mountains or the more cultivated character of the homes of succeeding Anglo Saxon generations.[6] Here the Steamers & Craft peculiar to the Western waters first present themselves. A strange feeling of contempt was the first impulse on beholding these "freshwater" craft and Sailors. Always accustomed to consider the steamer but a modification of the ship the appearance of a combination of improved chicken

[6] Mayer seems to have left the stage at Brownsville on the Monongahela River and to have proceeded by steamboat.

coops & teakettles *slipping* down a waveless stream
& managed by men half sailors half machinists, lack-
ing all the peculiar freedom of motion & hardy, salty,
appearance of our old Tars of the seaboard struck me
as a "decided failure", ["]small potatoes". Added
to this the whole concern seems to be perpetually
labouring under the effects of an "awful cough"
which it in vain endeavours to get rid of. This state
of the system developes itself in a decided system of
ague & fever shaking and stewing the whole affair.

At *Pittsburg* any one with ordinary propensities
to cleanliness are at once shocked by the coating of
coal dust in which every thing is enveloped. The
inhabitants are employed as it wer[e] in the Sysiphian
labour of keeping themselves clean — & altho' the
majority seem long since to have relinquished the
task as hopeless and have turned their attention to
combating the elements in another form, reducing
them to subjection and use in the form of various
articles of glass & iron, manufactures for which the
city is famous. forty iron furnaces & thirty five
glass-houses belch forth continuous volumes of bitu-
menous smoke. Beside Iron & glass there are fac-
tories of Salt, copper, & cotton The internal im-
provements connected with Pittsburg are numerous
& very substantially constructed. With Miss Helen
Dunloss a talented & amiable young lady I visited
the hill on the opposite side of the river (Coal
Hill) — which commands a very extensive view of

the city & surrounding country.[7] Mr Baum also
was extremely kind & attentive

Altho' at first sight rather prejudiced against the
steamers, since becoming a passenger on board the
Messenger, I have become more reconciled & have
found *poetry* & *pictures* here as elsewhere.[8] Our
faith in the ideal world is strengthened when occa-
sionally there flit across our path faces & forms ex-
pressive of the most attractive & endearing feelings.
Such was a face I saw to day in company with others
probably her relatives all apparently possessed of the
same attractive qualities. Fair lady we may never
meet again but — I should like deucedly to paint you.
It is not in the cabin among our friends of the first
class alone that we are to see the expression of the
beautiful & affecting, but descend to the deck of the
steamer & after contemplating that wonder of human
ingenuity the steam engine — "go aft " to the groups
of emigrants. Here, a german family, the old man
& frau, & his pretty daughter, of whom I got a sketch
by stealth.[9] The modesty of the girl the dignity &
matronly consequence of the mother the determina-
tion & tranquillity of the old man & the hopeful coun-

[7] Miss Dunloss returned Mayer's visit in the summer of 1854.
Journal, 1847–54, p. 220, 254, 266.

[8] The " Messenger " was a steamboat of the Pittsburgh and Cin-
cinnati Packet line. A picture of this boat appears in Charles H.
Ambler, *A History of Transportation in the Ohio Valley,* 174
(Glendale, California, 1932).

[9] The sketches mentioned here are not in the Ayer Collection or
the Mayer Papers.

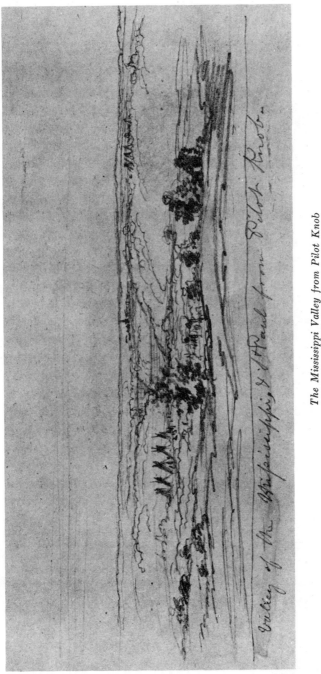

The Mississippi Valley from Pilot Knob
St. Paul appears in the distance.

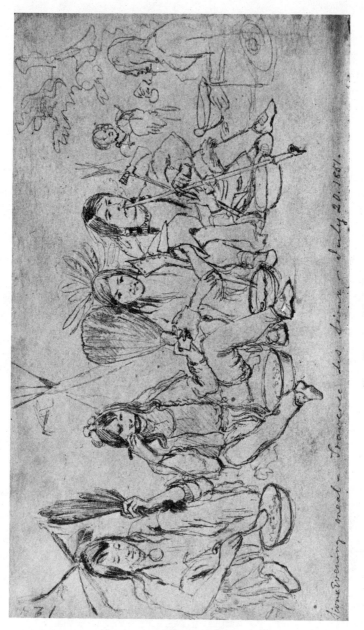

Sioux Evening Meal, Traverse des Sioux

tenance of the ruddy youth who helps himself from the well stored oaken chest of ample family dimensions to his allowance of brown bread & sausage forms a domestic picture of rare beauty. Near this group is a daughter of Erin with her raven locks disordered & her large dark eyes glazed with the bursting tear as resting her head between her hands she watches with a mother's anxiety the sick child extended on the birth [berth] or rather shelf before her. the father is there too, his interest divided between the mother & his child. The numerous groups of [other emigrants with their][10] children, the rude boatmen engineers & modern cyclops of the boilers give ample employment to an artist or student of nature — should he neglect to look upon the beautiful scenery of the Ohio.

[Seated on his chest which contains his all & that of his faithful grandson is an old blind man, whose only consolation for the loss of the most pleasurable of the senses, consists in enjoying the melody of sound which he draws with surprising skill from the strings of an old violin. His face bears an exp[r]ession of quiet, & beautiful resignation with a tinge of sadness — his grey hair is thrown back over his head & exposes a forehead of benevolent form.][11]

Cincinnati: May 12th The steamer Messenger on

[10] The passage in brackets is crossed out in the original diary.

[11] The passage in brackets is written at the top of a left-hand page facing the material that immediately precedes it in the printed text.

which I came down the Ohio I left with some regret.
That attachment which is formed to those with whom
we have shared common dangers or pleasure is felt
on leaving [those] with whom we have passed several
days, having become domesticated to a certain ex-
tent aboard our steamer. Could one travel on our
Western waters with an assurance of safety I know
of no more agreeable mode of passing a summer's
week. The boat is a moving theatre of [or] museum
of human Character. here are congregated together
natives of every land — American German, Irish,
Scotch, Spanish, English and French, Negro & White.
The travelling merchants' agent, the farmer, the
emigrant the tourist, the invalid, the "blackleg"
the military man, the preacher & the artist, while
attached to the boat itself are the captain & his
boatmen a peculiar race, the negro firemen who en-
tertained us as they passed their town where most
of them resided when "home" by shouting at the
top of their voices the chorus to one of their glees a
huge negro giving the words with stentorian expres-
sion — all these again modified by individual charac-
ter and circumstances, form studies of endless novelty
& amusement to an observer. Much information is
also acquired by the intercourse with fellow passen-
gers, as there are scarc[e]ly any who may not have
seen or known something peculiar to themselves.
Seated on the "guards" with my companions a stiff
breeze rendering the atmosphere of a delightful tem-

perature & unoccupied but by the pleasures of the
passing moment, no lack of amusement & instruction
was to be found — as a succession of beautiful views
was presented to us, the wild & uncleared hills, the
towns just emerging into existence — then a gradual
transition to a more cultivated country where man
& nature strove to vary the surface of the earth with
every variety of foliage.

Occasionally a steamer passes & is hailed with a
rude shout by the rough denizens of the " deck " —
which is returned with one equally uncouth from the
rival boat. A shout from a flat boat or raft is usu-
ally treated with dignified silence. With the excep-
tion of an occasional canoe or dug-out crossing the
river, the steamer[,] the raft & the flat boat are the
only craft seen upon the Ohio's surface. No sail is
ever seen, the current being too strong & the course
of the stream too tortuous for such mode of pro-
pulsion.

The scenery of the Ohio is peculiarly beautiful, it's
upper portion passing thro' a richly wooded mountain
country the sides of the mountain being seperated in
most instances by a narrow skirt of meadow land or
" *bottom* ", these green hills reflected in the waters of
the river either by moonlight or day — and sinking
away into the faintest blue of the distance, the clear
sky above the glassy waters beneath, a pleasant
breeze, good company animated by mutual courtesy,
and prospect of a happy termination to our journey

beget contentment, & its soothing influence acts upon us irresistib[l]y the joke is passed, information is communicated, friends made, & the sordid cares of commerce & strife of existence forgotten in the contemplation of the beautiful, the true, the natural. On the deck below the same spirit prevails tho' in a ruder developement, the boatmen & stokers shout their songs, the fiddle scrapes a merry jig, a "hodown" follows & tho' without a cent in their pocket, "O'er all the ills of life victorious" they thus occasionally vary their labours by giving rein to their animal spirits, no doubt are happier than many who with thousands are strangers to care-less enjoyment. My sketch book greatly amuses my deck friends for there I find ready use for my pencil, poverty and hard labour are strangers to the formality of fashion — the passions show their marks upon the face untrammelled by a hypocritical smirk of exclusiveness & pride. The temptation to endeavor to draw these beautiful shores is irresistable & I have already fill'd half my sketch book with unsuccessfull attempts to *hint* their beauty.

II

Art in the Queen City of the West

MAY 13th Cincinnati. [Thomas] Cole's "voyage of life" at Mr [George K.] Schoenberger's.[1] Rid of the allegory they might be good landscapes tho' far inferior to many of Coles works.[2] Allegories of this description except in the hands of men of the very greatest genius are seldom successful. The boy & boat &c become mere accessories to the landscape & dwindle into theatrical tinsel. Again, the landscape is destroyed by a strained effect & composition. The "Elijah" in the

[1] Schoenberger assembled a large collection of art objects at Cincinnati, and a picture gallery was a feature of a magnificent home that he built in a suburb in 1864. He was a director of the Western Art Union of Cincinnati in 1847–48. *Biographical Cyclopædia and Portrait Gallery of Ohio*, 6:1457 (Cincinnati, 1895); D. J. Kenny, *New Illustrated Cincinnati*, 221–224 (Cincinnati, 1895); *A Sketch of the Women's Art Museum Association of Cincinnati*, 8 (Cincinnati, 1886).

[2] Thomas Cole was among the earliest American landscape painters to use the native scene as his subject. His "Voyage of Life" is a series of allegorical paintings from which engravings were made. The latter were widely distributed and they were very popular. It is interesting to note that this series of engravings was exhibited at Le Duc's book store in St. Paul in June, 1851. *Pioneer*, June 26, 1851.

same room is far superior — (why are these allegories failures?).

At M^r [Nicholas] Longworth's is the bust of " Genevra " by [Hiram] Powers executed solely by his own hand & presented to his patron as a token of gratitude.[3] How greater than princes is he who can make such returns to his friends! It represents the head of a maiden in full bloom of youth — the features have acquired sufficient sharpness to convey the womanly character without losing the beautiful fullness of the young virgin. The face is full of expression of the tenderest feelings — the feautures classical without the coldness of some Greek sculpture. The "texture" is admirable the effect of flesh perfectly conveyed & the hair & drapery equally careful & truthful, nothing slurred or sketched. How different the style of art of the picture by [Benjamin?] West in the adjoining room representing Laertes & Ophelia. Pow-

[3] Longworth settled in 1805 at Cincinnati, where he studied and practiced law, experimented with grape culture, became a successful wine manufacturer, and made a fortune in real estate. He supplied funds that made it possible for Hiram Powers, a talented local sculptor, to go abroad to live. Powers executed his "Ginevra" in 1840; the "Greek Slave," of which he made six duplicates in marble, was modelled in 1843. One of the latter statues was in the rooms of the Western Art Union at Cincinnati. See *Appletons' Cyclopædia of American Biography*, 4:17, 5:97 (New York, 1888); John P. Foote, *The Schools of Cincinnati and Its Vicinity*, 204 (Cincinnati, 1855). See also Mayer's Journal, p. 156, for the artist's opinion that "The reputation which Powers acquired in Europe awoke the Cincinnatians to the appreciation of Native talent and they have manfully stood by their Artists ever since."

ers' Greek slave is here at the Art Union rooms. The first impression to me was disappointment and certainly the *forms* of many parts of the figure are objectionable, being rather those of the woman accustomed to wear our modern clothes & to pursue the present habits of life than the female form in its purity. These changes may have been necessary in order to destroy all ideas of sensuality but it may be carried too far & the *plumpness* of form give way to *scrawniness*. The back of the figure *I* think much superior to the front & all the views in that position are very fine. The expression and "feeling" of the whole figure with the exceptions I have noticed is remarkably delicate & refined. The bust of Judge [Jacob] Burnet is at the house of that gentleman where I saw the original & the bust. It is a remarkably fine head full of dignity and truthfulness. The utmost detail is developed without destroying the masses or expression. Every form is beautifully made out & the effect of flesh and hair is admirable. It seems humanity turned to stone — & possesses none of the hardness usually seen in marble works. This is particularly remarkable in the modelling of the *mouths* of Power's statues which resemble more a cast from the life than a stone.

The Art Union Room & the *Artists'* Union rooms contain many creditable specimens of native as well a[s] foreign talent. The artists of Cincinnati, & this city has been peculiarly prolific in men of this class

are mostly the uneducated votaries of Art i. e so far as Academic instruction is concerned. The tendency of the school is good, self reliance & constant reference to nature, regardless, perhaps too much, of the great canons of art.[4] The painters are mostly landscape Artists and the beautiful country by which they are surrounded supplies them with ample material for study & subject. The most eminent in landscape is [William L.] Sonntag a native of Cincinnati & a social agreeable & modest gentleman.[5] He has travelled over the greater part of this country visiting all our finest scenery & has studied entirely in the school of nature. His landscapes are remarkably fine, distinct, characteristic & truthful. [Thomas W.] Whitridge, [Robert S.] Duncanson (a negro), also paint good landscape [6] the general defect of the artists here being a want of massiveness in the foregrounds & a hardness & harshness of drawing & colour.

[4] An account of the development of the " Fine Arts " in Cincinnati appears in Charles Cist, *Sketches and Statistics of Cincinnati in 1851*, 119–128 (Cincinnati, 1851). The writer includes a long list of local artists, in which many of the artists mentioned by Mayer are noted. Cist describes the " Arts Union Hall " as a " fine saloon," which " occupies the fourth story of the building at the corner of Sycamore and Fourth Streets; to which it has given its own name." The hall seems to have been used chiefly for temporary exhibits. See also Foote, *Schools of Cincinnati*, 207–209.

[5] Sonntag was born near Pittsburgh in 1822, but he passed his youth in Cincinnati. An account of his career appears in *Appletons' Cyclopædia*, 5:606. Mayer mentions him also, *post*, p. 203.

[6] A sketch of Duncanson appears in Wendell P. Dabney, *Cincinnati's Colored Citizens*, 89–93 (Cincinnati, 1926).

[Joseph O.] Eaton paints a good head, and bids fair
to excell. There are others here of lesser degrees of
talent, but these stand highest. Sculpture is pecul-
iarly cherished in Cincinnati the nurse of Powers, &
[Shobald V.] Clevenger, who is inferior to him as far
as I have seen. At the Art Union room I saw a fine
landscape by [John F.] Kensett of N York & a good
hunting scene by [William S.] Ranney of N Y. There
is also an exquisite head by professor Shroeder of
Dusseldorf which is a model for our artists as regards
effect, drawing, & all the technical parts of the art.
It is a female head & bust, & arm & hand, very beau-
tiful — highly finished yet broad & transparent.

Cincinnati is one of the most beautiful and attrac-
tive cities I have yet seen, situated on a gently rising
plain & surrounded on three sides by hills, the fourth
bounded by the river which here takes a simicircular
curve. The hill to the east commands a fine view
of the town & surrounding country & is the site of
the Observatory where an astronomer is stationed to
make observations &c.[7] The city is regularly laid out
and its architectural adornments are in excelent taste.
The materials used being mostly a species of free
stone of a light drab colour. They do not possess
the white marble or beautifu[l] bricks of Baltimore
but their buildings evince private taste & a pervading

[7] For an acount of the Cincinnati Observatory, see Cist, *Cin-
cinnati in 1851*, 341–346. The corner stone of the observatory
was laid in 1843 by John Quincy Adams.

public spirit. The Burnet house is a *magnificent* hotel of Palladian architecture — adorned with the finest mirrors, gilding, marble pavements & finest furniture.[8] Tho the accomodations are excellent I should have preferred for comfort the less ostentatious "*Inn.*" Prosperity and progress are every where evident & the long line of steam boats & piles of merchandise on the levee, the bustle of passing crowds, the whizz & whirr of factories & the elegant stores, bank buildings & public halls give token of a brilliant future to the Queen city of the West.

[Cincinnati besides the extensive business connections with the surrounding country is one of the greatest pork markets in the world. There are numerous factories & Steam Engines constantly at work. The cultivation of the vine is carried on successfully on the shores of the Ohio above & below Cincinatti, especially at Vevay.][9]

To Wᵐ F. Coale & Mr [John L.] Ste[ttinius], grandson of Mʳ Longworth I am indebted for kindnesses.[10] Altho' not very intimate with Mr & Miss Dale of Baltimore I met them with great pleasure accidentally at the hotel. In the midst of strangers &

[8] A picture of the Burnet House forms the frontispiece of Cist, *Cincinnati in 1851.*

[9] The paragraph inclosed in brackets is written at the top of a left-hand page facing Mayer's final comments about his visit to Cincinnati.

[10] John Longworth Stettinius was the son of Nicholas Longworth's daughter Mary and John Stettinius. C. F. Goss, *Cincinnati, The Queen City,* 4:612–615 (Cincinnati, 1912).

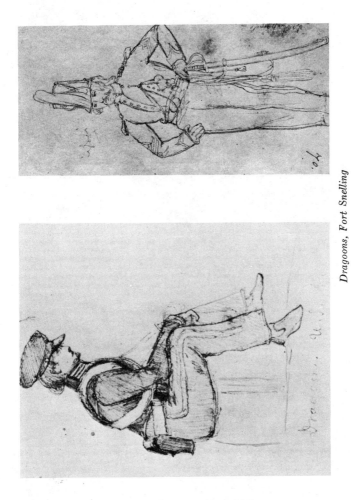

Dragoons, Fort Snelling

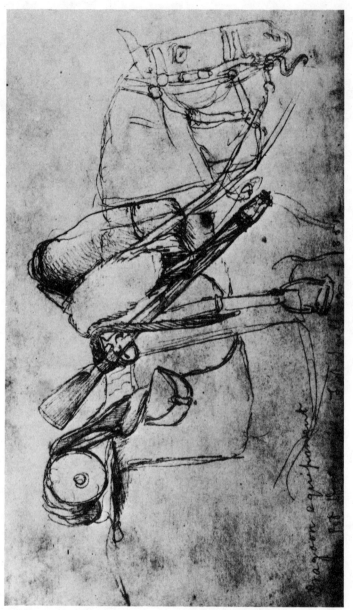

Dragoon Equipment, Fort Snelling

a strange city one grasps the hand of a fellow citizen
with peculiar tenascity.

May 14. Left Cincinnati on the Ben Franklin, a
" crack boat," — & arrived in Louisville by 10½ but
remained on board until the morning.[11] Old gentle-
man of stage-coach notoriety turned up again, the
old man is evidently filled with the milk of human
kindness, a diet which has possible impaired the
sterner qualities of his mind — for he firmly believes
the young ladies to be very respectable women. He
still had the sense to discontinue the acquaintance
on board the steamer. He has wealth & uses it well.
Plenty of time & money he desired to take a tour
to the west, but as his wife dreaded the dangers of
Western waters he has taken the clergyman with him
& pays all his expenses. He kindly assisted a poor
man on the boat & gave him his own great-coat
" Forgive us our trespasses as we forgive those who
trespass against us." A weakness of intellect is
amply compensated by his kindness of heart. He
has taken a fancy to me & introduced me to Mr W.
Cave Johnson, formerly a distinguished politician &
Postmaster general under Polk's administrat[ion][12]
He is a tall venerable looking man with flaxen hair &

[11] The " Benj. Franklin " was built at Cincinnati in 1848. James
T. Lloyd, *Lloyd's Steamboat Directory, and Disasters on the
Western Waters,* 269 (Cincinnati, 1856).

[12] For an account of Johnson's career, see Joshua W. Caldwell,
Sketches of the Bench and Bar of Tennessee, 187–190 (Knoxville,
1898).

thin visage marked by lines of anxiety & care, tho'
his eye gives evidence of the undying flame of talent.

Conversed with an Irishman, walked the deck by
one of the loveliest moons I ever beheld with an
Englishman who has been making a tour from
Canada thro' the country a man of some information
& *neat* character but a little ah-a-a ingleesh & con-
cieted — tho' rather more liberal to this country than
I had anticipated. As I retired a " Cannie Scot "
demanded a share of my stateroom which I could not
refuse, & found him honest.

The scenery for some miles below Cincinnati is of
a gently undulating character the hills on either side
being less bold than above, but as we got below
Vevay the river widens & the hills acquire a more
massive & extended form, richly wooded to the waters
edge with a thick umbrageou[s] & uniform vegetation.
The atmosphere was perfectly clear & the glassy sur-
face of the water reflected with perfect distinctness
the forms of the embracing mountains, the setting
sun throw[ing] the whole scene into deep transparent
masses of mellow light & shade. The day retired &
the rival moon rose to contest the palm for beauteous
limning of the landscape grand & to which the prize
is due I know not so beautiful were both yet each so
different. The moon rose full & the transparent
atmosphere & unrippled river furnished a suitable
theatre for the exhibition of her silvery magic. Here
& there a light in some Cabin ashore, or the fire on

a raft or flat boat was reflected in the water, giving variety to the scene, or the ponderous mass of a steamboat come slowly onward th[r]o' the uncertain light, enveloped in portending cloud of smoke & steam, emblem of power, moving majestically thro the quiet water, regardless of current, wind or weather. The occasional shout or song of the boatmen were the only evidences of any animated presence than our own — the vast forest spreading over hill & vall[e]y to water edge & mountain top, & not a habitation seen of man or human kind. The deep shadows & uncertain distinctness of the scene seemed to taunt the human with his own shallowness & to tempt him on & lose him in the depth of thought begot of peering into caverns of unfathomable shade — the light like liquid silver was evanescent, flitting on the surface of the water & the moon alone above seemed steady in its gaze as it looked with seeming smile on the maze, in which its beauty had beguiled our flippant fancy's.

As we passed down the river we beheld the quiet resting place of the truly good President Harrison. North Bend at the mouth of the Miami River is the seat of his family & his remains rest on a knoll which [is] visible many miles up & down the river an object of solemn suggestion.

III

The Mammoth Cave of Kentucky

LOUISVILLE May 15th 1851. In company with Mr Hall of Washington & the Hon W. Cave Johnston [sic] of Tennessee put up at the Galt house where I met Col¹ [Joseph P.] Taylor of Balte the late President's brother. The comparison between Louisville & Cincinnati is by no means flattering to the slave city. One notices the absence of that activity & neatness which distinguishes the former. That look of thrift & healthy progress is replaced by a sluggishness of public enterprise & a subjection of the senses, inseperable, I fear from slave labour. Here I first perceived myself in a more southern land than my native state. The physiognomy & costume assumes a more generous & liberal aspect. The sharp feautures & energetic eye & motion of the northerner & bluntness and his businesslike manner are excha[n]ged with lighter clothing for the easy contentment of manner & expression & more open social feeling of the southerner. One still bears the marks of his puritan origin while the cavalier still glimmers thro' the southern planter's exterior. This

ease of manner & hospitality thro' [*though*] traits greatly to be admired and imitated do not compensate for the want of public energy & enterprise which is so nobly exhibited in the sister city of Cincinnati.

On the morning of the 16th Left Louisville in the stage for the Mammoth cave — a distance to Bell's where we stopped that night of 95 miles.[1] The road at first lies thro' the most beautiful natural parks the trees in which are beech, maple, & Tulip poplar chiefly, of great size and covered with the thickest & most luxuriant foliage, possessing a richness of form of colour which speaks a most fertile soil & healthy growth. The underbrush seems to have been entirely displaced by the fathers of the forest & the green sward seems as tho' tended by a careful gardener. The surface for some miles is level much of the road following the course of the Ohio river & as it meanders along its banks affording beautiful views of that majestic stream. At salt river a stream somewhat noted in our political annals as giving origin to the term " rowed up salt river," [2] we took the ferry & crossing

[1] It was customary for tourists who planned to visit the Mammoth Cave to spend a night at a tavern kept by Robert S. Bell, who was famous for his hospitality, his excellent table, and a drink known as " peach and honey." Horace Martin, *Pictorial Guide to the Mammoth Cave, Kentucky*, 16 (New York, 1851); Franklin Gorin, *Times of Long Ago (Barren County, Kentucky)*, 63 (Louisville, 1929); Kentucky taxlists, cited in a letter of Nina M. Visscher of the Kentucky State Historical Society, May 26, 1931.

[2] Salt River, according to Webster, is " an imaginary river up which defeated political parties or candidates are supposed to be sent to oblivion."

passed thro' a gorge of the mountains highly picturesque Rocky & well wooded, with a bea[u]tiful spring on the road side which drops from ledge to ledge of the rocks in a silvery cascade. After this & until reaching Bell's our destination by stage route the country is sterile & uninteresting, probably the least fertile portion of Kentucky.

The pleasures of the morning ride were much heightened by intercourse with the driver a good specimen of a race rapidly diminishing, the *American* stage driver, a person entirely distinct from the English individual of that title. In the presence [*present*] instance he was tall & well proportioned, a large frame muscular & enured to hardship, with little of the encumbrance to agility called *fat,* his feautures are decidedly acquiline the mouth compressed with determination & the eye bright. Complexion sun-burnt, the slouched felt scarcly screening his face from the sun's scorching rays. In fact he would be an admirable model for the pioneer of our backwoods representing a physiognomy peculiarly *American.* Affable & polite there was nothing servile in his manner but you felt that he was to be treated with proper respect, & that he considered himself politically at least your equal. None of that cruelty to his horses was exhibited which too often disgusts us in others of his class. My fellow travellers were a young Kentuckian named Richison & an old negro who was going home at his ease, stopping to visit his friends

at the roadside plantations. He was a member of one of those patriarchal establishments only found in our southern country. I understood from the driver that he was the old *friend* & constant adviser of his master who consulted him on all occasions with regard to the disposition of *their* affairs. He was looked up to with evident veneration by all the younger darkies he met & to whom he never fail'd to address some gossip for he seemed universal[ly] known & regarded.

Arrived at Bell's an eccentric old landlord who treated us in a generous manner tho' his announcements were given rather a voice of command than invitation. He is a veteran of 74 & has never been a day absent from his present residence for years. He is a man of good sense, some humour & a disposition to accumulate, the first of which qualities united to his venerable years have rendered " old man Bell " an oracle. With a gruff kind of *command* he invited [me] to take some of his peach-brandy for which he is famous & I bear witness to the excellence of the preparation as well as to the admirable supper which followed, for this is a land literally flowing in milk & honey, venison of tenderest quality & other delicacies of the wilderness graced the board to which we were *ordered* in the same style as to the brandy. After supper the boy was called to take my trunk & a candle a hint which I understood to me[an] " go to bed,["] & acted therein.

In the morning a negro drove me to the Mamoth cave hotel & soon after being provided with a guide I proceeded to visit that great natural curiosity.[3] Proceeding a few hundred yards down a richly wooded ravine you arrive at a large cavity in the hill side from which so cold a draught of air issues that the change startled you by it[s] suddeness & seeking the cause you perceive that the yawning mouth of the cavern is before you. descending several steps & following rapidly the footsteps of the guide you are past the current of air & find yourself in perfect stillness within the cave. For some distance the harmony of the scene is destroyed by the present [presence] of the remains of salt-petre works formerly used during the war of 1812, great quantities of this article being extracted from the dirt of the cave.[4]

Beyond this the subterranean scenery begins & it is probably unequally [unequaled] by any other example known. An immense cavern fifty to sixty feet in

[3] Bell's tavern was located nine miles from the cave. See Martin, *Mammoth Cave*, 17. A picture of the hotel at the cave forms the frontispiece of this volume.

[4] The remains were still to be seen in the cave in 1901. Early in the nineteenth century it was found that the cave abounded in "nitrous earth," and from this was extracted saltpeter. The cave was privately owned at the time, and during the War of 1812 its owners "made a fortune" from it. An account of the method of mining the saltpeter and an estimate of its importance to the United States during the war appear in Horace C. Hovey and Richard E. Call, *Mammoth Cave of Kentucky: An Illustrated Manual*, 11 (Louisville, 1901). See also Martin, *Mammoth Cave*, 20.

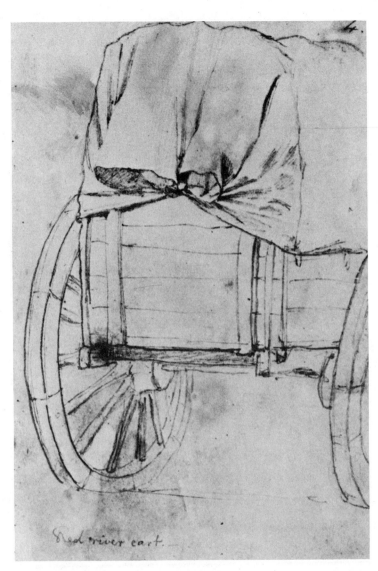

A Red River Cart

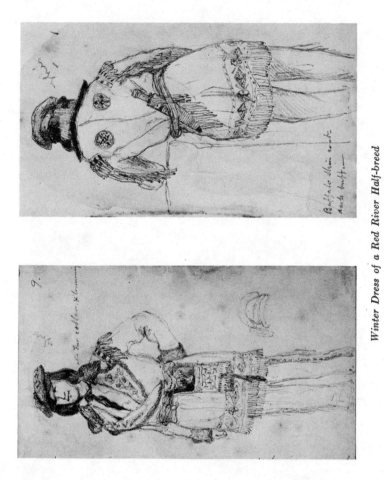

Winter Dress of a Red River Half-breed

width & often more in height extends for four miles
from the entrance, & constitutes the main cave. Here
perfect stillness reigns & awful silence, never broken
but by the hasty flight of some solitary bat & that
only near the entrance. Impenetrable darkness fills
every cavity & our lamps rather hint that [than] fully
reveal the immense masses of jagged, & riven rocks
strewned upon the bed of the cave apparently tossed
& torn by some tumultous torrent. Rising from this
confusion wild the ledges of rocks tower above one
another in grand masses to the ceiling or roof which
is nearly flat & appears as tho' laid over this chasm
chaotic by some cunning architect — beyond is im-
penetrable darkness and all around are scattered the
enormous fragments casting shadows of alarming
form & magnitude It seems a fit residence for gigan-
tic spirits & but little imagination is required to be-
lieve their presence, for the form of an immense rock
has given it the name of the giant's coffin.

Passing two houses of stone which had been erected
for the residence of consumptive invalids who for the
sake of a restoration to health were willing to become
denizens of this dismal abode for some months, the
atmosphere having at one period been supposed bene-
ficial to patients of that class,[5] you arrive at the "Star
chamber" a portion of the main cave which has
been thus named from the circumstance of certain

[5] Some remarks on the supposedly pure and healthful atmosphere
of the cave are quoted by Martin, *Mammoth Cave*, 39–41.

crystals or white substances reflected from the midst of the dark mass of the roof giving the idea of a starry sky, the deception is remarkable. Beyond the cave increases in rugged & apalling grandness passing th[r]o' many scenes of great picturesqueness One of these is the cascade hall where a stream dropps from the ceiling a hundred feet to the floor beneath, & the grand temple an immense rotunda near the termination of this portion of the cave. Numerous avenues branch from this one to great distances the greatest distance from the entrance to the extreme end being about 9 miles. These are of lesser size than the first & seem to bear greater evidence of the action of water than other portions. Numerous pits, domes & stalactite & stalagmite formations are found & the general direction is a descent until you reach the "river," a stream some thirty feet wide & often as deep running as the poet says "thro' caverns measureless to man down to a sunless sea". This region partakes more of the horrible, dismal & dreary & suggests the memory of the unhallow[e]d journey of Dante & Virgil, it is a fit place for the wandering & wearied damned & realizes our ideas of Pluto's realmns.

One branch of the river is aptly named the Styx, the other Echo river. On this you embark, the guide acting as oarman Seldom do you encounter such a situation. In a small flat-boat steered by a guide who by the dim light might easily be imagined

an uneasy spirit of the place, the still quiet stream cloudily revealing the sharp angles & points of treacherous rocks lurking just beneath the surface, the low arched roof with the sides rising perpendicularly from the river robbing the drowning wretch of even the sight of a shore on which a hand-hold could be found — & the wild song of the guide dying away in echo[e]s which give the effect of an organ accompaniament of some unseen hand — & you have a scene where you feel yourself doubtful of your waking existence. At one point of the pass[a]ge and for a space of thirty yards I was obliged to compress myself to the smallest compass in order to pass under the superincumbent rock. Had the river risen, as it has been known to do, before our return our situation would have been truly awful for our chances of escape would have [been] resting on finding a passage thro' Purgatory[,] a dangerous & intricate ravine where the water does not rise *as* rapidly as in the river.

On landing you find yourself in the "Infernal" regions & they are well named for a place of greater dreariness & utter absence of all that can serve to occupy the mind or offer repose to the body I cannot imagine. An irregularly arched way with an uneven & tortuous bed, composed of rock seemingly formed of mud of the most fetid colour, not offering even the gratification of an angle to the eye for all the forms are rounded into one another in ungraceful

curves the floor being of so *uneasy* a surface as to suggest no idea of repose but rather to cause that species of progression seen in landsman on a pitching ship, then all is damp, dreary, desolate, & the mind is irresistably turned upon itself — a fitting spot for the torments of conscience to be administered. Two other places are suited to Dante's ideas of punishment — here is the "Winding way" "or fat-man's-misery" a path which was once the bed of a torrent of about a foot in width & waist deep, here the gluttons might be compelled to walk for ever & until reduced in flesh. After this is the "valley of humility" where the proud must stoop double. From the infernal regions you walk three miles thro' an arched & tortuous rocky avenue over pointed & brocken rock to the "snow ball room" where the crystalization of gypsum on the ceiling give it the effect of an incrustation of snowballs. Gypsum formations are only found beyond the river the first portion of the cave being of darker limestone.

No living creatures are found within this subterranean world except a few bats who seek shelter in the mouth of the cave during winter, & species of rats who frequent the main cave & who as well as the fish found in the river are of a lighter colour than their brothers of the daylight world. The fish found in the river are small, colourless, & without eyes.[6]

[6] For a discussion of the flora and fauna of the cave, see Hovey and Call, *Mammoth Cave*, 100–107.

There are a few spiders & crawfish of a like unhealthy hue.

I returned from my tour of the cave, having been absent 8 hours & having walked about 18 miles, the effect of so much exercise being much less fatiguing than the same amount above ground, owing probably to the equable & agreeable temperature all parts of the cave at all seasons being about 60° of Fahrenheit.

Another cave in the vacinity, ("White's cave") contains more of the stalactite & stalagmite formation — which in its forms suggests many useful ideas of forms & ornaments to the architect. The stone is not brilliant except when broken when the crystalization is apparent. The whole of this region is limestone & contains many similar caves of smaller size. The only remains found in the Mammoth Cave were the bones of some gigantic human being & some of the bones of a mammoth & a wooden bowl found by an early explorer near a spring supposed to be of Indian manufacture. The mummies *said* to have been found here were discovered in a cave some three or four miles distant (Long's.).[7]

[7] According to Hovey and Call the story that mummies were found in Mammoth Cave had its origin in the fact that a mummy found in a neighboring cave was exhibited in Mammoth Cave. *Mammoth Cave*, 28.

IV

By Stage and Boat to St. Louis

MAY 19. Left the cave for Bell's & at 12 oclock found myself in the stage for Nashville in company with an old gentleman, of evident gastronomic taste. The country, which I first saw the next morning, resembles a prarie tho' of less extent & varied with clumps of trees & well cultivated farms The road is a fine one & we travelled rapidly notwithstanding the rain which fell in torrents until noon. Until arriving within about twenty five miles of Nashville the scenery is uninteresting. At this point we descend from a ridge of hills and enter a most beautifully undulating country covered with farms & plantations in the highest state of cultivation the neat airy white & stone coloured dwelling embedded in the beautiful natural parks which I had seen first in Kentucky but which here exist, if anything, in greater luxuriance. The houses partake of the cottage style two stories high covering a large space & surrounded by porches which protect them from the sultry heat of summer. Every thing here wears a more southern aspect, the sultry heat,

the Luxuriant & various foliage, the sprouting cotton plants, the cool costumes & the negro[e]s all bespeak an approach to the tropics. The trees mostly found here are the beech, sugar maple sycamore, buckeye, walnut, tulip poplar, Elm, & the usual varieties of oak, these are often covered with the most graceful festoons of grape vines & other running plants & the May apple grows in large patches beneath their shade, in the midst of blue grass & other grasses of nutritious character. Looking into the cool shade beneath these groves the light is seen in the distance falling here & there on the emerald carpet & presenting an enticing variety of effect. My companions during the day were increased by the addition of a "Kaintuck hauss trader" a giant of gaunt & bony frame with cunning eyes & rich firm mouth, & a farmer of thin nervous aspect who advocated slave labour & "wasn't to be put down, no whar!" Ar, bar whar, har thar &c. are the pronunciation of air, bear, hair, &c — & the observation "War gwine quite peert[,]" fast, lively[,] has been addressed to me more than once.

Nashville is beautifully situated in the midst of a fertile country & on the banks of the Cumberland river. It stands on a rock of limestone the soil being about 3 to 5 feet deep. It is regularly built & most of the houses have gardens attached. Many of the private residences of handsome specimens of domestic architecture & the public are many of them ele-

gant, the new state house now building after the design of W. Strickland being a tasteful & correct piece of architecture of white limestone & when completed will cost near a million of dollars.

At Mr F's I spent the evening enjoying the domestic comedy in which *Mrs* F & her daughter enacted the principal characters. Mrs F is a lady of sixty who apparently desires to make herself *excessively* agreeable & supposes herself to possess "great conversational powers" & to be highly "intellectual" & perfectly au fait in all the maneuvres & [*blank in MS.*] of fashionable life having been frequently to Washington & looking forward to seeing her husband a political "Magnifico". She wears a turban & displays a great extent of forehead, or rather "frontal integument" from either side of which depends two rusty coloured curls of some length, a scarf thrown over a rather low silk dress which hangs on a thin & "jerky" figure of commanding height with a large fan twirled by three fingers & a pair of net-mits complete the external. On entering, the lady makes an antediluvian courtesy & throws herself into a chair in a neglige[nt] tho' studied attitude, one foot being thrust slightly forward, the other withdrawn and the arms "contracted", having "posed" a benignant smile graces the lower portion of her face & an intellectual spark is forced from her eyes. Her conversation is prodigiously animated a running fire of sentiment, the last review & Bolmar's French phrases,

her temperament she expects you to find poetic, but
is evidently the study of elegant extracts, U. S.
speaker, & the most approved topics of fashionable
life. Expression is applied by means of peculiar mo-
tion of the foot & fan & the cheeks are thrown "in
& out of gear" with wonde[r]ful facility, the same
worn-smile being reproduced thereby. She absorps
the conversation, indeed "she considers it her duty"
to entertain the company, poor M^r F says nothing
but sits as an "acessory" in the background & plays
with the children. Miss F the young lady of ——
years is an evident pupil of her Ma to whom she
looks with admiration & sympathises by look & foot
motion, their fans match & they use them accord-
ingly. I bid farewell, giving Mother & daughter "sea-
room" for their genuflexions which corresponded
precisely & retired with Mr F to the door who di-
rected me to my hotel.

In riding to Nashville I saw a woman & child
nearly exactly in the position of Raphaels "Madonna
della sedulla" — sitting at a cottage door — also a
rattle snake on the road side. The Cumberland
river winds between high cliffs of limestone, crowned
with Forests, which generally extend to the river's
edge & are reflected with great distinctness in the
clear water, especially at sunset hours. It is a beau-
tiful stream tho' small & difficult to navigate on
account of rocks & "snags".

May 23^rd Arrived at Peducah a small tho' thriv-

ing town below the confluence of the Cumberland & Ohio rivers. The steamer from Louisville on which I wish to embark for St Louis did not arrive until dusk, & I thus lost sight of the scenery of the Ohio from Louisville to "the mouth" with the exception of the small distance from the mouth of the Cumberland to Peducah. The Ohio is here very wide, generally not less than a mile, the banks much lower than above Louisville & thickly timbered. Altho' lacking the picturesque variety of its mountain course above Cincinnati, it is yet here a magnificent stream, elegant & feminine — broad deep, & clear bounded by a country rich in useful products.

An old gentleman named "*Bell*" of Tennassee was my companion on board the Lady Franklin & was a very clever, sturdy Western & southern specimen.[1] I supposed him to be my only acquaintance aboard the "Lady Franklin" the Louisville steamer, but with my usual luck, I had not been long in the crowded Cabin before a gentleman next me, asked if I was not from Baltimore, he seemed to know me having seen me there & at Louisville, tho' he was unknown to me. I found him to be a Mr Makorl a travelling agent of Duvall Keighler & Co of Baltimore on his way to the trading towns on the Missouri river &

[1] The "Lady Franklin" was a side-wheeler, built at Wheeling in 1850. In the summer of 1851 it was first used in the upper Mississippi River trade, and it was continued in this service until 1856, when it sank. George B. Merrick, *Old Times on the Upper Mississippi*, 278 (Cleveland, 1909).

he proved an agreeable & gentlemanly companion.[2]
I soon made other acquaintances from whom I de-
rive information & pleasure & I[n] travelling this is
as essential to one's profit as the observation of the
country.

This boat presented more the picture which I had
imagined of a Western steamboat than any I had seen,
the great number of passengers & the mixture of
character to be seen all peculiar to this region & na-
tion. There is nothing which has attracted my at-
tention so much as the fine physical developement
of these men of the West, the majority six-feet in
height & often over, but generally well proportion[ed],
robust, stalwart, & hardy. It is probable that no-
where could so fine a body of energetic active men,
be found prepared to face any danger & accomplish
any work of enterprise. Altho' giving the palm to
the male sex in the West for physical development,
I must still claim for the fair & graceful daughters
of Maryland & Virginia the superiority in feminine
attractions to their Western sisters.

One of the causes of disease & most trying vicissi-
tudes to health in this region are the rapid changes
of temperature. A day ago I was sweltering in the
heat of the south & now it is cold enough for all the
winter clothes I can muster. The " father of waters "

[2] The firm of Duvall, Keighler, and Dorsey, " agents domestic
cotton and wholesale goods," is listed in the Baltimore directory
for 1851.

hails me with an attendant Eolus. On awaking this morning I found myself upon his busom ploughing our way in defiance of a chilly ["]north-wester". I was made certain of my locality by an old & bony character declaring "we had gone right peert in the night & were a goin up the Massesseppi". The river here & until you reach it's confluen[ce] with the Missouri, which many consider the parent stream, is wide turbid, & filled with uncertain currents, sweeping down ward with gigantic power sweeping all obstructions from its course, & cutting away the banks on either side while it adds to them upon the other, raising treacherous sandbars in a day & destroying an island which it reforms fifty miles below. The banks are low of dark earth originally the sediment of the river, & are being continually removed or replaced by the changing course of the stream, the land on either side is flat extended some distance back to low ranges of hills called "bluffs" — and covered with a thick growth of wood. It has not the *beauty* of the Ohio, but possesses a heedless grandeur & power unknown to the former, the signification of whose name is "the beautiful river".

At 4 o'clock on the morning of the 23rd of May we arrived in St Louis & I took lodgings by the advice of Mr Bell at the "American" which I found an excellent house, affording more comfort than the more expensive hotels of fashionable celebrity. St Louis is a city of rapidly increasing importance, it is

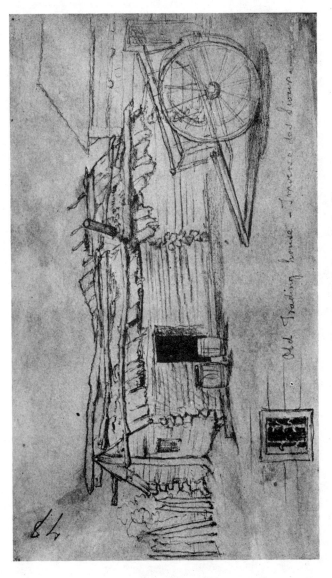

Trader's Cabin, Traverse des Sioux

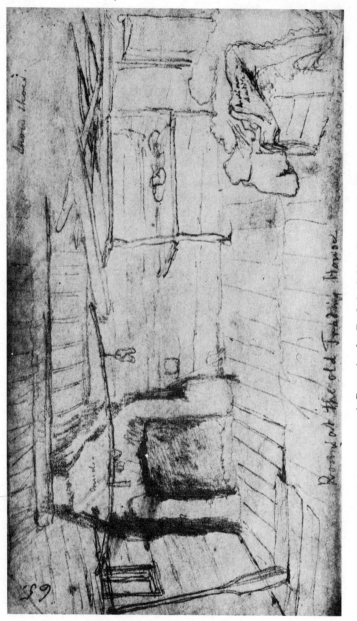

A Room in the Trader's Cabin, Traverse des Sioux

strictly a commercial city commanding the great
produce trade of Illinois, Iowa, Wisconsin & Mis-
souri. It receive[s] produce from these states & ships
it to N. Orleans. It also supplies the Missouri & the
neighboring states with goods of all sorts — & it is
on the road to the improving regions of the "far-
west". All these advantages combine to make it a
place of great trade. The effect of its peculiar con-
dition is eviden[t] in the appearance of the city and
its inhabitants who all wear the anxious & care worn
looks of "men of business" not unmixed, I regret
to say, with that reckless, & irreligious spirit which
seems induced by the easy acquirement of the means
of support & the selfish, heedless pursuit of wealth.

The city has the appearance of a place in the prog-
ress of erection, nothing appears complete, or settled
by age, the streets partly paved, houses being built,
sewers dug & crowds of busy anxious faces hurrying
to & fro. So rapid & vast hast been the increase of
the population [of] this city, that time has not been
sufficient to keep up with the demands for its ex-
tension.[3] The old or French portion of the town
is closely built or rather rebuilt since the great fire
of 1849, which destroyed almost the entire business
portion of the town.[4] This extends along the river

[3] Between 1840 and 1850 the population of St. Louis increased
from 16,469 to 77,860.

[4] For a vivid description of the fire of 1849, especially along
the St. Louis water front, see Hiram M. Chittenden, *Early Steam-
boat Navigation on the Missouri River*, 185–187 (New York, 1903).

which runs at the foot of a wide "levee" which affords landings for at least 100 steamboats nearly that number being always moored to the bank, taking in & discharging freight, letting off steam, & pushing out or arriving. This collection of steamers brings together an immense concourse of drays, carts, wagons & every variety of pedestrians & freight. There is probably no busier scene in America in the same space. For two miles a forrest of smoke stacks is seen towering above the "arks" from which they seem to grow.[5] All between this and the line of warehouses is filled with a dense mass of apparently inextricable confusion & bustle, noise & animation. more steamboats are probably seen here than at any port in the world, they being, the only means of transportation to & from this place; but 'ere long the Railroads are destined to diminish their monopoly.[6]

One might find material for study of the human mind within this space to occupy him for some time. The "decks" of the steamers alone are a world in themselves, the emigrants, the boatmen, & the variety of travelers of the labouring class which teem on these Western waters are there seen in every position & occupation. The upper & new portion of the

[5] A crude drawing of the St. Louis levee is in Mayer's Sketchbooks, 40:26.

[6] The rise and decline of the St. Louis steamboat traffic are the subject of a chapter in Walter B. Stevens, *St. Louis: The Fourth City, 1764–1911*, 1:255–280 (St. Louis, 1911). The city's first railroad began operations on December 1, 1852.

city is regularly laid out, with broad streets & the
public buildings & private residences are many of
them in very good taste.

*(Of the Western states Illinois probably offers
as great inducements to the agriculturists as any, as
large a proportion of the land is arable & it affords
crops of grain & corn of great yield. It's surface is
gently undulated and is the first state where the
prairies are found. Ohio produces grain, corn, and
fruit & manufactures extensively, Indiana & Illinois
grain & corn — Kentucky, ditto Tobacco & hemp,
Tennessee grain & cotton & Tobacco. "Hog & hom-
iny" abound in Ohio, Indiana & Illinois. Kentucky
raises mules & Tennessee grows more corn than any
of the states & raises large herds of cattle.)

Called in St Louis on Dr Hoffman & Mr Cassen,
& was kindly treated by Dr Saunders.[7]

[7] William H. Saunders, M.D., and J. A. Kasson, attorney, are
listed in the St. Louis directory for 1851.

V

On the Missouri Frontier

MAY 25th Left St Louis in the steamer Diana Vernon for Tully but on arriving at Hannibal discovered that the river had risen to an unprecedented height having overflowed its banks & spreading over the praries & bottom lands had in some places swelled to fifteen miles in width where it usually is but one. I was therefore obliged to land at "La-grange "[,] Tully & the adjoining towns of Alexandria & Canton being completely surrounded with water & the houses mostly rendered uninhabitable, all means of egress to the surrounding country except by means of "skiffs " being destroyed.[1] After passing the mouth of the Missouri the Mississippi becomes clearer, & the shores higher presenting a stream winding thro' well wooded bluffs & flats and

[1] Tully was a Mississippi River port of some importance adjoining Canton on the north and located about nine miles north of Lagrange in Lewis County, Missouri. The "memorable high waters of 1851 almost totally destroyed " Tully, and it is now one of Missouri's "obsolete towns." *History of Lewis, Clark, Knox and Scotland Counties, Missouri*, 224 (St. Louis, 1887); Samuel Cummings, *The Western Pilot*, 144 (Cincinnati, 1849).

studded with numerous islands — & its romantic character increases from this point to its rise in the lake.

At Tully a Kentuckian alias a Western-Yankee conveyed me thro' no very agreeable roads to Byrneham Wood the residence of my aunt Mrs. Flora Byrne.[2] There are few regions better adapted to farming & the enjoyments of "country life" than this portion of Missouri. A wide bottom or prarie studded here and there, tho' sparsely, with clumps of trees extends some miles back to a range of bluffs, or rather to a table land which continues with few interruptions to the rocky Mountains. The bluffs between the bottom & the upland praries is well timbered & the underwood is *as yet* suffic[i]ently low to admit the passage in any direction with ease of a horseman. Beyond this the praries begin increasing in flatness & extent until they reach the Rocky mountains. The timber is of large size & the foliage rich, black-walnut sycamore attaining a great size, cotton wood, maple (sugar) & the usual varieties of oak also abound. The praries are as yet covered here & there only with clump & thickets which have grown up since the settlement of the country, the Indian custom of burning the praries having formerly destroyed all the young trees.

I was much gratified to meet my aunt who I had not seen since she left Baltimore her former residence

[2] A pictorial record of Mayer's visit to Byrneham Wood is to be found in his Sketchbooks, 40:1–21, 39, 40.

& native city. Her farm is at the foot of the bluffs & comma[nds] a view of the praries which extends to the river six miles distant. This is now covered to within a mile of the house by the river & presents the apearance of a lake studded with Islands. This prarie is five miles wide & extends along the bank of the river for *seven* miles. A grove formed chiefly of that most graceful tree, the American Elm is not far from the house & the full extent of the prarie is seen here & there thro' the arborial arches.

This county (Clarke) was the favourite hunting ground of Black-hawk and his braves & the trees of the Elm-grove still retain in their bark the marks left by the various parties who had encamped beneath their shade but twenty five years ago.[3] Now the country is comparatively well settled chiefly by Kentuckians & Virginians. The former are a hardy pioneer race but lamentably deficient in education & the desire to procure it. Their ignorance gives rise to many amusing incidents — all of which furnish a field of observation to my aunt Flora. Their nearest neighbor is an old Kentuckian of the Name of Lucas who with his family reside in the former "Quarters."[4] He is a fine specimen of the back-

[3] Some information about the activities of Black Hawk in Clark County, which is in the extreme northeast corner of Missouri, and about the effect of the Black Hawk war of 1832 in that vicinity is to be found in the *History of Lewis, Clark, Knox and Scotland Counties*, 245–248.

[4] Sketches of Lucas appear in Mayer's Sketchbooks, 40: 19, 21.

woodsman & realizes Cooper's idea of " Leatherstock-
ing " He is tall, over six feet, & square built & broad
giving evidence of great strength & powers of endur-
ance, his face is founded on a classic construction

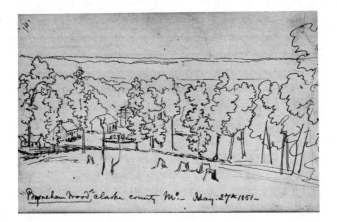

(tho' rather shorter in the nose than the standard)
& tho' bearing the marks of fatigue, endurance, &
exposure, an expression of great delicacy & even
refinement is evident — great decision & perfect good
humor in the mouth & the clear piercing eye of
the hunter looks out from it's corrugated cavern
beneath his shaggy brows. He is erect as an arrow
& his motions have yet the freedom of alertness
of the wary woodsman, altho' his ringlets are greyed
by sixty winters. Honesty & kindness, bravery and
determination characterise him. His daughters are
even less educated than himself, being ignorant of

even reading & writing yet of naturally intelligent
& active minds, one of them possesses the most
perfectly *Grecian* face I have ever seen, the construc-
tion & form of the head being exactly similar to some
of the antique heads of the Muses, tho' lacking the
intellectual expression requisite to those characters.
These girls exhibit none of the bashfulness one might
expect tho' modest in the demeanor, this is to be
referred to the independent & republican ideas en-
gendered from their infancy. They consider them-
selves "as good as anybody", to use their own
expression. They consider that their ancestors got
along very well without education & they think that
they may do the same. It is a pity indeed that a
people of so many natural good qualities should be so
dead to their intellectual progress. They are Roman
Catholics.

The day after my arrival Ed. Fu[r]ness & Kelly
being obliged to go some miles into the back country,
they invited me to accompany them, the probability
of seeing a deer hunt being an inducement. As we
cantered along thro' the wild woodlands, Kelly, that
embodiment of Irish heart & humor, entertained us
with the "widow Malone" & other choice Irish lyrics
which he sang with a clear voice & *native* expression.[5]
The dogs accompanied us & we met with no other
than false alarms produced by the scent of some in-
nocent rabbit when we reached a Smithy where a

[5] A portrait of Kelly appears in Mayer's Sketchbooks, 40:3.

noted hunter proposed to add his hounds to the pack
& having stationed my friends at points where the
deer were likely to pass I accompanied in on a
"drive" as it is termed. We had searched hill &
dale for [a deer] & the horn had sounded often to
withdraw the pack from "false scents" and our
patience & hopes were nearly exhausted, when from
a thicket near by a deer with tail & head erect leaped,
in fear & uncertainty from its concealment, & in-
stantly, ho! Juno! Tully! Boxer! & the hounds were
in full cry we followed at full speed & I instantly
lost all fear of ditches & dikes in the excitement of
the chase. The sharp crack of a rifle told of the
huntsman's alertness, but it failed to hit its mark
& merely turned the course of the animal so that my
friends lost their venison. We rode for some time
& followed the chorus of the hounds until we lost
them in the distance, the deer having chosen an un-
usual course. A day after he was found, some ten
miles distant where the dogs had killed it. The
chase has its charms, but I dislike to see the poor
creatures wantonly murdered.

A large mocassin snake paid with his life the pen-
alty of intruding himself on our presen[ce] as we were
about to seat ourselves on his residence an old log.
The rattlesnakes have nearly disappeared from this
country, but the mocassin who are nearly as poison-
ous, & more dangerous as they give no warning, still
remain. There are other snakes but the most singu-

lar is the jointed snake which when struck seperated
into portions which seem to have been united by a
kind of ball & sockett joint. If the head which is
attached to a portion is not killed it will return &
unite the other portions to itself. They are generally
about an inch in diameter & two to three feet long,
& but rarely found. These facts I have from un-
doubted authority.[6]

My stay in Missouri was rendered peculiarly agree-
able by the kind attentions of my aunt & with her
society & the many "studies" for my pencil which
present themselves on all sides I could have passed
a summer with ease, at Byrneham Wood. The nu-
merous amusing anecdotes of western life which my
aunt has related to me with the peculiar zest which
she possesses I shall long laugh over. An old woman
who had heard of the piano, desired to hear it played
upon & on beholding the operation, remarked "Wall
now, I guess our July An[n] might larn to do that, fur
she's mighty handy with the knittin needles". On
being told of paper hangings she remarked "I guess
ye hangs em up in winter & takes em down in the
summer". A young man who "did" the faces of
the citizens with red & white earths on levenpenny

[6] It is likely that the snake that Mayer saw was an ordinary
water snake, a species that is frequently found in logs in Missouri.
That region is the northern limit of the range of the water moc-
casin, which leaves the water but rarely and does not go into logs.
Mayer seems to have accepted without question the story of the
mythical jointed snake.

calico seeing the portraits of my aunt & the Doctor,
took one down & rapped it with all his might to dis-
cover the material & remarked that [he] thought
calico "jest as good", & when asked if he was going
to Italy to study the old masters, he said, "I dont
no nothin bout the ole masters, Smith's my boss".
These are but specimens, their number is infinite.
With all their ignorance, their hearts are most often
in the right place and there are many who fill their
sphere in the log cabin with greater honor & nobility
than the titled denizen of a palace. I shall not soon
forget "Old-man Lucas" and his interesting & beau-
tiful daughters.

June the 3ʳᵈ My aunt bid farewell to Byrneham-
wood for some years that she may educate her daugh-
ter Annie, a sweet & charming girl of twelve, who has
grown up, like the flowers of her native praries un-
tainted by the pestilential air of city fashions &
conventional life.[7] She is a child of nature & a "pra-
rie bird" can manage a horse like a circus rider &
find her way in any direction thro' the woods and
praries Her mind is clear, & solid, free from the rub-
bish of crowded seminaries & her heart is alive to the
least want of another — she'l make a woman, if she
withstand these cities.

Taking leave of Geo. Fletcher & Ned Furness who
will find themselves lonely after this & bidding fare-

[7] Some portraits of Annie Byrne are in Mayer's Sketchbooks,
40: 40.

well to Mr Lucas' family we travelled over desperate
roads or rather over the untracked praries for the
whole day in hopes of reaching "La Grange" the
nearest landing for steamboats, at present accessible
from the back-country — but as we were toiling over
an uneven & rutted prarie we were hailed by the
honest voice of Fletcher, who without further "to-
doo" pulled down the fence & insisted in the name
of Mr Eagan, on our stopping the night under his
roof. We were received with Virginian hospitality
& witnessed a *solemn* sunset over the prarie — its
vast extent being in deep shadow while the horizon
was relieved against a blood red sky. The monotony
of our journey had been broken by the "miring" of
our horses in the muddy bank of a stream misnamed
"Sugar creek." Oxen loaned by the neighboring
farmers dragged the carriage out after an hour's de-
lay & we proceeded on our way. At breakfast the
conversation turned on the subject of carrying arms,
& I received a wrinkle from "old-man Lucas" who
said that "he'd never carried anything but a few
percussion caps in his waiscoat pocket & they an-
swered every purpose" for when he got in "saasy"
company he "jest tuk one or two from his pocket
& began to play with them" & he found that the
hinted presence of a pistol soon lulled the storm of
his opponent.

In due season we arrived in St Louis again the time
having been pleasantly beguiled on the boat by lis-

tening to the delightful songs of my aunt who accompanied herself on the guitar. My little cousin's wonder & delight on seeing the various novelties of the city was amusing indeed, for it was to her a new world who had never before (but for a day or so) seen any thing but the wild woods & praries & nothing in the shape of a town larger than the villages on the river.

VI

Up the Mississippi to St. Paul

ON THE 8th of June took passage & went aboard the Steamer "Excelsior" up for S^t Pauls & Fort-Snelling a distance of near eight hundred miles from S^t Louis.[1] The boat was crowded with frieght [sic] Emigrants & cabin passengers. I found myself in a state-room with a M^r [Charles] Sexton, Editor of the S^t Croix Enquirer, Wisconsin, who proved a useful companion, & amusing "study".[2] Thin as an anatomy his smile was ghastly & like a

[1] The "Excelsior," a side-wheeler of 172 tons, was built at Brownsville, Pennsylvania, in 1849. It was used in the St. Louis and St. Paul trade in 1850, and in 1851 it was one of three boats to run on the Minnesota River. The treaty commissioners with their attendants and supplies were transported to Traverse des Sioux aboard the "Excelsior." See *post*, p. 145. It was owned and commanded by Captain James Ward. The distance by river between St. Louis and St. Paul, according to the government survey of 1880, is 741 miles. Merrick, *Old Times*, 267, 298; Thomas Hughes, "History of Steamboating on the Minnesota River," in *Minnesota Historical Collections*, 10:137, 158, 161.

[2] Sexton's newspaper evidently had not been published during his absence from his Wisconsin home, for the *Pioneer* for July 24, 1851, includes the following comment: "ST. CROIX ENQUIRER. — . . . this interesting little sheet has been resuscitated, by C. Sexton, Esq., and comes to us considerably improved in appearance.

grinning skull a sort of "melancholy joy," & his com-
plexion of so death-like a hue that I once was about
to wake him to know if he was dead! an unavoid-
able bull, I confess. Yet this carcass of a man had
been to the Rocky mountains & pierced the forests
of Oregon until he had gazed on the Pacific & had
returned again with two companions by a southern
route through Utah & Nebraska to the states again.
He was by birth a "Yankee" & formerly, I conjec-
ture a printer, then a reporter, & now an Editor,
a man of energy, thrift perseverance & intelligence
& "good-hearted enough".

A number of Prussian emigrants of the better class,
with their beards[,] good figures & foreign costumes,
a party of Irishmen, said to be "noble", a certain
officer of the army undoubtedly "royal" who amused
us & astonished too by his wit & extensive informa-
tion, merchants from St Louis & the east, raftsmen
from the head waters of the Mississippi, farmers from
Iowa & Wisconsin & in fact representatives of almost
every state in the Union, with Canada & Europe were
found in the cabin.

Judging from its advertising columns, (and what surer way is
there?) we should think that the business of Willowriver had
trebled since last year." The editor seems to have been Charles
Sexton, who is listed in the manuscript census records of the
town of Buena Vista, St. Croix County, Wisconsin, for 1850 as
a printer thirty-two years of age, whose birthplace is Vermont.
The census schedules are in the possession of the State Historical
Society of Wisconsin. Buena Vista, now known as Hudson, was
platted in 1848 at the junction of the Willow and St. Croix rivers.

On Deck were Germans and Irish a filthy set, who[se] uncleanliness no doubt hastened the deaths which occurred among them & I was heartily glad when we landed the last at Dubuque. The first in-

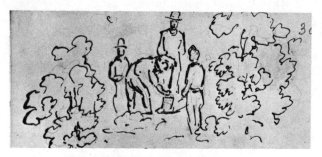

Burial of the Cholera Dead

timation I received of the presence of death in our midst was the tolling of the bell & the mooring of the boat at the foot of a high bluff on the Illinois shore, soon some hands jumped a shore[,] a grave was speedily dug & as the last rays of the setting sun glided from the waters face, a bird sent up a joyful note over the grave of the infant which an hour before had breathed its last. We proceeded on our way an[d] 'ere two days more had passed we had buried *five* deck passengers[,] I fear some of them victims of cholera no doubt aggravated or induced by filthiness, exposure, fatigue & improper diet.[3]

[3] A pen and ink sketch of the " Burial of the Cholera dead " is in Mayer's Sketchbooks, 40:30. Cholera was " very prevalent on

At Keokuk we received on board M[r] C. Butler of
New York who accompanied Miss [Anna C.] Lynch
the authoress, whose acquaintance I made & with
whom I led off a Virginia reel in the cabin to a good
old fashioned fiddle.[4]
I shall recall with pleasure my fellow passengers on
this trip. A Mr [George A.] Richmond of Boston,
residing in S[t] Louis was a happy combination of the
Eastern & western man & a gentleman who I hope
to meet again. Tom Jackson, an open hearted, good
natured Anglo-American, M[r] Schultz, the clerk of
the boat an intelligent German — Mr. Sexton[,] Mr
[Phineas] Banning of Phil[a][,] Henry Thompson of
Balt[o][,] & my friend in the army "Old stokin" I shall
not forget.[5]

the river " in 1850; there was a serious epidemic of the disease in
Wisconsin in 1851 and 1852. Governor Alexander Ramsey, in his
diary for June 11, 1851, notes that a steamboat arrived at St. Paul
with "a few cases of cholera reported on board." The unpub-
lished Ramsey Diaries are in the possession of the governor's
daughter, Mrs. Charles E. Furness of St. Paul; the Minnesota His-
torical Society has a copy. See also Merrick, *Old Times*, 274;
Knut Gjerset and Ludvig Hektoen, "Health Conditions and the
Practice of Medicine among the Early Norwegian Settlers," in
Norwegian-American Historical Association, *Studies and Records*,
1:18 (Minneapolis, 1926).
[4] Butler and Miss Lynch also are mentioned *post*, p. 203. Miss
Lynch was a well-known writer of the middle nineteenth century.
Before 1851 she had published a volume of poems and several
prose works. In 1855 she married Vincenqo Botta, professor of
Italian at the University of the City of New York. *Appletons'
Cyclopædia*, 1:325.
[5] Mayer gives the addresses of Richmond and Banning, *post*,
p. 203. The Colonel Bladen Dulany mentioned on the latter page

At Davenport & Rock Isla[n]d we enter upon a seemingly new character of country & climate, the bluffs begin to rise, first into grassy hills with clumps of trees here & there seemingly prepared by nature for the farmer, while on the opposite shore a large forrest reaching back for miles over a gently undulating country the Rapids of Rock Island run between for fifteen miles. passing these the river becomes of a glassy smoothness & transparency & then [the] air has a peculiar clearness & bracing vigour which is unknown to lower latitudes. The bluffs on one or the other side rise to four & five hundred feet clothed from summit to river brink with forests except where their vertical position affords no resting place for trees & there the bare rock[s] are seen, like the ruins of old, cast[l]es guarding the entrance to this chosen haunt of nature. Ascending one of these bluffs, we found ourselves 400 feet above the river & beheld a magnificen[t] view of the river as it wended its way thro' the surrounding hills & praries now & then seeming to have enclosed within its arms some chosen spot of beauty, some Island for a fairy home. large praries are some times on either side with the bluffs miles distant. then the hills appro[a]ch & seem to block up the entrance until in some unexpected direction the river again appears. The scenery is lonely & grand & the absence of all appear-

probably was "Old stokin," since a portrait in Mayer's Sketch-books, 40: 29, is labelled "Col. Dulany, U.S.M.C. 'Old Stockin.'"

ance of man's presence replaces that "sympathy" which cultivated scenery excites by a feeling of awe, so that we feel as intruders in this region which na-tures [sic] seems to have set apart as her own.

As we neared Lake pepin we first had intimation of our having passed thro' this long line of solitude & that we were emerging in a new region on one side civilization had advanced & the log cabin & neat frame of the New England settler looked over the river to an Indian village where co[u]ncil smoke is still seen & the Scalp dance still celebrated, while the trading house & the church are seen surrounded by Indians, half-breeds, French voyageurs, Americans & foreign emigrants — while birch bark canoes & pel-tries lie by the side of the steamboat & the last " Yan-kee notion ".[6]

Arrived at S[t] Pauls June 15th 1851.[7] As the sun was setting on the 14th two indistinct forms were seen gliding close to the shore & as we approached them two canoes, one paddled by a frenchman, the other

[6] Probably this word picture describes the trading village of Wabasha as it appeared in 1851.

[7] The arrival of the " Excelsior " on " last Saturday morning " is announced in the *Pioneer* for June 19, 1851. As the publication day is a Thursday, this would mean that the boat arrived on June 14. The announcement continues: " She had a drove of cattle on board, to feed the Indians on, during the treaty. . . . A barge was towed up by the Excelsior, which is to be left at Saint Paul and filled with white sand to be taken to Saint Louis on the next trip of the boat down, to be used there in manufac-turing glass." In the same issue of the *Pioneer* the " Excelsior " is advertised to leave St. Paul every alternate Friday for St. Louis.

by an Indian were revealed to us. by degrees in the morning more frequent became the intimations of savage presence We passed Kaposia or Little Crow's village[8] — & then the canoes & squaws, cheifs [sic] & papooses were frequent sights.

S[t] Pauls is situated on a bluff probably about fifty feet above the surface of the river, commanding a fine view of the surrounding country & catching the breezes which sweep down the course of the river & over the adjacent hills. The plain which surmount[s] the bluff is of ample extent for the erection of the proposed "city." Two years ago it was little more than a mere trading post for the Indians — but already it assumes the appearance of a bustling New England village & well attests the presence of an energetic & *free-soil* population. It is singular to meet so few "old *residenters*" for no one seems to have passed more than one winter here.

Here an entirely different race are seen commingling with the Anglo-Saxon from those we see in the more southern portion of the West. The French were among the first settlers of this region. Here are the descendants of the "voyageurs" the companions of La Salle & Hennepin & they still retain

[8] Little Crow was the hereditary chief of the Kaposia band of the Sioux or Dakota Indians. In 1851 his village was situated on the west bank of the Mississippi on part of the site of South Park, a suburb of the present city of South St. Paul. Warren Upham, *Minnesota Geographic Names*, 170, 443 (*Minnesota Historical Collections*, vol. 17).

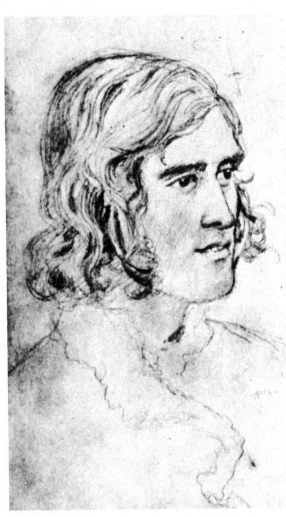

Michel Renville

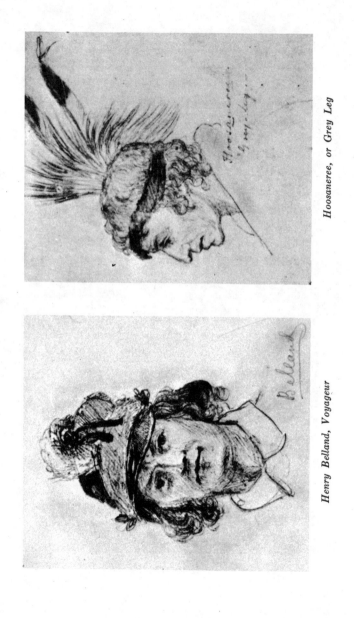

Hoosaneree, or Grey Leg

Henry Belland, Voyageur

their national distinctions [9] How different their manner, appearance & attitude from the "Americans" around them They have the vivacity, merry jest & laugh & expressive attitude & gesture of old france. They still speak french, which is heard as much as English & these two with Indian are often heard at once in the same group. They are generally of smaller size than the Americans & of light active figure, they are employed as boatmen, raftsmen & Indian traders. Most of them have Indian or half-breed wives which gives rise to another branch in the population of Minnesota. The scarf sash, pipe, & mocassins are the only remnants of the old voyageurs dress to be seen among them. The costume of the voyageurs was a mixture of Indian & European a blanket coat reaching to about the knees, leggins & the breech-clout, & mocassins. The head was covered in summer with a fur or felt hat, adorned with feathers, the hat usually black & somewhat after the "Spanish" form. Sometimes a close fitting woollen cap without visor — somewhat like a night-cap was worn. In Winter the clothing was warmer & a

[9] Most of the early French inhabitants of St. Paul were traders who had come from Canada or their descendants. Many of these people were of mixed French and Indian blood. A large number of them are mentioned by name in an article by M. M. Hoffmann entitled "New Light on Old St. Peter's and Early St. Paul," in *Minnesota History*, 8:27–51 (March, 1927). The voyageurs were the French-Canadian canoemen who played an important rôle in the fur trade. Their activities and habits are described by Grace Lee Nute in a volume entitled *The Voyageur* (New York, 1931).

"capuchin" hood, often attached to the collar of the
coat protected the head. the hair & beard was often
worn long & a sash was tied around the waist outside
the coat.

C. K. Smith Esq, the Secretary of the Territory
& the Governor received me with much kindness [10]
& I received a diploma of my election as a member
of the Minnesota Historical Society soon after my
former connexion with the M[arylan]d Hist[orica]l
Society was known.[11] I found Governor Ramsey
giving audience to a deputation of Sioux Indians
who had come from "Six's" village on the St Peter's
[*Minnesota*] river to ask supplies of food for their
children & families whom they represented to be in
a starving condition. Placed by his side with the
Indians seated around with their pipes sending forth

[10] Charles K. Smith of Ohio was appointed secretary of Minne-
sota Territory when it was organized in 1849, and Alexander Ram-
sey of Pennsylvania became governor. Mayer met Ramsey before
going to Minnesota. See *ante*, p. 4. Smith returned to Ohio in
1851, but Ramsey remained in the new commonwealth and became
one of its foremost citizens. Chiefly as a result of Smith's efforts,
the Minnesota Historical Society was incorporated on October 20,
1849. See Folwell, *Minnesota*, 1:257. A sketch of Smith is in
Minnesota Historical Collections, 8:495–497.

[11] There is no record of Mayer's membership in the Minnesota
Historical Society in its archives or in its *Proceedings* for the years
1849 to 1858 (St. Paul, 1858). Mayer was librarian of the Mary-
land Historical Society from October 1, 1848, to November 1, 1850.
He did not become a member of the latter organization, however,
until November 3, 1853, though he was greatly interested in its
activities. Journal, 1847–54, p. 41, 77; *Sun*, July 29, 1899; letter
of Louis H. Dielman, chairman of the library committee of the
Maryland Historical Society, October 12, 1931.

dignified volumes of smoke, I had a fine opportunity to observe their manners & mode of speech. An old man arose having given his pipe to his neighbor & shaking hands with the Governor & interpreter, began with much energy & expressive gesture to detail the object of their visit & its causes, pausing at every sentence to shake hands with the governor & to give the interpreter time to translate his speech. at the conclusion of every sentence the other Indians all exclaimed Hoo, i. e. ["]*yes, it is so.*" Having concluded, another old man arose with his war-spear in his hand & corroborated his friend's account. The Governor replied by rating them for their want of thrift & for certain violations of treaty which had occurred in their territory & told them that the power of their "great-father" extended from the rising to the setting sun & that no matter where they were they would be punished for their crimes. He concluded by giving them the required supplies & "tickets" for bread at the bakers in St Paul.[12]

[12] Mayer's visit to the governor evidently took place on June 17, for in his diary under that date Ramsey notes: "Had a visit from 2nd chief of 'Six's' band & his people, complaint — hunger — gave them an order on Tyler for 2 flour, one keg powder & some bread tickets." The Sioux in question were from the village of Little Six or Shakopee, on the site of the present city of the latter name. The Tyler mentioned by Ramsey probably is Hugh Tyler, who was "special agent and acting commissary" for the Chippewa treaty at Pembina in the summer of 1851 and who played an important part in the consummation of the Sioux treaties of that year. See Folwell, *Minnesota*, 1:276, 288, 302–304. For a note on the name of the Minnesota River, see *post*, ch. 8, f.n. 10.

Some of these were fine specimens of Indians, I
met them a few hours after in the street & was struck
by the peculiar ease & grace of walk & attitudes hav-
ing all the litheness & "nonchalance" of childhood
with the dignity of man, they are remarkably erect,
tall, with small hands & feet, & the graceful & varied
manner in which their large blankets are worn, de-
pending their majestic folds from their broad shoul-
ders, & calling to mind the dignified occupants, of
the senate house or Forum Their rifle carried with
so much variety of posture & the num[e]rous pouches
& trinkets add to their picturesque appearance.
Their hair is worn long, some times plaited, & where
parted vermillion is rubbed into the seam, feathers,
wampum &c also adorn their heads. A shirt of fig-
ured calico is sometimes worn & a "breech-clout"
always The leggins reach to the middle of the thigh
& are attached to the belt by strips of cloth or skin,
while a garter is tied below the knee & mocassins
cover the feet.

Continued in Vol 2 of Journal[13]

The use of mocassins contributes very much to the
elegant walk of the Indian — the feet have then their

[13] The first entry in volume 2 of the diary is preceded by the
following notation: "Memoranda &c. Tour to Minnesota — 1851.
Vol. 2. St Paul's Ma to [blank in MS.] June 23rd to [blank in
MS.] 1851." The fact that Mayer did not fill in the blanks that
he left at this point seems to indicate that he never completed his
diary. For a discussion of the possibility that the diary is incom-
plete or that part of it was lost, see ante, p. 25.

natural elasticity & by comparison the wearer of shoes or boots has a hobbled & awkward gate. We, who call ourselves *civilized,* scarce know what the *natural* walk of man is, we are so accustomed to the hampered motions of clodhoppers & dandies. Compared with the figures of the Anglo Saxon the Indian is lighter lither & more erect formed rather for feats of agility than strength. *Power* & Strength, seem the characteristic of the American. A boat-hand from the steamer is a model for Hercules — a Sioux warrior for Mercury or Mars.

VII

Indian Life at Kaposia

AVING received an invitation from D[r] [Thomas Smith] Williamson, a missionary to the Sioux,[1] to whom I had a letter, to visit him at his residence at the village of Kaposia or Little Crow's village (as it is generally called, that being the cognomen of the chief, whose name is, in Dacotah, "*Chatah-koowamanni*" or Sparrow hawk walks shooting, which by the French traders was corruptly translated "Petite corbeaux," or Little Crow),[2] I was placed under the charge of an Indian who conducted me to his canoe a "dug-out" where his two wives were in attendance to paddle us to their

[1] Dr. Williamson, missionary and physician, began his work among the Minnesota Sioux in 1834. For an account of his early activities in this region, see Folwell, *Minnesota*, 1:198–200. During his long residence among the Sioux, Williamson acquired a wide knowledge of their customs, and he seems to have given Mayer the benefit of his experience, for numerous notations and corrections in the diary are in his handwriting.

[2] Little Crow's Dakota name is given as *Chetan wakan mani*, "the sacred pigeon-hawk which comes walking," in Frederick W. Hodge, *Handbook of American Indians*, 1:769 (Bureau of American Ethnology, *Bulletins*, no. 30 — Washington, 1910). Mayer seems to have been a bit uncertain about the chief's name. Some

residence One of these, opposite to whom he sat, I being behind him, was evidently the favourite tho' both were young & pleasing in Expression. As we floated down the stream in the twilight, the paddles being lazily plied by our female sailors, my lord occasionaly condescended to assist them in their toil & between the intervals of his labor, discussed with his wife their evening meal & the topics of the day — a portion of food being passed to the less favoured lady in the stern who with rather a pensive expression occasionally joined in the conversation The first had the childlike simple expression common to the Indian women & its pleasing effect is greatly due to the white teeth & dark sparkling eyes contrasting with the long black hair falling luxuriantly over the shoulders. They evidently possessed all the coquetry & teasing arts of their civilized sisters.

I have thus far found the Indian women mirthful, & enduring their laborious lot with patience & cheerfulness. They are not as attractive to an artist as the men, they being generally small & heavy, early marriage & constant drudgery having destroyed the symmetry of their forms. Their faces are very similar in expression[,] a good humored innocence of dis-

rough sketches of Little Crow made at Kaposia, in the Sketchbooks, 40:61, are labelled " 'Chatahnkooavamannee' or he who pursues the hawks 'Sparrow hawks walks shooting' "; a finished portrait made at the Traverse des Sioux camp on July 2 bears the caption: " Chatannahkowahmanee The hawk that chases walking — alias — Little Crow or Petit Corbeau."

position [*blurred*] being evinced by it. As they grow old their faces are marked by lines of care & if ill humor grows with increasing years & they attain sufficient age to acquire the venerable white hair of senicity [*senility*] they are fit models for hags.

[The feet of many of the Indian women seem formed to rival those of the Venus de medici. They possess the same construction, the instep high & the foot arched, the toes strait & fully formed & free in their motions. The direction of the four toes forming a slight angle with the great toe & the second toe projecting beyond it, for it is the longest. The mocassin replaces the sandal & prevents the bones of the feet from spreading. French shoes distort them by forcing them into a space too small for their reception.][3]

Labour seems evidently to be the misplaced province of woman. Our civilized ladies are in all respects the superiors of their savage sisters. The only one I saw who in anyway attracted my attention was a young woman of about eighteen who was tall, with a figure as yet undestroyed by labor easy & graceful in her motions which were peculiarly feminine, modesty & the absence of stays being characteristics of the Indian women, an example which their more enlightened sisters might occasionally profit by. This, added to the neatness of her dress & glassy blackness of her

[3] The paragraph inclosed in brackets is written in pencil on a left-hand page facing page 7 of volume 2.

long hair, black eyes with long dark lashes & the
pleasing expression of more than usually regular fea-
tures gave her great advantages of appearance over
her fellow squaws. [So bashful was she that I seldom

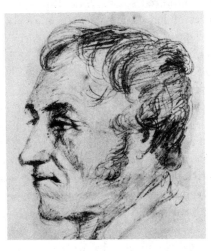

Dr. Williamson

got more than a glance of her & as to sketching it
was out of the question.]⁴ The women appear to
advantage in the canoes, the motion of the paddle
serving to display the taper of the arm & wrist & the
heaving of a well developed chest.

Dᵣ Williamson received me kindly & I was lodged
comfortably under his hospitable roof for "three or
four *sleeps*," as the Indians say. The village of "*Kap-*

⁴ The sentence inclosed in brackets is crossed out in the original.

osia" or *"the lithe people,"* is situated on a small
piece of bottom land which intervenes between the
bluffs & the Mississippi river.[5] It commands a very
bea[u]tiful view up & down the stream & contains
about three hundred souls. The village is composed
of two sorts of habitations winter houses & summer
houses or *Tipis*[,] a house, or *Waykayas*[,] skin cover-
ing[,] & Tipitonka's[,] large.[6] The winter house is a
tent made of furless buffalo hides tanned like buck-
skin & sewed together, supported on poles & held to-
gether at the seam by splints of wood, it being left
open at the top to permit the smoke to escape & be-
neath is an aperture for egress & ingress — thus form-
ing a circular conical edifice with the ends of the poles
protruding from the top, the edges of the skin falling
over & varying the colour & form. These are the
winter habitations and are near ten feet in diameter
generally. A fire is made in the centre & the occu-
pants repose around it. In warmer weather it is

[5] A similar meaning for the name " Kaposia " is given by A. W.
Williamson in a list of " Minnesota Geographical Names Derived
from the Dakota Language, with Some that are Obsolete," pub-
lished in the Geological and Natural History Survey of Minnesota,
Thirteenth Annual Report, 1884, p. 107 (St. Paul, 1885). He
declares that the name meaning " light " was given to the people
of Little Crow's band " in honor of their skill in the favorite game
of *lacrosse*. . . . Success depended largely on swiftness (light-
ness)." For the location of Kaposia, see *ante*, p. 92 n.; a picture
of the village appears *post*, p. 112.

[6] The Sioux word *tanka* means " large " ; thus *tipitanka* may be
translated as " large house." Mayer applies the term, variously
spelled, to the summer house of the Sioux. The *wakeya* was the
" skin tent," probably the same as the ordinary *tipi*.

sometimes used. It is then thrown open, the aperture of entrance being enlarged & the portions of slack skin supported on sticks, thus giving rise to two graceful festoons from either side of the seam.

[Teepees or Tipi (French pron.?) belonging to Indians of the plains are sometimes forty feet in diam[e]-t[e]r. The poles of tamarak are of large size to the protruding end of the tallest of which is suspended a horses tail as indicating the residence of a principal warrior or a chief, the exterior being decorated with diagrams of his principal actions. I know not why, but there is a *home* feeling about the interior of a teepee. As I have lounged on a buffalo robe by the light of a smouldering fire, It reminds me of my childish positions on the parlour rug in front of a hickory fire, during the winter evenings The teepee is rendered very comfortable in the winter by piling straw around the exterior & strewing it within, & laying buffalo robes & furs upon it. Without, the snow soon accumulates above the straw leaving only the upper portion of the tent visible. Closing the entrance & building a fire it becomes a snug refuge from the inclement winters. Tepees last four or five years, but owing [to] the rotting of the lower portion of the skins decrease in size.[7] The tipi or skin lodge is (tender tilia or lynn ————) peculiar to the western or Dacotah branch of the Indian race; the Algonquin

[7] This sentence is written in pencil at the top of the left-hand page facing page 11 of volume 2.

having lived in bark-wigwams. The peculiar form of
war club used by the western Indian was unknown
to the Algonquin, as well as that style of dress in
which the long fringes of skin, falling from the arms
& leggins & adapted to the adornment of the *horse*
man. The Algonquin dress was pedestrian, the Daco-
tah equestrian.

The Winnebago leggins are loose & gaitered & like
the Sioux who do not gaiter are *gartered* below the
knee. The Chippeway garter at the ankle. The
Winnebago hair is never brought forward.] [8]

The summer house is similar in form to our log
cabin, tho' more nearly approaching a square, & the
roof reaching nearer to the ground. It is formed of a
frame work of saplings tied together with the [inner]
bark of the [quaking aspen] [9] covered and interwoven
with pieces of bark, the entrance is closed by a piece
of buffalo hide which hangs by a point from above
the door. Within, a platform or divan of about five
feet in width & elevated some two feet & a half from
the ground, extends around three sides of the apart-
ment leaving a quadrangular space in front of the

[8] The passage inclosed in brackets occurs on two left-hand pages
facing pages 10 and 11 of volume 2. The second paragraph is
written in pencil.

[9] The words inclosed in brackets are crossed out in the original
manuscript. Elm and basswood bark were commonly used by the
Sioux in the building of their lodges. For an excellent description
of the construction of the Sioux summer house, see Samuel W.
Pond, " The Dakotas or Sioux in Minnesota as They Were in
1834," in *Minnesota Historical Collections,* 12: 353.

door & in the centre of the lodge about six feet square, in the centre of which a fire is made. Over this hangs the kettle. Formerly crockery of Indian manufacture took the place of the copper Kettles supplied by the traders. The smoke from the fire escapes thro' an aperture in the roof which also serves to admit the light. There are sometimes two of these. At the back of the divan skins are hung & buffalo robes & other peltry cover the surface, on which the inmates repose surrounded by their arms, trinkets, women & dogs, the combination of so many picturesque ac[c]essories & the light admitted in so *artistical* a manner contributing to make a scence [*sic*] full of scenic effect.

These houses are certainly very comfortable and admirably adapted to the indulgence of the indolent disposition of the Indian. Here he sleeps at night, and during the day lolls at his ease, smoking, chatting with his friends or repairing his arms & ornaments, all other occupations being considered unworthy the attention of a man. [During the season of occupying the Teepeetonkah they sleep much during the day, except when on a hunting excursion.][10] All the drudgery, the work of cooking, paddling the canoe, bringing firewood, pitching the tipi,[11] in fact

[10] The sentence inclosed in brackets is written at the foot of a left-hand page facing page 12 of volume 2 over the following notation in pencil in the handwriting of Dr. Williamson: "Sleeps at night? During the season of occupying the tipitonka or bark houses the men sleep as much by day as by night that is the young men unless when he goes ahunting."

[11] Above this word, in pencil, Dr. Williamson wrote "teepee."

all the occupations of Indian life except such as ap-
pertain to war or the hunt or fishing [12] devolve upon
the women who seem to [bear their laborious lot with
cheerfulness & seem] [13] to consider that department
as their appropriate sphere.

At the gable end & over the door is a shed or flat
roof extending some eight or ten feet from the build-
ing & supported by posts unhewn. This furnishes a
shady retreat where the inhabitants generally sit on
benches or rather *tables* constructed on either side
of the door on mats woven in tasteful patterns of
rushes, by the squaws, while the children & dogs play
around in all the wildness of savage license. These
scaffolds are used for drying maize &c and during hot
nights for sleeping. Here sits the squaw (or tawe-
chew (wife) " squaw " not being a Dacotah word,) [14]
sewing mocassins or dressing a child's hair while she
gossips to her fellow & watches the papoose [15] which

[12] Mayer originally wrote: "except such as appertain to war
or the hunt divulge upon the women." Opposite this statement,
on the left-hand page facing page 13, Williamson wrote in pencil:
"the hunt & fishing." Mayer then seems to have corrected his
first statement.

[13] The passage inclosed in brackets is crossed out in the original.

[14] The Sioux or Dakota word for wife is *tawin;* the word *tawincu*
means "his wife." The word *squaw* is of Narraganset origin,
according to Hodge. "As a term for woman," he writes, " *squaw*
has been carried over the length and breadth of the United States
and Canada." *Handbook of American Indians,* 2:629; Stephen R.
Riggs, *Dictionary of the Dakota Language* (Washington, 1852).

[15] Facing this passage, which is on page 14 of volume 2, Dr.
Williamson wrote in pencil: "papoose is not Dakota it should
be hokshiyokope."

hangs from the roof above. On the top of the shed
are often laid the canoes of birch-bark & about them
are seen the male children with their mimic bows &
arrows, hunt, & war-dance, & not unusualy " my lord "
& his friends ascend to overlook their own & their
neighbors residences & occupations. [A few feet in
front of the door of his residence is hung upon a pole,
somewhat after the manner of the classic " trophies ",
the " medicine " of the Indian. This may be any ar-
ticle whatever, such as a particular animal's skin, a

curiously shaped stone, a piece of wood, a trinket of
some sort, any thing, in fact, to which the Indian
ascribes a particular connexion or " correspondence "
with himself.] [16] Within, the pipe is passed round
while the war story, lengend [sic] or jest is told, or some

[16] The passage in brackets appears on two left-hand pages facing
pages 14 and 15 of volume 2.

"medicine" or mystery matter discussed. One or two
are engaged in making a pipe or a ramrod or feather-
ing an arrow another is humming the monotonous
music of the dance, accompanying himself on a drum
of native manufacture, while a woman is braiding and
adorning her husband's glossy tresses. The venison
is simmering in the kettle and a dog half concealed
by the cumbrous trappings of a saddle is catching
musquitos under his masters feet. In such occupa-
tions as these the Indian whiles away the year, the
daily routine of sleeping, smoking & gossiping & an
occasional swim in the adjoining river, being varied
by a deer hunt, fishing, a visit to the adjoining towns,
& the various dances, ball plays, & mysteries of sav-
agedom. The houses were arranged in rows with the
"tipis" intervening here & there, pleasantly varying
the angularity & ruggedness of the long succession of
"tetonkas." [x]

[[x] It is seldom that the Indians congregate in vil-
lages during the winter. After the gathering of their
crop of corn in the fall, they seperate into parties of
from one to three or four famil[i]es, & with their *tipis*
depart for the woods which afford shelter from the
inclemencies of winter & brings them nearer to the
game on which they subsist during that season.
Hunting & trapping for their own food & to procure
skins for traffic are their occupations until the spring
when they return to their village to plant the corn,
in which employment the women are the cheif actors.

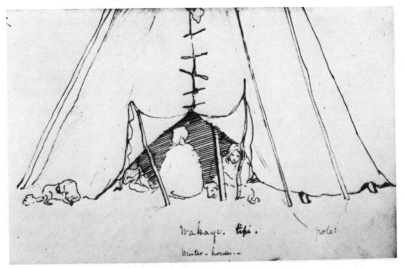

Sioux Winter Lodge, or Tipi

Sioux Summer Lodge

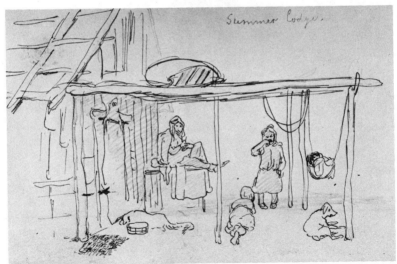

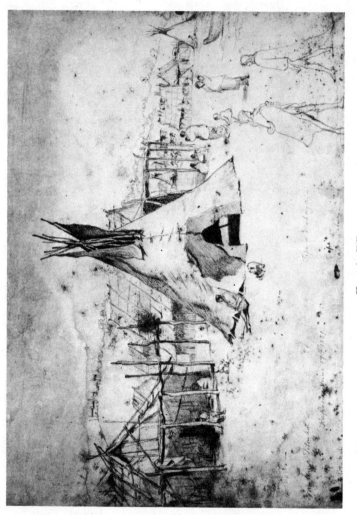

Kaposia Village

This important business over, the spring-hunt takes
place, the women generally remaining in the vil-
lage.[17] Those Indians who live upon the woodless
plains of Nebraska & the Far-west lead a more no-
madic & wandering life constantly following the trail
of the buffalo. They have no tetonkahs, not being
fixed residents of any particular spot. The skin lodge
is portable & their only shelter.][18]

In the distance on the hill which overlooks the
village [Kaposia], their former place of residence, re-
pose on elevated biers, the dead.[19] Here retires the
mother & the widow to weep over the loss of a child
or husband & to pray the great-spirit for their happi-

[17] The object of the spring hunt was to catch muskrats. As it
began in March, before the ice broke up on the lakes and streams,
it is likely that the corn was planted after, rather than before, the
hunt. Pond, in *Minnesota Historical Collections*, 12:370, 372.

[18] The paragraph inclosed in brackets occurs on three left-hand
pages facing pages 15 to 17 of the diary. Its position in the text
is indicated by an "X" both in the text and at the beginning of
the insertion. Mayer revised parts of the passage, in pencil,
making it read as follows: "Hunting & trapping for their own
food & to procure skins for traffic are their occupations until the
spring [when they] go to their sugar camps, the men hunting musk-
rats whence they return to their village to plant the corn, in which
employment the women are the cheif actors. This important
business over, they return to their village to enjoy the ball play,
gambling, &c or go in search of berries &c Those Indians who
live upon the woodless plains of Nebraska and Missouri territories
lead a more nomadic & wandering life."

[19] The Sioux regularly placed their dead on scaffolds or in the
branches of trees. The "burial customs and mourning" of these
people are described in detail by Pond, in *Minnesota Historical
Collections*, 12:478–485. The Kaposia cemetery was a famous one,
since most of the travelers who visited the upper Mississippi saw
and described it. One of these travelers, Henry Lewis, includes an

ness in the spirit land.[20] The cradle of the child & the arms of the warrior are placed by their side that their spirits may serves [sic] their former owners as they did during his life. The scalps of hostile Chippeways, the hereditary enemy of the Dacotah, stretched upon hoops are placed by the body of the departed as evidence [to the great spirit][21] of the valour of his race, and as a propitiation of the favour of the diety. On the death of an Indian his body is wrapped in his robe or blanket, & since the intercourse with the whites a coffin is, if possible procured. It is then placed upon a scaffold, raised six or seven feet from the ground, where it remains for several months, & even years, often until it falls to pieces & the bones are scattered upon the ground, to be collected & deposited in a grave. The coffins are often bound around with a red or brilliant colored piece of cloth, which makes them conspicuous at a distance. [Frequently portions of choice food are placed at the grave for the use of the deceased, who consumes the spiritual portion, when the young men eat the remainder. A watch is concealed near-by who sees that no animal disturbs the repast & when a sufficient length of time has elaps[e]d for the consumption of

excellent picture of a Sioux burial scaffold in his *Illustrirte Mississippithal*, 82 (Leipzig, 1923).

[20] The last ten words of this sentence are inclosed in parentheses and followed by a question mark in pencil. Mayer seems to have doubted the accuracy of his statement, for above the line, in pencil, he wrote: " that their spirits may not injure them."

[21] The words inclosed in brackets are crossed out in the original.

the spiritual portion, she leaves it If placed hot, it looses the spiritual portion with its caloric.] [22]

Soon after my arrival, while walking through the village my attention was attracted by a prolonged rattling, accompanied by a moaning, monotonous sort of chaunt [alternating with grunts & growling] [23] proceeding from a tipi, which was closed complet[e]ly while fern leaves with which the interior was strewn protruded from beneath the edges of the skins. I was told that it was occupied by a sick child over whom a conjuror was performing his incantations in order that he might remove the cause of his ailment.

[When afflicted by any misfortune they attribute it generally to the ill favour of some of the "medicine" men. An Indian at "Traverse-des Sioux,["] whose child is diseased believes her misfortune to be the result of the jealousy of his relatives on account of his influence with the traders.] [24]

When a person is sick they believe some spirit, (with which they think every object to be endowed), to have taken possession of & overcome the spirit which naturally belongs to the sick man. This spirit is of course an evil one, & all means are resorted to

[22] The passage inclosed in brackets is written in pencil on a left-hand page facing page 17 of volume 2.

[23] The words inclosed in brackets are written in pencil in the original diary.

[24] The passage inclosed in brackets is written on a left-hand page facing page 18 of volume 2. Since Mayer here refers to Indians at Traverse des Sioux, it may be inferred that he added this note after he went to that place.

by the conjuror to remove it. [When conjuring they
dressed with little regard to display — the face painted
black the hair disarranged & his blanket & breech-
cloth his only covering. [L. J.] Boury saw a conjurer
lately in this dress shaking a rattle over the head of
a patient. He grunt[e]d & groan[e]d for some time
& then an assistant held a figure of a thunder-bird
suspended from the end of a stick, before the door
of the tent.[25] The conjuror fired at it with powder
& then contin[ue]d his mummery.][26] Prayers, sup-
plications & threats, The most hideous sounds & gri-
maces [imitations of the concealed animal & grunts &
groans][27] are made to frighten away the spirit, & when
these have been carried to as great an extent as the
abilities or judgement of the conjuror permit him, he
notifies the friends of the sick man that they must

[25] The conjurer and his patient are pictured by Mayer in his
Sketchbooks, 45:34; some drawings of "thunder birds" appear
42:71. The belief in a marvelous bird, whose voice was the thun-
der and who "used lightning as a means of destroying enemies,"
prevailed among the Sioux in common with many other tribes of
Indians. See Pond, in *Minnesota Historical Collections*, 12:403.
Boury was an artist and a member of the party that went to
Traverse des Sioux. Evidently the two men kept in touch with
one another after leaving the West, for in his Journal, under date
of January 18, 1854, Mayer records: "Boury called to borrow
my Indian sketches. He is about leaving for Paris — his ideas of
Art being merely imitative — to study drawing there." Mayer
drew a sketch of Boury at Traverse des Sioux. Journal, 1847–54,
p. 142; Sketchbooks, 42:116.

[26] The passage inclosed in brackets is written in pencil on left-
hand pages facing pages 18 and 19 of volume 2.

[27] The words inclosed in brackets are written in pencil in the
original diary.

be ready with the arms to destroy the spirit as it
escapes from the body of the deceased. Accordingly
when the din & clamor of rattle & voice have reached
their height, a signal is given & the friends who stand
at the door of the lodge discharge their arrows or
guns at the invisible demon as he flies thro' the air.
Should it be found that this effort has been unsuc-
cessful, the conjuror repeats his hocus-pocus with
whatever additional " medicine " he can summon to
his aid. Should the man die, the reason is plain, the
spirit was stronger than his " medicine " or else that
another evil spirit had entered. Should the invalid
recover he is a great doctor, & his medicine is all-
powerful. " What fools! " we exclaim, " to be thus
deluded," but, does not a very similar confidence
exist among our *enlightened* brethren? Rattles are
not used but " puffs " often have a similar effect.
The " Wechastah wakun," *man* SPIRIT, *wonderful,
mystery,* is unknown but M Ds are manufactured by
the gross from materials inferior to many an Indian.[28]
Fern leaves are considered as peculiarly appropriate
to the presence of the man of mystery & are therefore
strewn upon the interior of the lodge.

The medicine man, in an Indian community is
looked upon as the great wise-man and priest of the

[28] Accounts of the customs connected with the activities of the
medicine man, known among the Sioux as *wakan witshasha* or
" mystery man," appear in Hodge, *Handbook of American Indians,*
1:837, and in Pond, in *Minnesota Historical Collections,* 12:475–
477.

band to which he belongs. He is consulted on all
occasions, and his opinion is considered almost in-
fallible as it bears the stamp of divine origin & is the
result of supernatural influences. His power is only
surpassed by that of the cheif who consults him on
all occasions of importance. The number of medicine
men is not limited but any one can begin business
for himself provided he has the requisite talents for
hocus-pocus & humbug, and is a member of the medi-
cine mystery, and entitled to take part in the
medicine-dance.[29] The medicine mystery or college
is a secret society composed of the principal men of
the tribe who are initiated into the mystery with
great ceremonies & bound to secresy; of what, it is
difficult to say for the secret has never been divulged
to any white man & those who have been longest
among them know no more than the merest stranger.
The dance & medicine feast take place at the same
time and are the principal festival of the order.

On the death of an individual, his relations, as a
manifestation of their grief, neglect all personal adorn-
ment, cleanliness, or attention to dress. Their hair
is cut off, their faces painted black, they wear the
poorest clothing & often lacerate themselves & " mor-
tify the flesh" in the most painful manner. This
mourning cannot be discontinued until a medicine

[29] The medicine men were not necessarily members of the medi-
cine dance society, although they frequently belonged to that or-
ganization. A good account of the medicine dance of the Sioux
is given by Pond, in *Minnesota Historical Collections*, 12:409–415.

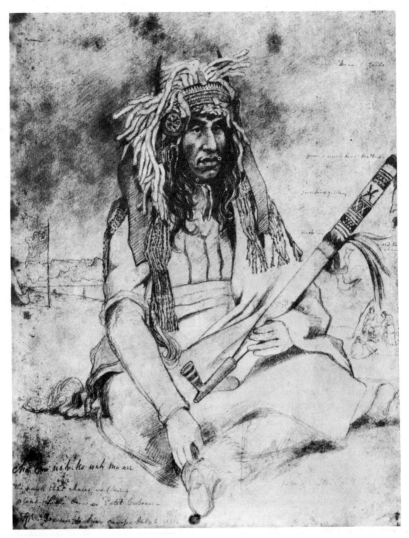

Chief Little Crow

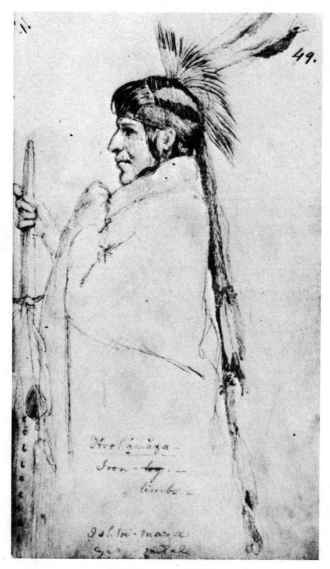

Hoohamaza, or Iron Leg

feast has been given by the near[est relative of the diceased, who collects the bones of his ancestor, which by this time have fallen from the bier, preceeding the burial of which the medicine-feast & dance is celebrated.

All persons who are thought worthy of the honor & who are able to pay for it, (the initia[tio]n fee, which is divided among the members, being often very large) are prepared to be inaugurated as members of the [medicine] lodge. A large lodge or arbor is erected capable of accommodating the members & the candidates for admission who having been seated around it & the vessells containing the foods placed over the fires, the ceremonies are commenced with the initiation of the candidates. This takes place during the dance. Each member rises, with his medicine-bag in his hand & dancing round to the sound of the drum, points his medicine bag in the manne[r] of a gun, at the member to be admitted. The effect is instantaneous, he is seized with violent convulsions, retchings & spasms, during which he vomits or pretends to vomit, or else to bring out of his arm, leg or breast, a bead or small shell which is afterwards preserved with sacred care in his medicine-bag. Previous to entering the lodge the candidate has been privately instruc[t]ed in his part. Two beads are given him one of which he swallows, the other he is directed to conceal in his mouth or elsewhere & to produce it after having simulated violent spasms &

convulsions. His signal for performing is the presentation of another's medicine bag at him. All finally go thro' a similar performance. Each in his turn presents his medicine-bag to his neighbor who falls as tho' shot. All go thro' this mummery & after some continuance of the ceremonies the feasting follows on which occasion every one is expected to eat to repletion & to devour all that is set before him. Presents prepared by the host & his relatives are then distributed to the guests. These are often valuable, as a horse, a gu[n] or a lodge. The bones are then interred, the ceremonies ended & the mourners at liberty to resume their accustomed habits. Children who are subject to epeleptic fits, convulsions & extraordinary dreams &c are generally brought up with a belief of their supernatural mission & at the proper age are installed as " great-medicine " men. To such an extent is their belief in this mystery carried that we cannot doubt their sincerity as I have heard a father performing these incantations & singings over his sick child. This institution is said to be of comparatively late origin, having been instituted about fifty years ago by the " Shawnee Prophet "][30] The impression among the traders & those best acquainted with the Indians is that this famous secret consists in the knowledge of the fact that there is no secret

[30] The passage inclosed in brackets, ending here and beginning on p. 121, is written on left-hand pages facing pages 24, 25, 26, and 27 of volume 2. The final sentence is written in pencil. Tenskwatawa, the " Shawnee Prophet," was a twin brother of

at all, except that of decieving [*sic*] themselves & the
uninitiated with the idea of their greater insight into
affairs than their neighbors, X a supposed connection
with the spiritual world. note X

A stroll thro' the village [*Kaposia*] on the day after
my arrival gave me some idea of my probable success
in procuring sketches of Indian character. Pursuing
my usual plan of taking my sitters unawares & with-
out reference to their permission — or disinclination
I met with various success. Many expressing sur-
prise on discovering my objects, & laughing immod-
erately at the result, & showing no objection to my
continuing, while others observed with stoical indif-
f[er]ence & coldly declined being sitters.

The crowd of children, women dogs & youths who
collected around me while I was sketching a "tipi"
"teepee" gave me some notion of the extent of hydro-
pathic treatment among them & the conclusion was,
by no means, favourable to the cleanly habits of my
friends. This is however greatly the result of neces-
sity, for few have a sufficiently large wardrobe to
enable them to make frequent changes in their cos-
tume. In the summer they bathe frequently, espe-
cially the younger portion of the community, the

Tecumseh, the famous Shawnee chief. In 1805 the prophet called
his tribesmen about him and "announced himself as the bearer of
a new revelation from the Master of Life." Mayer's impressions
of Tenskwatawa's teachings seem to be inaccurate, since he de-
nounced "witchcraft practices and medicine juggleries." For a
sketch of the "Shawnee Prophet" and his teachings, see Hodge,
Handbook of American Indians, 2:729.

presence of unpleasant odours & apparent uncleanliness is therefore more attributable to the absence of the wash tub than of the bath. In attempting to sketch an old woman, I received a large portion of the Dacotah vocabulary of imprecations & expressions of countenance worthy of Hecate. They think that I acquire some influence over them by possessing their portraits — some have no such superstition, but consider it an honor.

I was invited to enter the lodge of the Indian * who had brought me down the evening before, & I found him with his friends smoking & chatting. The pipe was passed round & I smoked two or three whiffs & found the "Kinnikennick" quite agreeable. Their pipe-bowls are made of a red stone of close grain & susceptible of a high-polish. It seems a fine quality of sandstone & is procured at the "Pipe-stone quarry" which is situated [blank in MS.] distant [blank in MS.] The stems are of wood highly ornamented with porcupine quills, feathers & horse hair, — & the Kinnikennick is the inner bark of the willow dried & smoked with a small proportion of tobacco.[31]

* Hoohamaza or Iron-leg [author's note.]

[31] Various kinds of bark were mixed with tobacco in the making of kinnikinick. The red stone from which the Indians made their pipe bowls was "'an indurated clay,' graduating into red shale," which was secured at a quarry in what is now Pipestone County in southwestern Minnesota. The stone is known as "catlinite," in honor of George Catlin, the "eminent painter of Indian scenery and personages," who visited the quarry in the summer of 1836.

In company with D^r Williamson I visited the chief
"Little Crow" to whom I was introduced as a friend
of Captain [Seth] Eastman, U.S.A. which was evi-
dently a recommendation to his regard, the Captain
having for many years been stationed at Fort Snell-
ing, became intimately acquainted with the Indians
and was much liked by them.[32] His admirable
sketches of the scenery of this country and of the
Indians give him a high rank as an amateur artist,
& [coming in the same capacity seemed a natural
consequence to the Dacotahs.][33] The chief is a man
of some forty five years of age & of a very determined
& ambitious nature, but withall exceedingly gentle
and dignified in his deportment. His face is full of
intelligence when he is in conversation & his whole
bearing is that of a gentleman. He declined' sitting
to me until he was dressed in a manner more becom-
ing his rank, he being then clothed in nature's garb
with the exception of his breech clout.[34] His uncle

Folwell, *Minnesota*, 1:119–121; George Catlin, *Letters and Notes
on the Manners, Customs, and Condition of the North American
Indians*, 2:201–206 (London, 1842).

[32] For an account of Mayer's meeting with Eastman, see *ante*,
p. 4. While Eastman was stationed at Fort Snelling he became
much interested in the Indian life of the upper Mississippi region,
of which he made numerous records in pictorial form. His wife,
Mrs. Mary H. Eastman, wrote several volumes of western sketches,
which he illustrated.

[33] The passage in brackets is crossed out in the original diary.

[34] Mayer did draw some crude sketches of Little Crow's head
at Kaposia. See his Sketchbooks, 40:61. A large drawing of the
chief in elaborate costume, dated at Traverse des Sioux, July 2,
1851, is in the Ayer Collection.

Hoosaneree, (Grey leg) is a venerable old patria[r]ch & affable & gentlemanly in his manners [35] — indeed, I have seldom met with the same number of persons taken promiscuously from the ranks of civilized life who possessed so much genuine politeness, gentlemanly feeling & kindliness of manner as the Kaposia Indians.

This chief succeeded his father in the office of chief — he was absent from his village for some time & during his absence his brother had endeavoured to usurp his situation. As "*little-crow*" returned to his village & was nearing the shore in his canoe, his brother leveled his rifle. little crow saw it & dodged, the ball, well aimed, passed thro' both fore-arms as he grasped his paddle — & he bears the marks to this day. his brother was shortly after killed by the tribe for this offence.[36]

Early in the morning speech[e]s from the chief & "medicine bottle" a very loquacious & old Indian, & a principal man, announced that the hunters would depart in search of deer that day.[37] Soon, the young men were seen emerging from their lodges catching their horses, saddling them & providing the various

[35] A picture of this Indian is in Mayer's Sketchbooks, 41:50.

[36] Another account of this incident, which occurred in the summer of 1846, by F. V. Lamare-Picquot, a French traveler, appears in *Courrier des Etats-Unis* (New York) for March 12, 1847. It has been translated by Anne H. Blegen and printed in *Minnesota History*, 6:275–277 (September, 1925).

[37] Two sketches of "Wah-kon-ojanjan or the Sacred light, or Medicine-bottle" are in Mayer's Sketchbooks, 40:77.

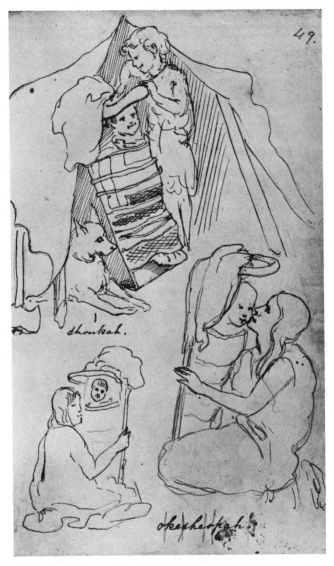

Sioux Children, Kaposia

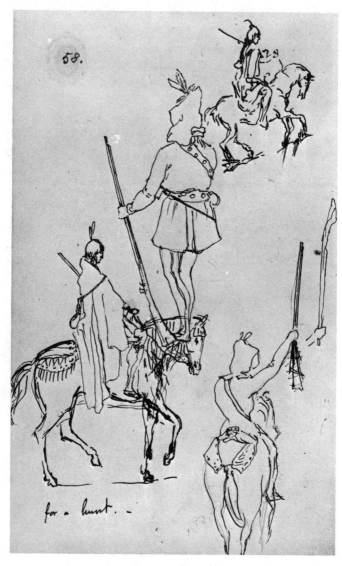

Departing for a Hunt, Kaposia

necessaries for a residence of some days in the woods.
The costume was different from any I had seen & as
they wended their way through the dell leading thro'
the bluffs, they seemed like knights of old, crusaders
with long white cloaks & capoted monks who grasped
the lance and sword for Holy church & savior's praise,
some like rude Gothic bishops arrayed in temple copes
as fit for fray as feast. The hoods which they wore
are the usual winter headdress of the Dacotah, hav-
ing been introduced by the French trappers at an
early period of their intercourse & their name the
"Capuch(in)"[38] indicates their origin in the old
world. They are made of an oblong piece of blanket
doubled & sewed together on one side. This seam
passes from the forehead to the crown of the head &
the hood is tied under the chin. [This "capuchon"
when attached to the coat give that garment the name
of a "capote" These coats are made of blanket
"without a waist" & the "capuchon" is sewed to the
collar. It is bound with a belt or sash in which the
Indian or voyageur carries his pouch, pipe, & knife.
The blanket is sometimes bound around the waist
by a belt & disposed so as to answer the purpose of a
coat.][39] The blanket is put on in a manner resem-

[38] Mayer seems to have been in doubt about the spelling of this
word, since above the final syllable, which he inclosed in paren-
theses, he wrote "on."

[39] The passage inclosed in brackets is written on a left-hand
page facing page 30 of the diary. The first sentence is crossed
out; the final sentence is in pencil.

bling a cope, over a rude blanket coat, the leggings cover the lower extremities as usual, tho' of less showy materials than on more ceremonious occasions. The rifle, & pow[d]er horn, & pouch, the ever ready pipe, stuck in the belt, a pouch for the "kinnikennick" the knife with it's ornamented scabbard, the camp kettle slung to the saddle &, the blankets & skins, & ornamental gear of the horses are the accessories. The numerous picturesque groups that were formed & disolved as they prepared to depart employed my pencil, altho' the rapidity of their motions & the prejudice against my art militated somewhat against my success. The hoods were worn on this occasion as a protection against the musquitos which abound in this country.

The Indians of the Kaposia band have made but small advances in civilization yet they are among the most sober, honest & best conditioned of their race in the neighborhood of Fort Snelling. Some few have professed Christianity and several are educated, being able to read & write their own language. They were the pupils of the missionaries who have instructed them from books printed in Dacotah for purposes of instruction. The principal portions of the bible & a book of hymns have also been translated into the language and a paper entitle[d] "Dacotah Tawax-itku"[40] or "the Dacotah friend" is now published at

[40] The second word of this title is written in pencil in the hand-writing of Dr. Williamson.

S[t] Pauls edited by the Rev[d] Gideon H. Pond.[41] The word Dacotah, by which name all that nation of Indians called by the French "*Sioux*" is designated, signifies a friend or a nation of friends — some translate it freely — "One of many".[42]

Five or six young Sioux girls have been taken into the family of D[r] Williamson where they are instructed in their own language & receive the same English education and attention accorded to his children. A teacher has been placed here by [the] government & receives a regular salary but either from want of success in his efforts or inertion on his part there was no school at the time of my visit, altho' frequent applications are made to D[r] W for admittance to his family.[43] There are difficulties attending a day school,

[41] A list of books in the Dakota language, including a spelling book, readers, translations of portions of the Bible, and prayer books appears in Riggs, *Dakota Language*, xii. The *Dakota Tawaxitku Kin, or the Dakota Friend* is among the works listed and is described as a "small monthly paper, in Dakota and English, published at St. Paul by the Dakota Mission." A file of this paper, which appeared monthly from November, 1850, to August, 1852, is in the library of the Minnesota Historical Society. Gideon H. Pond, its editor, and his brother, Samuel W. Pond, in 1834 went to Minnesota as independent missionaries; they later became affiliated with the American Board of Commissioners for Foreign Missions. See Folwell, *Minnesota*, 1:183.

[42] Riggs, in his *Dakota Language*, describes the word "dakota" as an adjective meaning "feeling affection for, friendly"; Hodge, in his *Handbook of American Indians*, 1:376, explains that it means "allies." The word "Sioux," according to Dr. Folwell, is "the white man's contraction of *Nadouessioux*, 'adder,' a spiteful Chippewa nickname." *Minnesota*, 1:79n.

[43] The latter part of this statement originally read as follows: "the school has not been carried on for some years, altho' frequent

which are obviated in that where the pupils are con-
stantly under the influence of their instructor & his
family. Many causes are assigned for the failure of
these schools, viz the intrigues of the traders, some
of whom consider it their interest to keep the Indians
in ignorance [44] the prejudice of the Indians to ad-
vancement & the inaction of the teachers. It is dif-
ficult to say which or whether all combined is the
cause. I heard the children at Dr W's recite & sing
& they seemed in all respects equal to the generality
of white children, in regard to intellect.[45] Their lan-

applications are made to Dr W for admittance to his family."
Opposite it, on a left-hand page, appears the following notation
in pencil in the handwriting of Dr. Williamson: " no school when
I was there." Mayer evidently accepted Williamson's correction,
for he crossed out part of his statement and wrote above the line:
" there was no school at the time of my visit."

[44] Mayer originally wrote: " Many causes are assigned for the
failure of these schools, viz the intrigues of the traders, whose
interest it is to keep the Indians in ignorance." Opposite this
statement, on a left-hand page, appears the following notation in
pencil in the handwriting of Dr. Williamson: " some of whom
consider it their interest." In accordance with this suggestion,
Mayer crossed out the words " whose " and " it is " and wrote
above the line: " some of whom consider it their."

[45] The government teacher at Kaposia was S. M. Cook. In his
report for 1851 he states that " the school under my care has dur-
ing the last year numbered, daily attendance, seven; number en-
rolled, twenty-one." The school was not a success; according to
Dr. Williamson its failure was due to reports spread among the
Indians to the effect that they might receive the funds reserved
for educational purposes " in cash if they would keep their chil-
dren out of school." The mission school that Mayer mentions was
taught by Dr. Williamson's sister, Miss Jane S. Williamson. A
number of her pupils boarded in Dr. Williamson's home or in the
home of another white family living at Kaposia. Spelling, reading

guage is well adapted to Music & the hymns which they sung were far more harmonious in their sound that [*than*] the English originals, altho' the Dacotah has not a softened sound in conversation; but is rather harsh & guttural.

I bid farewell to the Doctor, much gratified with my visit & he procured me two Indian women who promised to take me to S^t Paul for a " consideration." As I entered the canoe he desired me particularly to observe the features of one, & for that purpose I placed myself opposite to her — but this was a breach of Dacotah etiquette not to be permitted for her gestures & expression soon informed me that I must turn my back on the ladies, & substitute the contemplation of the surrounding scenery & the back of her half-breed son who sat in the bow and assisted the women in navigating our craft. Swiftly sped the light canoe altho' stemming the current of the impetuous Mississippi now swelled to it[s] largest size. But the skill of the *voyageurs* directed our boat beneath the bending willows and meeting-boughs overhead, into the quiet sloughs between the Island & main shore. here we sped more rapidly thro' this forest canal, passed trees curled by lightning & storm into the water, & by drift logs of huge size, pine trees escaped from the forests one hundred miles above the falls of

in English and Sioux, arithmetic, and geography were among the subjects taught in this school. Indian Office, *Reports*, 1851, p. 175–177, 182.

St Antony. At last we emerged into the broad & rapid river & I lay in the bottom of the canoe, lazily admireing the scenery of this most beautiful of rivers until we reached St Paul & I landed again among the voyageurs, Yankees, French & Indians, with their peltries, notions, oxen, & pipes.

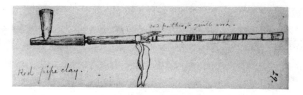

VIII

Social Life at Old Fort Snelling

JUNE 24th 1851. Left St Paul for Fort Snelling where I arrived in an hour & was politely received by Franklin Steele Esq. to whom I had a letter, he introduced me to his wife, formerly Miss [Anna] Barney of Baltimore.[1] I was enabled to procure board at Mr [Philander] Prescotts the interpreter & superintendant of Indian farming. He is an old resident of this country & familiar with the Indians, speaking their language fluently & connected with them by marriage.[2] His long intercourse with them seems to have given him a reserved manner

[1] Franklin Steele was the sutler at Fort Snelling from 1838 to 1858. He was a prominent figure in frontier Minnesota, particularly in the development of the lumber industry. Hansen, *Old Fort Snelling*, 87; Daniel Stanchfield, "History of Pioneer Lumbering on the Upper Mississippi and Its Tributaries," in *Minnesota Historical Collections*, 9:354.

[2] Philander Prescott settled in the vicinity of Fort Snelling in 1820. He married Mary Keehei, a Sioux woman of the Lake Calhoun band. See Warren Upham and Mrs. Rose B. Dunlap, *Minnesota Biographies, 1655–1912*, 392, 615 (*Minnesota Historical Collections*, vol. 14). Prescott's report as "Superintendent of farming for the Sioux" for 1851 is in Indian Office, *Reports*, 1851, p. 173.

quite unusual in this country. He seems a well-
meaning man, but I should preferr him a little more
communicative.

The accomodations are rude in many respects &
Shade of my grandmother! how would your ideas of
housekeeping be outraged were you to witness the
condition, optically & nasally of this domicil. The
loft where your grandson reposes has the *musty* smell
of the accumulated cobwebs of years, enhanced by
the peculiar Indian odor, far different from that spicy
import of Hindoostan which emanated from thy
kitchen oh, revered old-lady, 'Tis the smell of *stale*
kinnikennick smoke, the incense arising from un-
washed untensils & congregated greases, arising thro'
the chinks of my *lofty* floor, from the kitchen beneath.
Add to this, want of ventilation & a serenade in
touching strains performed by a select band of Minne-
sota minstrels, vulgo, Musquitos — such are the lux-
uries of travel! yet do we not app[r]eciate *home* the
more. We learn how others live & are happy, re-
turning thanks for their enjoyments(!) yet we see
grumblers in neat well ventilated whitewashed & car-
peted garrets, eligibly situated in the most fashionable
streets of our cities. Indeed, I have undergone a
gradual descent in my accomodations since leaving
home where I sleep in an "*attic*" & I now, as I write
this, find myself seperated from Mother earth by a
buffalo robe & my great-coat, sheltered from a pelting
storm by the tent roof, [of my friend Governor Ram-

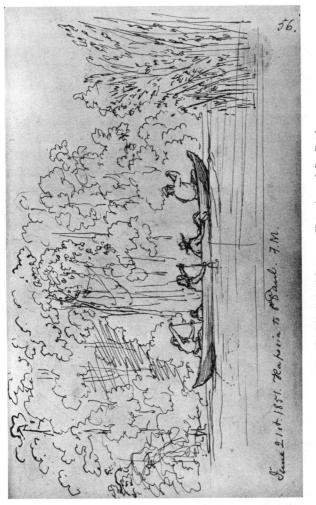

June 21st. 1851. Kaposia to St. Paul. F.M.

On the Mississippi between Kaposia and St. Paul

Mayer is second from the right.

56.

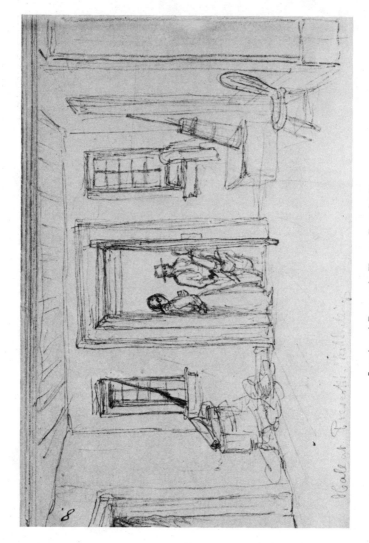

Interior of Prescott's House, Fort Snelling

sey of Minnesota][3] more than one hundred miles from
the *comforts* of Fort Snelling, surrounded by wild In-
dians & a country where no white men but traders &
missionaries live nearer than St Paul, yet I consider
that is an ascent, figuratively speaking, from the gar-
rett, if I may dignify those quarters with the name of
my homely bedroom, which I occupied at the inter-
preters.[4] Yet a residence at Mr P's had advantages.
His business & intercourse with the Indians brings
many of them to his house & they furnish studies
for thought & pencil which I should lose in more com-
fortable quarters.

[His son in law, a tall raw boned Yankee, of rather
amiable qualities is misnamed *Petty*-John, but John is
unfortunately of enormous altitude & jointed after the
manner of a steam engine[5] His motions, actions, &
voice are all on the ponderous, hard & harsh style of
execution as musicians would say. He walks the floor
& an earth quake seems approaching, he asks me for

[3] The passage inclosed in brackets is crossed out in the original.

[4] This portion of the diary was evidently written after Mayer
reached Traverse des Sioux.

[5] Prescott's son-in-law was Eli Pettijohn, a native of Ohio who
went to Fort Snelling in 1841 as a government employee to fur-
nish supplies and teach farming to the Sioux. He is listed in the
manuscript schedules of the Fort Snelling census for 1850 as a
farmer, thirty-two years of age. His wife, Lucy, was aged twenty-
one. In the late seventies Pettijohn went to California, where
he began the manufacture of the breakfast foods since known by
his name. See a sketch of Mrs. Prescott in the Minnesota His-
torical Society Scrapbooks, 1:16, and an obituary sketch of Pet-
tijohn in the *Minneapolis Tribune*, May 23, 1915. The census
schedules are in the possession of the Minnesota Historical Society.

the salt & I am startled by a trumpet blast. Night &
morning we have prayer & singing (be it far from
me to ridicule any one's devotions,) & after "broth-
er" Prescott who is short & pursey & wears large
silver spectacles & an expression of devotional con-
tentment, has closed the book & announced the hymn,
son in law starts off, instant[ly] in full blast & hard
at it as tho' determined to bear down all opposition,
the hymn book & Psalmn tunes in lengthy line on
the table before him, his ponderous jaw "swings off"
& the deep cavern of his mouth is opened. The
sounds which are emitted tho' loud & full & appar-
ently due to the mouth owe much to the impending
organ of expressive size & acquiline form which is the
striking characteristic of our friend's face. His eyes
are half closed, for all his nervous energy is required
to the work [of] the vocal machinery below. A lock
of his long straight hair has escaped from behind his
ear & covers one eye, at the same time that it fur-
nishes a background to the nose when viewed in pro-
file. His head is cast up, his long digits trace the
verse, & his extensive feet are with drawn beneath
the bench, in modest retirement & concentrated ef-
fort. When he has completed the task he wipes the
perspiration from his forehead with a calico hand-
kerchief & subsides into Egyptian solidity. He would
be a "pendant" for Hogarth's old woman in the
church scene in that artist's series of Industry &
Idleness. For all this, Mr Petty-john is a man to

be respected, & I am indebted to him for his good intentions in rescuing me for one night from the horrors of *that* loft, altho' he scarcely bettered my condition by placing me in the interpreters office, where the accumulation of dust & stale tobacco smoke was in proportion to that gentleman's repugnance to permitting the "women folk" to "put things to rights."][6]

A letter from Governor Ramsey introduced me to Mr Nath[anie]l McLane, the Indian agent at this post, a brother of Judge [John] McLane of Ohio.[7] He is a very kind & clever old gentleman, hospitable & communicative, & his house, to which he has given me a general invitation, (endorsed by a *special* one to dinner, the *proper* style) is rendered specially agreeable by the presence of his pretty-black-eyed & *healthy* complexioned daughter who inherits many of her father's attractive qualities. After the deprivation of ladies' society for some time one discovers it's value as a portion of the sum of our

[6] The paragraph inclosed in brackets is written on three left-hand pages facing pages 40 to 42 of volume 2 of the diary. The point at which it should be inserted is indicated by Mayer.

[7] Nathaniel McLean was Indian agent for the Sioux at Fort Snelling from November, 1849, until the spring of 1853. He is listed in the manuscript schedules of the Fort Snelling census for 1850 as a printer, sixty-two years of age. His family included Mary McLean, aged twenty. He was known as a journalist, since in 1849 and 1850 he was one of the editors of the *Minnesota Chronicle and Register*, a newspaper published at St. Paul. His brother was Judge John McLean of the United States Supreme Court. Daniel S. B. Johnston, "Minnesota Journalism in the Territorial Period," in *Minnesota Historical Collections*, 10:254.

habitual enjoyments,—& after gazing on nothing much superior to the Indian women, with their dark complexion & high cheek bones & disgusting figures it is certainly very *refreshing* to meet a young lady of refinenement [*sic*], & a respectable degree of beauty. My situation therefore excuses this eulogium on the merits of Miss Mary M^cLane. As this fair one stood by me on the porch of her fathers dwelling, having respectively ministered to our inner selves by partaking of the aforesaid dinner we descried at a distance on the prarie a long mass of dark colour creeping slowly across the prarie, & as they approached nearer & nearer we descried a detachment of dragoons under command of the redoubtable Leut^t Gardner, having in charge seven Winnebagoes whom they had arrested in attempting to leave the country to which they had been removed by the Government & return to their former hunting grounds which they had sold to the U. S.[8]

[8] Lieutenant John W. T. Gardiner of Company D, First United States Dragoons, was stationed at Fort Snelling in 1848–49 and again from 1850 to 1852. The Winnebago, under a treaty negotiated in 1846, gave up their lands in Iowa. They were given a reservation at Long Prairie, in Todd County, Minnesota, and to this place many members of the tribe were removed between 1848 and 1850. The Winnebago, however, were dissatisfied with this reservation; they " were induced to maintain a constructive residence at Long Prairie because their annuities were paid there, but many individuals and small bands remained wanderers." It was probably one of these groups that Lieutenant Gardiner took to Fort Snelling during Mayer's visit. Folwell, *Minnesota*, 1:311–318; George W. Cullum, *Biographical Register of the Officers and Graduates of the U. S. Military Academy*, 49 (Boston, 1891).

June 27. Spent the after part of the day with Mr
& Mrs Steele & family[,] Mrs Whitehorn and Leut
[Anderson D.] Nelson at Lake Calhoun[,] which is
distant about seven miles from The fort.[9] It is ap-
proached by a road across a most beautiful prarie,
slightly rolling in surface & skirted by "Coteaus"
covered with forest. The eye can pierce an unob-
structed distance of several miles across this beautiful
lawn, for such it seems to be, & one is constantly
expecting to see neat farm houses appearing at every
turn. The whole country has the appearance of a
cultivated grazing country, its rolling & hilly surface
being varied with open praries & wooded hills, the
trees appearing in clumps & masses of a few acres,
looking like the orchards of the Eastern states at a
distance. This description is applicable to the whole
valley of the Minnesotah river (S[t] Peter's).[10] Lake
Calhoun is about three miles long by two broad, & its
clear glassy waters are confined in shores covered
with pebbles of various colours. From this you rise

[9] Lake Calhoun is now within the city limits of Minneapolis.
In 1850 the Steeles had four children — three daughters, aged
seven, four, and two, and a son, Franklin, aged one year. Mrs.
M. Barney, probably Mrs. Steele's mother, and Rachel Steele
also lived with the family. See manuscript schedules of the
Fort Snelling census, 1850. Lieutenant Nelson was stationed
at Fort Snelling from 1848 to 1849 and again from 1851 to 1853.
Cullum, *Graduates of the U. S. Military Academy*, 104.

[10] The Minnesota River was called the St. Peter's by early
explorers and traders. The Indian name was officially given to the
stream by act of Congress in 1852. The meaning of this name
is discussed by Dr. Folwell in his *Minnesota*, 1:455–457.

to the undulating surface of a prarie one [on] one side, while wooded banks skirt the opposite shore. The lake abounds in fish & is a favorite pleasure ground for the officers of F[ort] S[nelling].

[*Fairy Circles* — compass flower

Perfect circles of grass of more luxuriant growth than the surrounding & included prarie are among the phenomena of the West. They vary in diameter from six to one hundred feet, and increase annually, by the seed falling outwards. They have been named "Fairy circles," & many hypothoses have been advanced as to their origin — some attribute them to the rolling of the buffalo. Others to the presence of a species of mushroom, which decaying, leaves the ground it occupied of richer quality than before.

Another wonder of the prarie is the compass-flower the leaves of which always grow from the stalk in a due north & south direction, provi[n]g an unerring guide to the lost wanderer on these pathless plains. It is known as the "rosin plant" & attains a height of three or four feet. It is not found north of Prarie du Chien.

Ant hills of large size are seen tenanted by their numerous & industrious inhabitants & surrounded by high walls of luxuriant grass. Snakes & roses, prarie flowers.] [11]

[11] The section inclosed in brackets is written on two left-hand pages facing pages 43 and 44 of volume 2. The title and the last five words are written in pencil.

IX

Camping at Traverse des Sioux

JUNE 29. Unexpectedly summoned I found myself on board the " Excelsior "[1] in company with Gov^r Ramsey & Luke Lea Esq, the commissioners appointed to treat with the Dacotahs for a portion of their territory west of the Mississippi.[2] Hon H[enry] H. Sibley, Mr [Ashton S. H.] White of the Home department,[3] D^r Forster [*Thomas Foster,*] secretary to the commission, Mr [W. C.] Henderson,

[1] The "Excelsior" left St. Paul on the evening of June 28; it is likely that Mayer boarded the boat on the following morning at Fort Snelling, where Governor Ramsey went on board. Luke Lea arrived at St. Paul on the evening of June 27 on the "Excelsior." Twenty-five dragoons, who had been promised to Ramsey as an escort, received such late notice that they could not get ready to leave and the boat departed without them. Goodhue, in *Pioneer,* July 3, 1851; Ramsey Diary, June 21, 28, 1851.

[2] The membership of the treaty commission is discussed in some detail by Folwell in his *Minnesota,* 1:275–277.

[3] White and Mayer seem to have been very friendly at Traverse des Sioux; Mayer mentions him frequently in the diary and the two men sketched portraits of one another. See Mayer's Sketchbooks, 42:31, 56, 62; 43:46. White was a clerk in the department of the interior at Washington. He accompanied Lea from Washington when the latter went west to act as commissioner at the treaties of Traverse des Sioux and Mendota. See *Register of All Officers and Agents, Civil, Military, and Naval, in the Service of*

Mr [Richard] Chute & his lovely wife[,] [4] M^r [Hugh]
Tyler, commissariat, Indian traders, & men of French,
half breed & American blood [5] & a delegation of the
principal men of the Kaposia band, headed by their
Chief were also on board, & the tent furniture, buffalo
robes, blankets, rifles, mocassins &c indicated our
destination to be the " Traverse des Sioux " a trading
post & Indian village, about one hundred miles & ten
miles from the mouth of the S^t Peters or Minnesota

the United States, 1851, 134 (Washington, 1851); Ramsey Diary,
July 26, 1851. The sketches of White and Mayer are reproduced,
post, p. 161, 162.

[4] Chute probably went to Traverse des Sioux to represent the
interests of the trading firm of W. G. and G. W. Ewing of Fort
Wayne, Indiana, with which he was connected, and which had
numerous claims against the Sioux. He later settled permanently
in Minneapolis. See W. H. C. Folsom, *Fifty Years in the North-
west,* 521 (St. Paul, 1888); Folwell, *Minnesota,* 1:277n. Good-
hue, in the *Pioneer* of July 10, refers to Mr. and Mrs. Chute's
presence at Traverse des Sioux: " In our company are a gentle-
man and lady from Indiana; and the lady is certainly the most
resolute, enthusiastic admirer of frontier life that ever was seen.
She is the most artless, fearless, confiding, enchanting woman that
ever went anywhere; and her loveliness contrasts so favorably
with the coarseness of those wild red women."

[5] In addition to the treaty-makers specifically mentioned by
Mayer, the following individuals were present at Traverse des
Sioux: Alexis Bailly, L. J. Boury, F. Brown, Joseph R. Brown,
Hercules L. Dousman, Alexander Faribault, William H. Forbes,
James M. Goodhue, William Hartshorn, Alexander Huggins, Henry
Jackson, Joseph Laframboise, William G. Le Duc, James H. Lock-
wood, a Mr. Lord, Kenneth McKenzie, Martin McLeod, Nathaniel
McLean, Stephen R. Riggs, Franklin Steele, Wallace B. White,
and Dr. Williamson. According to Goodhue, " There probably
never before was an Indian treaty attended by so few persons
and with so small expense." Goodhue, in *Pioneer,* July 24, 1851;
Hughes, in *Minnesota Historical Collections,* 10:111.

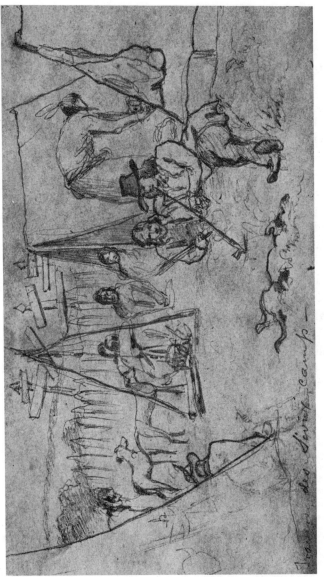

Camp Life, Traverse des Sioux

river,[6] where they [the] different bands of Sioux were invited to send their principal men to treat with the U.S. for the purchase of their lands.

June 30th 1851. found us at Traverse de Sioux on a lovely prarie which rises gently from the river & so undulates until reaching the more distant & level praries. The Indians as we had advanced into their country, and stopped at their villages assumed a wilder character, but did not seem so happy, well fed & comfortable as those who live near S[t] Paul & receive annuities from the U. S.[7] As we approached these village[s] the chief assembled his band on the hurricane deck and as a compliment to the village they were nearing in full chorus sung their brave song or chaunt, at the end of every stanza of which a whoop & yell was given. A speech from the chief followed, at the end of which all gave the usual approving "Hoah!" When nearing "traverse des Sioux" they all attired themselves in full costumes with eagle plumes & turkey-beards[,] deer tails & horse tails &c. that they might appear to their brethren in becoming

[6] The distance from the mouth of the Minnesota River to Traverse des Sioux by water is only about seventy-five miles.

[7] Those who had had more frontier experience than Mayer did not feel that annuities, which were received by the Sioux of eastern Minnesota under the terms of a treaty negotiated in 1837, served to improve the condition of the natives. Goodhue, in the *Pioneer* for July 17, notes the arrival of a group of Sisseton at Traverse des Sioux whom he describes as " better looking, cleaner and better dressed, than the lower bands; which is perhaps by reason of their never having been paralyzed and stupified with annuities." For the provisions of the treaty of 1837, see Folwell, *Minnesota*, 1:160.

plight. The provision, baggage &c were landed & an
ox given into the hands of our butcher who divided it,
surrounded by eager eyed Indians, evidently much in
want of food. The tents were pitched, the U. S. en-
sign hoisted in front of the commissioner's marquee,
& every preparation made for a fortnight's stay in
camp.

Little Crow being attired in state he fulfilled his
promise to me by sitting for his portrait.[8] His head-
dress was peculiarly rich, a tiara or diadem of rich
work rested on his forehead & a profusion of weasel
tails fell from this to his back & shoulders. Two
small buffalo horns emerged on either side from this
mass of whiteness, & ribbons & a singular ornament
of strings of buckskin tied in knots & colored gaily
depended in numbers from his head to his shoulders ·
& chest.

Our camp consisting of several tents and tepees
commands a view of St Peters' river, the prarie with
its numerous lodges, the trading & mission houses and
the surrounding country, & is tenanted by the com-
missioners & their officers & a motley collection of
Frenchmen and half-breeds, traders, interpreters,
voyageurs & trappers. The Kaposia band seem to be
considered as especially our friends, & their tents are
pitched near by, so that an intimate acquaintance
exists between them & the members of the camp.

[8] The chief made this promise when Mayer visited him at Ka-
posia. See *ante*, p. 125. The portrait is reproduced *ante*, p. 119.

Their proximity affords an opportunity for constant observation of their habits & manners, & an agreeable intercourse with them confirms us in our ideas of their superiority in condition & manners to their neighbors.

The afternoon was occupied in witnessing a ball play performed by the women.[9] This is one of the most exciting & picturesque sights which can be witnessed, particularly when played by the men, their figures being more perfect, & the dresses more picturesque & beautiful than the women. Greater numbers engage in it, the stakes a[re] more valuable & the game consequently more exciting. The women's dress is their usual costume with the exception of the blanket, and some additional ornament disposed around the chest.

The Kaposia Indians are noted for their proficiency in this game, & their name has some reference to this quality. Kaposia — the light or lithe, active people. A challenge having been sent to the Indians resident here was accepted. The stakes were arranged & they proceeded to attire for the contest by denuding themselves to their breech-cloth & adorning their heads in every variety of fanciful manner. The hair is new greased combed & plaited & then, with the aid of feathers, ribbons, streamers of red cloth, & bands of richly worked embroidery, arranged with care in the

[9] The game described by Mayer was known as " la crosse." It was played in varying forms by Indian tribes throughout the eastern part of North America. Hodge, *Handbook of American Indians*, 127.

great variety of manners which their imagination suggests. A collor or necklace & bracelets or armlets are put on. The breech cloth, worked sometimes in fanciful patterns by the squaws, is bound round the waist by a cincture. To this is generally attached some pendant ornament of feathers, furs & cloth, hanging from their belts & it contributes greatly to the *effect* of motion as they fly rather than run after the ball. Often a wing of some bird of large size hangs behind them, [or attached to the arm].[10] Often a string of sleigh bells give animation to the chase as it mingles with their cries & eager exclamations. Their toilet is completed by painting their faces with brilliant colours, and with a less valuable pigment made of a white or black clay they color their bodies. A favourite ornament is produced by smearing the palmn of the hand & then patting the surface of the body so as to leave the impression of the hand. An Indian is thus often covered with these hands. This dress, or rather the want of it, displays their elegant figures to the greatest advantage, & on no occasion does the Indian appear in so suitable & tasteful a costume & one which is perfectly in harmony with the occupation in which they are to engage. The neat & airy head dress, brilliant in color & not subject to derangement from motion, but contributing to the grace of their swift movements, as their long hair,

[10] The phrase inclosed in brackets is written in pencil in the original diary.

& pendant "tails" ["]wamekenunke" stream upon the wind, their feathers & crests tossing, their bodies turning with serpentine ease & deerlike swiftness, they run, vault & spring into the air, & course from one end to the other of the lawn-like prarie, like so many Mercuries, the brilliant colors of dress & paint, & the flashing armlets & diadems, & varied position leading the eye thro' an exciting & luxuriant chase.

Prepared for the game they sally forth to the appointed ground with loud whoops of defiance to their opponents, & headed by the chief, who seldom takes a part in the game, it being thought beneath his

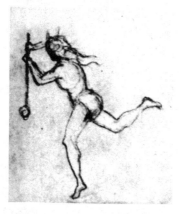

dignity except on extraordinary occasions, so far to relax the stateliness of his deportment. As they march along with stately & unencumbered step they seem so many monarchs of the soil they tread. Their blankets worn like regal robes, their heads with crowns seem clad. Their forms of classic purity & motion free as air. Arrived at the point where the game is to begin & where the judges, who are the old men & chiefs, are assembled, the various articles to be con-

tended for are arranged, if of convenient size they are strung upon a pole and erected on the ground. Larger articles as guns, saddles, horses &c, which are often gamed for, are merely placed at the stand. Bounds are then appointed beyond which each party endeavours to throw the ball, one party taking one boundary & the other the opposite, each strives to throw the ball beyond their own boundary & every time they succeed

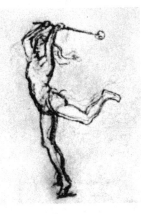

counts a game won. Every man is provided with a stick ("La crosse") made somewhat like a shepherds crook, so contrived as to retain the ball when it is caught or scooped up with the crooked portion. With these they "scoop up" the ball from the ground & catch it in the air & throw it often a great distance towards their respective boundaries.

At a signal the game begins by tossing the ball into the air, then commences the contest for victory, who shall throw the ball the oftenest beyond the boundary of their party. An active Indian catches it in his "crosse" as it descends, the opponent endeavours to prevent him from throwing it, but he flies like a deer

before his pursuers, his hair & "wamehenunke" streaming behind him, a bea[u]tiful race is the consequence, the possessor of the ball rapidly moving his "crosse" from right to left to retain the ball in its place, his opponent striving to the utmost to pass him & prevent him from attaining his purpose, but he artfully baffles his pursuers who are close upon his heels, suddenly he turns, dodges his rival, springs, like the "flying mercury" into the air, & the ball is hurled to an immense distance eagerly watched by the players. As it approaches the ground & its place of descent is apparent, the contending parties are instantly at the spot & then begins a strife to secure it again, a mass of writhing, pressing & flexible humanity, thrusting their "crosses" beneath each other's legs to try to procure the wished for prize, then, as one gets it & in trying to escape with it, it is knocked from his hand or he is tumbled on the ground his opponent falling often with him quickly they recover, and a thousand attitudes which display their bea[u]tifully lithe & elegant figures to the greatest advantage are produced in rapid suc[c]ession. One is at last successful, he shakes the crowd from him & runs as near to his bounds as he can without danger of losing his ball, he is at the extreme end of the prarie a half-mile distant from the place he left, again they contend and the ball is carried nearly to the opposite bounds, the chiefs & old men encourageing their men with a rapid stream of Dacotah fluency, the players contending to the

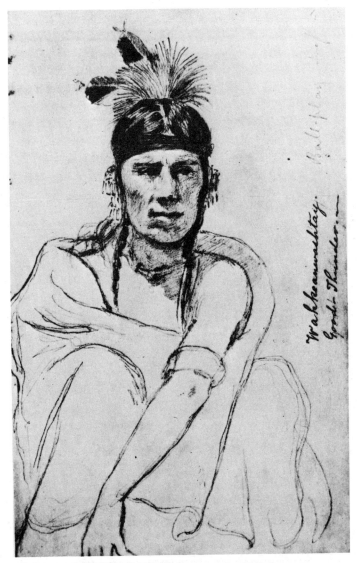

Good Thunder in the Costume of a Ball-player

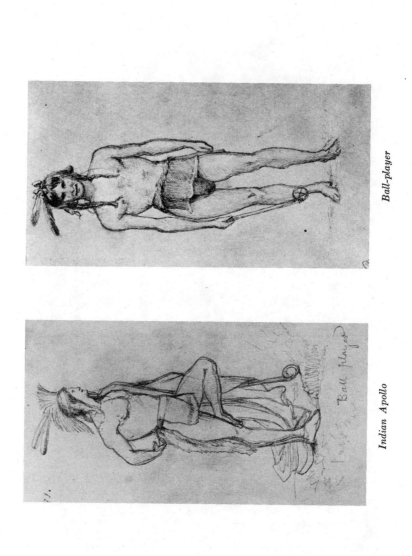

Indian Apollo

Ball-player

utmost, their suppressed words of eager rivalry indicating the vigour of their exertions, now in the eastern bound, now by your side, the crowd of spectators escaping from the stream of players by whom they are likely to be overwhelmned, from one end to the other of the immense p[r]arie, from your side to the distant horizon, they course with incredible swiftness.

One can have no idea of the physical powers of his race until he has witnessed this display, their rapidity seems that of animals of deerlike nature, their movements are so perfectly free & so unlike the motions of the white man. Tho' surpassed by the Anglo Saxon in strength & powerful muscular developement they possess a symmetry of form & equality of developement, unknown to those who are engaged in one particular employment, developing one set of muscles at the expense of the others & losing *activity* in acquiring *power*. But one fault may be found with the figure of the Indian, the arms are often a little too effeminate & small from want of exercise. In other respects they realize our ideas of the classic purity of form displayed in Grecian art. Their straight spines, robust chest, flexible loins, finely rounded shoulders, straight & tapering limbs & small hands & feet are all ideal in character. No better "*life-school*" could be conceived, the figure no more clothed than decency requires, the little ornament there is contributing to the contrast of colour & forms, displaying the beauti-

ful curves & changes of the figure to advantage. The models *unconscious* of their positions, which vary from the repose of the fatigued victor to the fleet progress of the racer. The figures varying in character expression & costume. These games continue often for the whole day with slight intermissions for rest, and in the course of this time forty or fifty miles at least must be run, as they easily keep pace with a trotting horse. At the conclusion of the game the victorious party take possession of the stakes & divide them among the winners. No one is permitted to become angry or to take offence at any rough treatment he may receive.

The 1st July tested the efficiency of our tents, a violent storm arose & pelted furiously over our heads, attended by a sweeping blast which threatened to overthrow our tents & tear them to pieces. All hands stood to the tent-poles which quivered like aspen stems, & succeeded in holding them fast until the abatement of the storm. Thanks to the sailmaker & his patron St Paul, they leaked not & like a ship which has weathered Cape horn, are [*our*] tents were considered proved as we are not likely to meet so severe a blow soon again.

This camp life is by no means a hardship as many might suppose, situated as we [are] in a bea[u]tifully picturesque & healthy country surrounded by agreeable & amusing associates, & hospitably entertained by "Uncle Sam". A mattress laid on the ground

& wrapped in a blanket[,] we breath[e] the pure air of
the prarie & sleep as soundly as in the most luxuriant
couch. The constant respiration of pure air, the
suc[c]ession of novel scenes, & the variety of cheerful
companions & amusing studies of character, con-
tribute to engender good digestion & cheerfulness.
The day is passed in visiting, reading[,] intercourse
with the Indians, seeing the ball-plays, dance &c & at
night, talks by the camp fire of frontier & Indian sub-
jects, witnessing an Indian dance or listening to their
wild, monotonous music, or turning to a neighboring
tent where are assembled the gentlemen of French-
descent the traders & voyageurs, we hear the canadian
boat songs, or the national airs of old France sung
with spirit by melodious voices, while the occasional
introduction of English songs, as "Sparkling &
bright," "Auld lang syne" & "Away with Melan-
choly" give variety to the evening's amusements.
The voyageur songs had their origin probably in Nor-
mandie whence they were brought by the Acadians
& Canadians & adapted to the movement of the
paddle & oar.[11] The tunes are very light airy &
graceful, full of beautiful expression suited to their
purpose & The accompaniments of the voyageur as
he paddles his canoes down the rivers of the north
& west. The words are the ballad of the French

[11] "Voyageur Songs" is the title of a chapter in Nute, *The
Voyageur*, 103–155. Mayer records the music of a voyageur's
song in his Sketchbooks, 43:49.

peasant sometimes poetical but the chief merit of the
song is the music. Seated at table I heard French &
Indian spoken almost exclusively & the co[u]ntenances
of foreign appearance, French, Indian and half breed,
beguile me into a belief of being in some foreign land.
May it not be called foreign, twenty five hundred
miles from home & in an Indian country.[12]

A few feet from the voyageur singers are the
"sauvages" whose music presents a contrast to their
more civilized neighbors. The instrument most popu-
lar with the Indian is a drum made by stretching a
piece of hide over the top of a keg, or similar to a
tambourine. The music is a monotonous measure
suited to the motions of the dance, two or three
notes perpetually repeated, varying little in measure.
Seated at the door of the lodge while their com-
panions & voyageurs are grouped around a [sic] they
commence their drumming & after a few moments
one of their number issues from the tent attired
somewhat in the costume used in the ball-play & with
a war club tomahawk or other war like instrument
in his hand. With grunts & wild cries he places him-
self in an attitude which resembles more a wild ani-
mal about to spring on its prey than anything I can
recall, & dances, or rather performs a succession of
jumps, stamps & hops, on both feet or on one, thrust-

[12] Mayer exaggerates somewhat the distance between Baltimore
and Traverse des Sioux. Actually he was about eighteen hundred
miles from the former place.

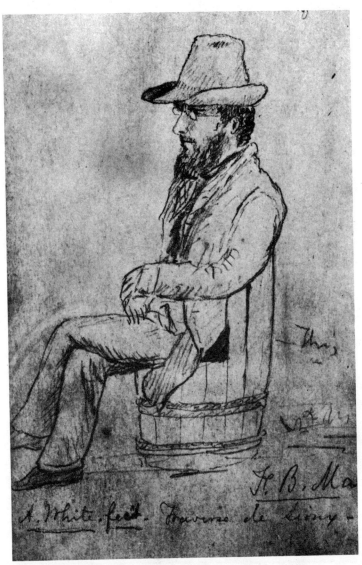

A Sketch of Mayer by Ashton White

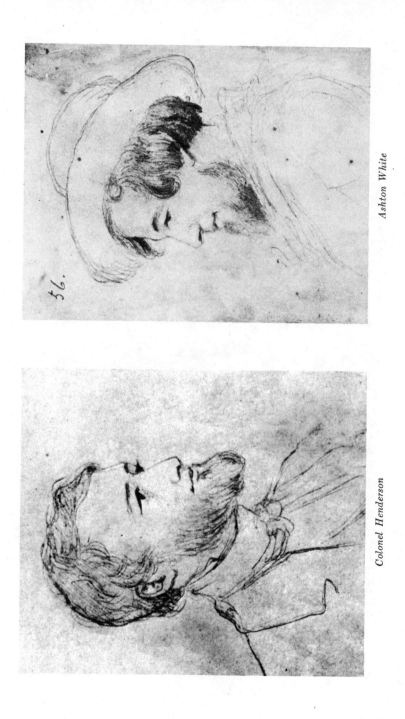

Ashton White

Colonel Henderson

ing his head out & in & grimacing in a wild & mali-
cious manner, evidently giving great delight to his
friends & exercise to himself. This is one of their less
important dances, the Winnebago dance[,] but it has
the character of all of them.

A War dance was celebrated last night by "Little
Crow" & his braves. None were admitted but those
who had taken a scalp & signalized himself by his
valour. Each carried his favourite weapon a war-
club, tomahawk or lance & danced, in the bear-style,
elevated their weapons above their heads & accom-
panying the "tam-tam" of the drums with a war
song. At the conclusion of each stanza, if I may so
speak, one of them stepped into the ring formed by
his companions & related in a bravado manner some
of his most daring exploits,[13] at the conclusion of the
recital a "hoah!" from all was the response & the
dance & song succeeded for a few minutes when an-
other stood up & endeavour[ed] to exceed his prede-
cessor in the extravagance of his story. This is the
only occasion on which the Indians are permitted
to "bragg" & vaunt their own courage & acts. They
avail themselves of the privilege however & use to the
fullest extent this safety-valve for their vanity. This
[is] a sagacious institution of the savage & might

[13] The following notation in pencil occurs at this point: "Di-
van — Arab resemblances to the Indians." The main body of the
manuscript is here written upside-down on left-hand pages, but
this notation is rightside-up at the head of a page. It faces page
62 of volume 2.

be introduced with great profit in some civilized communities Instead of being annoyed as one often is by a drippling stream of self-conciet [*sic*] it might be retained by its possessor until an appointed period when it might be discharged in a torrent — leaving him at other times as the Indian is, perfectly silent on the subject of his great actions. [A Bragging festival annually, or quarterly, to suit the circumstances of the various cases is therefore suggested.][14]

Friday morning last [*July 4*], as we rose we wer[e] star[t]led by a horseman riding into camp & announcing, "Hopkin's is drowned"! But the night before the gentle Missionary had been among us & attracted all by his pleasant manners.[15] We could not realize the news. He had gone early that morning to bathe in the river, his usual custom. He did not meet his family at breakfast & soon his clothes were found on the bank. Every effort was made to discover, the body by the assembled whitemen & Indians, but without avail. A net was finally stretched across the channell in hopes that it might arrest it in its downwards course should it float. Three days had

[14] The sentence inclosed in brackets is crossed out in the original diary.

[15] This tragedy occurred on the morning of July 4. As a mark of respect for the dead missionary, the "grand celebration" planned for the day was cancelled. Robert Hopkins had been connected with the Traverse des Sioux mission station since 1843; he was ordained in 1848. Stephen R. Riggs, "The Dakota Mission," in *Minnesota Historical Collections*, 3:121, 123; Indian Office, *Reports*, 1851, p. 171; Goodhue, in *Pioneer*, July 10, 1851.

passed and a terrible storm arose, peal after peal of
thunder called the dead man from his grave & he
arose, a ghastly object covered with the mire & filth
of the treacherous stream, his hands clenched in
agony & his limbs stiffened in death yet tranquil was
his face, as tho' a prayer had passed them with his
breath. A noble looking Indian & a voyageur raised
him from the water still turbid with the passing
storm, laved him & swathed him in linen & as the
canoe glided with its ghastly load towards the former
desolate home of the widow it was followed by a long
line of silent spectators, Indians, French & Americans.
It stopped at the point where he was last seen & in
the faces of the Sioux quivering lips & moistened eyes
were seen tho' Indian stoicism opposed their utter-
ance. An aged woman bent beneath a century stood
before the body. She burst forth into a flood of grief
as she grasped her robe convulsively & bent herself
in agony. Oh, my son! my son! she exclaimed he had
pity on me, he fed me, he clothed me, & when I was
sick he nursed me. This was all I could gather, for
the sobs smothered her words. She retired weeping,
& then returned & the tears seemed dry the fountain
was exhausted, she had lost a friend. The Indian is
accused of want of feeling yet this woman was an
Indian, [& there were others near her in silent grief.] [16]
The rude coffin was soon prepared, the widow took a

[16] The passage inclosed in brackets is written in pencil in the
original diary.

last look, her grief was too deep for tears, silent, chill. Then the hammer & the nails the unostentatious procession to the grave, the hymn, a prayer, the clods returned upon the coffin lid & —[17]

[17] Hopkins' body was found on July 7. An account of this event, similar to that given by Mayer, and of the funeral of the missionary is presented by Goodhue in the *Pioneer*, July 17, 1851. Volume 2 of Mayer's diary is concluded at this point.

X

Half-breeds and Indians

STROLLING thro' the village of Karmeahton[1] in company with that fine specimen of a French gentleman Mr [Alexis] Bailly our camp master, we stopped before the farthest lodge.[2] "This is the lodge of Rda-mah-nee or the 'walking rattler' & here lives Winuna or Nancy McLure the natural daughter of an officer of our army & an Indian woman. We'll go in." On a mattrass covered by a neat quilt sat

[1] Mayer seems to have had some doubts about the name of the Indian village at Traverse des Sioux. In the margin of a drawing of Nancy McClure he first spelled the name "Karmeahton," but he crossed this out and substituted "Kaghmeatowar." He translated this name as "the village in the corner." Sketchbooks, 41:102.

[2] Bailly was a prominent Minnesota fur-trader of French and Indian blood. His trading post and home were located at Wabasha. There seems to be some question regarding his position at Traverse des Sioux. Mayer here refers to him as "camp master," and he speaks of Tyler as "commissariat" (ante, p. 146). According to Dr. Folwell, however, Bailly was "commissary of the commission" that negotiated the treaty. Goodhue speaks of Bailly as "assistant commissary" and "one of the most useful and active camp men, that ever was." Upham and Dunlap, Minnesota Biographies, 28; Folwell, Minnesota, 1:279; Pioneer, July 17, 1851.

Winuna, the most beautiful of the Indian women I have yet seen.[3] She is but sixteen & the woman has scarcely displaced the child[,] girl [in her face and figure][4] She possesses Indian features softened into the more delicate contour of the Caucasian & her figure is tall, slender & gracefully girlish. Her eyes are dark & deep, a sweet smile of innocence plays on her ruby lips, & silky hair of glossy blackness falls to her dropping shoulders. She received us with a smile & a modest inclination of her head. She understands English, for the departed missionary had been her instructor, but excessive modesty prevents her essaying to speak, her only answers being the innocent smile downcast eyes & nod of affirmation or denial. She has been visited by most of our camp, the rarity of her beauty being the attraction, & the purchase of mocassins the ostensible object.

She has been courted for a year past in person & by proxy by David Ferebeaux [*Faribault*] a young Indian trader of half breed descent & the ceremony of marriage was yesterday performed at our camp.[5]

[3] Nancy McClure lived with her grandmother in the Sisseton Sioux village at Traverse des Sioux, of which Red Iron, or Mazasha, was the chief. Her father, Lieutenant James McClure, was stationed at Fort Snelling from 1833 to 1837. In the latter year he was transferred to Florida, where he died in 1838. Nancy's Sioux name was Winona, which "means the first-born female child." "The Story of Nancy McClure," in *Minnesota Historical Collections*, 6:439, 440, 445; Hughes and Brown, *Old Traverse des Sioux*, 3.

[4] The words inclosed in brackets are crossed out in the original.

[5] The wedding took place on July 11. The groom was the son

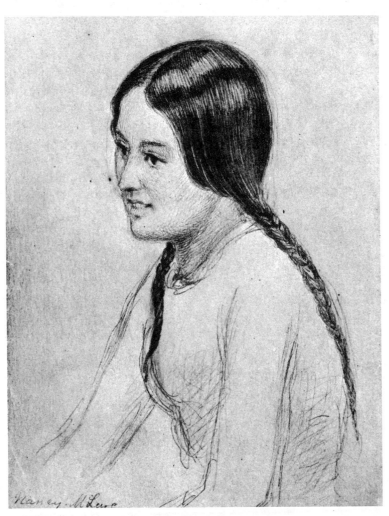

Nancy McClure

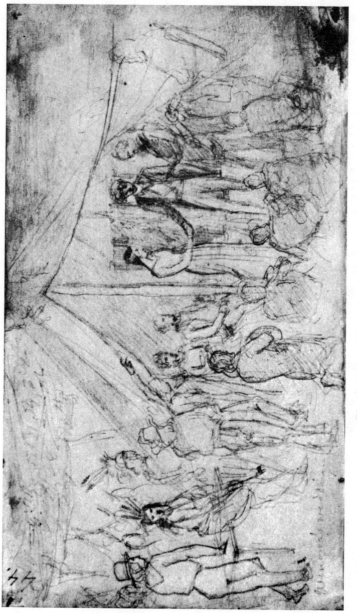

The Wedding of Nancy McClure and David Faribault

[two horses were given for the bride.][6] At the commissioner's marquee were assembled the bride & groom & his relatives, the Governor & the commissioner, & suite the voyageur half-breeds & canadian[s] & the Indians. Mr. Alexis Bailly the Magristrate [sic] present read the service of the Episcopal church the different personages grouped around forming a picturesque & novel scene.[7] The bride congratulated, the marriage was announce[d] by a salute of champaigne corks, the report of which soon summoned the camp to hilarious harmony, which flowed on thro' a hearty dinner & the subsequent toasts & broke like the surf as the company dispersed singing simultaneously by individual & collective efforts "Sparkling & bright" "Auld lang syne," & "Vive le Compagnie". A speech from the commissioner was translate[d] into Sioux & delivered to the Indians.[8]

As we retu[r]ned from dinner a long train of Sioux men & women, on horseback & on foot, arrayed in

of Jean Baptiste Faribault, a prominent Minnesota fur-trader. The bride relates that she "wore a pretty white bridal dress, white slippers and all the rest of the toilet" and that "there was a wedding dinner too, and somebody furnished wines and champagne for it, and I was toasted and drunk to, over and over again." Nancy McClure, in *Minnesota Historical Collections,* 6:446, 447; Goodhue, in *Pioneer,* July 17, 1851.

[6] The sentence inclosed in brackets is written in pencil in the original diary.

[7] According to Goodhue, Bailly was a "Justice of the Peace in and for this county." See *Pioneer,* July 17, 1851. It is interesting to note that Bailly's wife was a sister of David Faribault.

[8] Lea was the speech-maker. The text of his talk is given by Goodhue in the *Pioneer* for July 17, 1851.

their best, were seen wending towards the camp. The principal men formed a circle in front of the marquee entertained the commissioners with a dance. We were soon called from this, however by the announcement of a "Virgin's feast". It is customary among the Sioux, when the character of any young unmarried girl is impeached for her to give a feast to which she invites all who profess virginity whether male or female. A most solemn oath is taken as to the truth of their profession & any one who knows aught to the contrary is at liberty to drag the perjured person from the ring to be disgraced & hooted at by the tribe. A circle was formed one half of which was occupied by young girls, the other by youths & young men. Proclamation having been made by the crier that all who were virgins might join the ring, the guests took their places on the ground having previously touch'd a stone [which was painted red & a arrow stuck into the ground near it, the latter the emblem of piercing of conscience,] [9] which were placed together in the centre of the ring, that being the form of the oath, & signifying their acceptance of the terms of the invitations. All assembled, the crier proceeded to divide the food consisting of cakes of flour & [tea] [10] which were served round to the encir[c]led guests a portion having been

[9] The passage inclosed in brackets is written in pencil in the original diary.

[10] The word " coffee " is crossed out in the original diary; it is replaced by the word inclosed in brackets written in pencil.

sent to the old persons first. Scarcely had they be-
gun to eat & a morsel was about to enter the mouth
of one who had been seated with downcast head en-
veloped in her blanket, when a young man pushed
thro' the crowd siezed her rudely by the arm &
dragged her from the ring followed by the hoots
& sneers of the spectators. She arose, wrapped her-
self in her blanket & concealed herself behind a group
of her relatives, the picture of dejection & chagrin.
The feast was concluded with the consumption of the
food, no similar event occuring except one in which
I figured & unintentionally incurred the deprecation
of one of the traders, a married man, who as a joke,
having been a participater in the wedding festivities,
seated himself in the ring. The bystanders suggested
that some one should "pull him" out & I accepted
the office. he was much offended & the Indians have
laughed heartily at him. As I intended no harm, he
must take the will for the deed. The friends of the
girl who had been disgraced declare her innocence.
The legend of the maiden's rock is connected with
this custom. A rejected lover maliciously dragged
Wenuna a Sioux maiden from the virgin feast. The
false accusation stung her to despair & she threw
herself from the rock.[11] [Many instances are cited
where malice has induced unsuccessful lovers or se-

[11] Maiden Rock is a prominent landmark on the east bank of
Lake Pepin. The legend connected with this spot tells of Winona,
a Sioux maiden whose parents tried to force her to marry a man
of their choosing when she loved another. Rather than obey, she

ducers to drag innocent girls from the feast. Some
have had the boldness to dare their accusers to the
proof & to demand the evidence of the truth of the
accusation & thus thwarted their enemies.] [12]

[An Indian has just arrived who announces that
two Dacotahs have been waylaid by four Chippe-
ways & scalped within two miles of S[t] Pauls. It is
reported that they proceeded to the house of a trader
as they returned to their country & endeavoured to
rob him, but he shot one & wound[ed] the others &
they retreated. Again an advanced courier of the
Siseton Sioux reports that two men, a woman & two
children who were travelling northward have been
murdered by night & scalped by the Chippeways.] [13]

This is an unusually rainy season & we are almost
daily visited by storms of wind & rain, the severest
came at midnight and broke our dreams by its ter-

threw herself from the rock into the waters below. The legend is
related by Stephen H. Long in his narrative of a "Voyage in a
Six-Oared Skiff to the Falls of Saint Anthony in 1817," in *Minne-
sota Historical Collections*, 2:24–26.

[12] The passage inclosed in brackets is written upside-down on a
left-hand page facing page 8 of diary A.

[13] The paragraph inclosed in brackets is written on two pages
facing and following page 8 of diary A. The last sentence is writ-
ten in pencil. Examples of Sioux-Chippewa conflict are common
in the pioneer history of Minnesota. The Sioux, living in the
southern part of the territory, and the Chippewa of the north were
hereditary enemies. A brief account of their perpetual warfare,
by Willoughby M. Babcock, is published under the title "Sioux
versus Chippewa," in *Minnesota History*, 6:41–45 (March, 1925).
On July 5, 1851, a report reached Traverse des Sioux "that two
Sioux had been lately killed by a party of Chippewas," according
to a news item in the *Pioneer* for July 17.

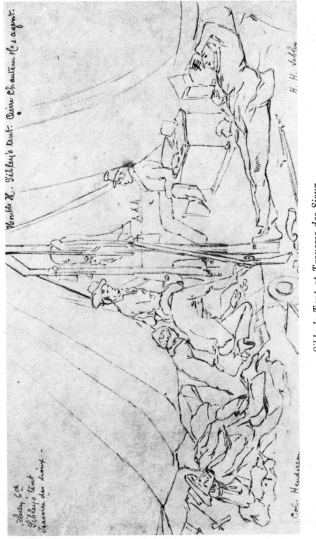

Sibley's Tent at Traverse des Sioux

Sibley is at the right, Henderson at the left.

29.

The editor of the "Pioneer"!

James M. Goodhue at Traverse des Sioux

rific howl. For two hours the lightning flashed contin[u]ously, illum[i]nating all things as by an ill-omened meteor, & the roar of the accompanying thunder the torrents of descending rain & the wind driving like [a] hurricane follow as the herald of its deeds. The accumulated streams descended from the hills & filled in its impet[u]ous force a ravine that was near us adding its voice to the chorus of contending sounds. The stout canvass of our tents seemed every moment about to be rent into ribbons, the tent poles trembled & the cords threatened to part at every blast. The fly had already given away & flapped as tho' it were a "thunder bird" demanding our destruction. The storm seemed spent & as it paused for an instant as tho' preparing for a redoubled attack, the profoundest darkness intervened & we heared [sic] the calls of our neighbors enquiring for our safety & informing us of their overthrow. They were the only ones who had suffered this misfortune, the other tents & all the teepees stood firm. All concurred in declaring, in poetic language that they'd "met with many a breeze before but never such a blow" The "oldest inhabitant" who happened to be present remembered one, his reserve, on such occasions, which had surpassed it. The storm abated & during the hours which passed till daylight jokes travelled from tent to tent thro' the pitchy darkness & the scien[ti]fic gentlemen were enabled to make many useful hygrometrical observations, such as the cubical contents of

hats, the absorbing powers of pantaloons & blankets & eff[ic]acy of wet sheets & hydropathic treatment. A musical gentleman suggested "A wet sheet & a flowing sea" and another dreamingly remarked that his feet were in the grand canal. A filtering apparatus seemed suspended above my head & a simalar one watered my knees while my blanket was gently moistended [sic] by the spray of the rival drippings. At daylight my clothes were "bien humide"! & my hat, 'twas water proof, & held a quart. ["]It's an ill wind blows no one good" is a good proverb — so I used the impromptu cascade from the prarie as a shower bath & dried my clothes by the morning sun & exercise.

We had thought that in this storm Eolus had spent his force but it has proved otherwise for scarce a day has passed without a gust & we are heartily tired of its continuance. The Indians seem the same & for the purpose of appeasing the thunder bird or destroying his influence, a medicine man of the Siseton band, yesterday gave a dance for that purpose.[14] An arbour was constructed of branches of trees large enough for a man to sit in & a vessel of water, a stone painted red & a crooked stick on which to rest his pipe

[14] Opposite this statement, at the foot of a left-hand page facing page 5 of diary B, Mayer wrote in pencil "The Thunder is the most important of the Dacotah gods." Goodhue calls this dance the "Round dance." He describes it in the *Pioneer* of July 17, 1851. Mayer's sketch of the dance is reproduced *post*, p. 181; an engraving based on the sketch, but lacking its life and action, is published in Schoolcraft, *Indian Tribes*, 6:352.

were placed at the door & at the foot of a tall sapling, to the top-most branches of which a figure of the thunder bird was suspended. It was cut in thin bark & rudely represented the form of a large bird. At the extremity of a radius of about fifteen feet from this centre, a hedge made of boughs similar to those of the arbor & about four feet high enclosed the sacred ground. Four arches of branches span[n]ed the entrances to the circle & four saplings with thunder birds at their summits similar to the centre one but smaller were erected at the side of each gate. The arrangement was quite picturesque & resembled the arbors & hedges of an ornamental garden walk.

The ceremonies commenced by the medicine man issuing from his lodge near by his face painted black & long grass interwoven with his hair, with rattle & flute, & esconcing himself in the sanctum-sanctorom. He immediately began his song and tat-too-ing on the drum similar to the usual Indian dance music, excepting an occasional variation with a whistle. A number of men attired in their best ran into the ring & danced in a circle around him keeping time with their feet to the music, & passing around him in a continuous procession, the faces expressing the liveliest animation. In a short time the music ceased & they retired with a whoop to recruit for another effort. Soon the music began again the dancers entered reenforced by additional performers, as they danced or jumped around, the horseman collected at

the next "set" lent their aid to the performances. As the invigorating music of the medicine continued more joined in until the area was nearly filled with a moving mass of men boys & women, Jumping around yelling & raising their weapons above the nodding plumes & headdresses. The horsemen then galloped at full speed around the exterior of the hedge their spirited horses flowing hair & agitated drapery & plumes forming a most exciting & bea[u]tiful equestrian spectacle. They realize the figures carved by the hand of Phidias on the frieze of the Parthenon to represent the annual festival of the Greeks in honor of Minerva. The small size, yet spirited & "blooded" character of the horses as they pranced & curveted in wild freedom around the circle their swelling necks & expanded nostril, the wild eye peering beneath a shaggy fore-lock, their long sweeping tails & mains & their tapering limbs & small unshod feet, suggest at once the live-like procession of the Elgin marbles — & prove the truth of the artist's observation & study of nature.

The stirrupless riders some with their blankets strapped around them their hair streaming from their crests of nodding eagle plumes at once recall the heroes of the parthenon clad in Grecian cloak & helmn. Nor does the Indian in this respect alone recall the classic models of antiquity, some have features strictly classic & their finely turned limbs & perfectly developed chests reminds us at once of the

The Thunder or Round Dance

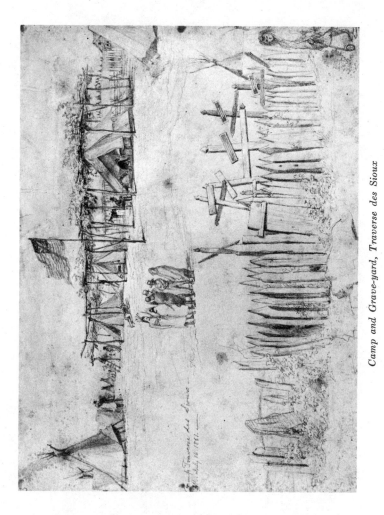

Camp and Grave-yard, Traverse des Sioux

ancient marbles of the museums of Art. There are other points of resemblance, as in their mythology where the God of thunder plays a conspicuous part. These are but instances of similarity produced by parralell stages of progress & habits of life — for at times when clad in long capotes & blankets, mounted with short stirrups & carrying a tall gun, or seated by their tent doors, they seem tableaux vivants of the Arabs of Vernet.[15]

[The Indian horse is a descendant of the Andalusians who have escaped from their mexican owners & formed large herds in the vast plains of the wests. They are their [sic] of the average size tho less powerful than the domesticated animal & apt to be mottled in colours. Their mane & tails are long & sweeping & in speed & activity they equal the civilized animal. Those in possession of the Sioux have been passed from tribe to tribe, stolen by their neighbors & have thus travelled northward. They are smaller than the Southern stock.][16]

As the music & motion grew faster & furious the

[15] Emile J. H. Vernet was a French painter of military subjects. There are two notations in pencil on a left-hand page facing the preceding passage. The first reads: " Hoo-hah-a-tah, many limbs or Briarcus is an Indian name "; the second, which is almost exactly opposite the end of the paragraph, consists of the single word " Asiatic."

[16] The paragraph inclosed in brackets is written in pencil on a left-hand page facing page 2 of diary C. Horses were introduced into the New World by the Spanish invaders of Mexico. Stray and escaped animals formed wild herds; the horses multiplied rapidly on the plains of the Southwest, and gradually they spread

horsemen retired & marksmen stood with guns at each gate, & at a given [signal] discharged them at the centre thunder bird who immediately fell to the ground, when the actors retired & the dance was done. As to the eff[ic]acy of this festival time will show, but tho' the thunder seemed appeased, the wind fully compensated it's loss last night. my unfortunate hat was found outside my tent this morning thoroughly immersed — the rim having formed a gutter which collected the water & isolated the crown.

13th July. As we returned from church at the mission where doctor Williamson had preached,[17] a large crowd of Indians had collected in view of a puppet which was intended to represent an enemy & around which an Indian was imitating the maneuvres of an attack showing the manner of a particular feat of the performer. A party of chiefs seated by proclaimed the lists open, when a brave with a gun cautiously approached & placed his blanket on a short stick to represent an ambush, & hid himself behind it, presently he hears an enemy, he cautiously looks out, then stealthily raises his gun & fires, he hides, again, fires, he is discovered, retreats almost on hands

northward. They were also introduced into the Mississippi Valley by explorers and by Indians who stole them from southern tribes. Hodge, *Handbook of American Indians*, 1:569.

[17] Goodhue reports that the services of July 13 were held in the "little mission school house, which the writer, with W. B. White is allowed to use for a bed room during the treaty." He relates that "Dr. Williamson gave us a very interesting biography of the lamented Mr. Hopkins." *Pioneer*, July 17, 1851.

& feet, he is loading & about to shoot, he is seen &
flies again, fires as he runs hides himself & fires again,
he is the victor he rushes out tramples the enemy to
the ground scalps him & retires with the applause of
the spectators.

July 14. Mr Chute, Mr Henderson[,] Mr Boury
& myself left the camp in [search] of a lake said to
exist on the opposite side of the river Minnesota
about five miles distant. With one exception, green-
horns at the paddle it was our primary lesson in voy-
aging. Our progress being up stream & in opposition
to a strong current our arms were fully employed,
what with poling, paddling & portaging, wading thro'
sloughs & pushing the canoe thro the tangled bushes
& grapevines, for we passed thro forests which are
usually ten feet above the river bank, we had a very
fair example of voyaging by the time we arrived at
the foot of the opposite bluffs. concealing our canoe
in the "cat tails" which bordered our landing to
prevent it's appropriation by some stray Indian, we
proceeded to explore the surrounding country in
search of this much-talked-of lake. What at a dis-
tance appeared a bea[u]tiful hill side clothed with a
green sward proved a steep ascent covered with thick
grass & brambles near as high as our heads. Attain-
ing the summit, the extensive view repaid our toil.

On the opposite side of the river extends an undu-
lating prarie bounding the horizon & about three
miles in length. At the farthest extremity a white

dot & a few conical elevations indicated the position of our camp. The river enlarged to ten times its natural size & covering meadows & skirts of timber usually high above its banks, extended to the foot of the

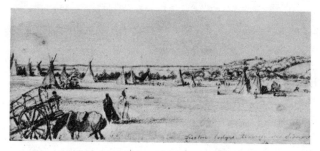

Sisseton Lodges at Traverse des Sioux

hills on the opposite side. These are abrupt & high & their surface is variagated with timber & open spaces, clear as tho' prepared for the reception of a herd of cattle or a wheat crop. These, extended as far as the eye can reach, present a pleasing contrast to the opposite shore. Anon we shall see neat farmhouses & villas perched upon the commanding eminences where now the eagle soars & the buzzard flapps his murky wing. Nature seems to have prepared this land for the husbandman, cleared open fields for his grain & cattle, & scattered forests for his buildings fire-wood & game & for his food & recreation provided lakes well stocked with fish — while the air seems pregnant with health & vigour.

From this beautiful prospect we turned to the woods & scrambled through underbrush & thickets, over logs & through swamps in hopes that we soon might find the crystal sheet we had imagined, but the only reward we received was the sight of a small lake surrounded by a swamp which we were obliged to wade, tormented by the hosts of musq[u]itos gnats & flies who guards this sylvan retreat. The heat was also excessive, & as we pushed our tortuous way towards our canoe again we were glad enough to prostrate ourselves on the wet earth & with hands & mouth, strive to imbibe a few mouthfuls from a delic[i]ous spring which we discovered in a thickly wooded ravine. The water was clear as crystal & cold & [as] ice but the musqu[i]tos which seem to have congregated at our approach, permitted us not to enjoy this slight luxury in quiet but compelled us to push on to the river we found our canoe safe. We reach'd the camp in safety, the wind & current greatly assisting our progress. Sunburnt faces & arms, empty stomachs & wet extremities, (for our canoe afforded a "sitz["] bath to its occupants,) & our wearied limbs bore evidence of our toil in discovering a lake which our companions now informed us *did not exist,* but having discovered one which they knew not of, the hoaxers were hoaxed & the laugh was mutual.[18]

[18] Goodhue, in the *Pioneer* for July 24, gives the following account of the search for the nonexistent lake: "Several young men of our camp started off in the morning, across the river, to see Cedar Lake, a handsome sheet, in the midst of a dark forest, dis-

As yesterday the Indians performed a sham-fight on foot, to day a somewhat similar maneuvre, was executed on horse-back. All the upper band of Sissetons, mounted their horses, being in full dress with the exception of their heads, which were nearly concealed by branches which they carried in their hands, & with which they were bedecked in different ways, mostly, sashwise. They thus presented much the appearanced accorded to McDuffs army when " Birnam wood did come to Dunsinane". This long cavalcade then proceeded to the various encampments discharging their guns as they passed, which were quickly answered by the others as the cavalry swept swiftly by, allowing no time for a ceremony which is sometimes practised, but which on this occasion was not agreeable to the horsemen. If an Indian of the encampment succeeds in inducing a horseman to dismount & engage in a sham fight & the footman performing the maneuvre of scalping is successful, his opponent presents him his horse. The custom is a complimentary one usual with friendly tribes or bands of the same tribe. Having passed the encamp-

tant, it is said, about five or six or seven, or it may be eight miles, or perhaps leagues, from the Traverse. They returned without seeing Cedar Lake, not knowing where to look for it but thinking, neverthelss, that they could come so near it, that the artist in their company, who draws every thing, from the cork of a porter bottle to a queer conclusion, would be able to *draw* it, but he did not. The fact is, like a Mackinaw boat, he draws but very little water; but when it comes to drawing rations, wet or dry, our painter is ' *thar!* ' "

ments of the different bands the[y] drew up before the commissioner's tents where they passed in review & were presented with a gift of tobacco & biscuit which was divided among them by their chief men. As they sped homeward in scattering parties, racing their horses over the prarie, up & down its gentle undulations, at one moment almost lost to view & the next emerging in distinct profile on the horizon, then sweeping off into the distance until lost among their teepees, they presented objects of picturesque interest, the vast extent of green prarie varied by their long shadows projected by the setting sun.

No situation is so well adapted for the view of a fine sunset as one of these praries, with its distinct & unobstructed horizon. The large & "quiet" mass of green sward serving as a foil to display the brilliant & various colours of the sunset to great advantage. The great clearness of the atmosphere adds very much to the beauty of the scence [scene], the delicate gradations of color & effect are distinctly visible.[19]

[19] Mayer drew a line through all but the first sentence of this paragraph.

XI

Sioux Gods and Men

THE DACOTAH have a god whom they call Ha-
o-kah, or the contrary god.[1] They suppose
him to be a little old man with a short body
& very long legs, who goes naked during the winter,
suffering intensely from heat, while in summer he
is warmly clothed to exclude the cold by which he is
chilled. Any one under his influence acts in direct
opposition to the usual deportment of sane persons.
If desired to go, he stays, to sleep he keeps awake, to
laugh he cries, he speaks by contraries. One under
his influence the other day, said, "how dry the river
is there is no water in the channel. I never saw it
so low." The river was then higher than it has been
for years. Two brothers under his influence entered

[1] The word "Ha-o-kah" is written in pencil, and apparently
is not in Mayer's handwriting. "The nature of the Heyoka is not
simply supernatural, it is the opposite of nature," writes Gideon
H. Pond in an account of "Dakota Gods," in *Minnesota Historical
Collections,* 2: 232. According to this writer the Sioux gods in-
cluded four varieties of Heyoka. "They feel perfect assurance
when beset with dangers, and quake terror when safe. With them
falsehood and truth are reversed; good is their evil and evil their
good."

the camp attired very much after the manner of her-
alds with short buffalo-hide cloaks painted with dif-
ferent devices, as birds, stars, diamond patterns &c,
& a long string of feathers pendant from their heads.
They walked or danced in a polka-like step arm
in arm their bow & arrows in one hand & in the
other they carried rattles which kept time to a per-
petual song or chaunt which they sang. Dancing
thro' the teepees they were told *not* to go to the
Governor's Camp, when they immediately turned
round & went there[,] a result which was desired by
the commissioners who wished to see them. A heavy
shower did not seem to disconcert them in the least.
[In entering a house they *backed* in & out.] [2]

The Dacotah religion is Pantheistic.[3] They in-
due every object with a spiritual existence or mysteri-
ous power. They pray to every object in nature
which they wish to appease or supplicate, if asked
what they pray chiefly too, they say to *stones*, for
there are more of them than almost any other object
they know. [Every person generally selecting some
particular object which is his " patron saint " as it
were — or " medicine ". If possible he procures the
object & having preserved it in an ornamental bag,

[2] The sentence inclosed in brackets is written in pencil on a left-
hand page facing page 2 of diary E. Some sketches of the
" Haokah dancers " appear in Mayer's Sketchbooks, 42:83, 84.

[3] A general account of the " religion and worship " of the Sioux
is presented by Pond, in *Minnesota Historical Collections*, 12: 401–
409.

pouch, or vessell, he keeps it with care near him, &
when he dies it is buried with him.]⁴

Beside these they have several invisible deities
who possess great power. These are the Spirit of
water, whom [*sic*] they say, is a "big fish" or "sea
monster", the spirit of lightning & who is a man, with
small body long arms & legs & large wings & clothed
in red who flies thro the air & his rapid motion &
bright garments causes the appearance of lightning.

[Neptune

"Oonc-ta-hee," i.e, one who is dreadful — he is
supposed to be a sea-monster of dreadful appearance
Wahkahende — [*blank in MS.*] The thunder which
is a favorite mystery is said to be caused by one or
some say, two great-birds, called "Wahkeah" whose
flapping or voice as they fly thro' the air causes the
sound of the thunder.⁵

Some think these deities to be solitary, others that
there are races of them. The Thunder birds & the
spirit of the water, who is the "medicine god" & bur-
rows under ground are always at war — & the light-

⁴ The passage inclosed in brackets is written at the foot of a left-
hand page facing page 2 of diary E.

⁵ According to Gideon Pond, the Sioux gods included two
"Onktehi," which in external form resembled huge oxen. "The
dwelling place of the male is in the water, and the spirit of the
female animates the earth." It is therefore the male that Mayer
describes as the Neptune of the Sioux. The Indians believed that
the missionary Hopkins was drowned because he had offended this
god. Pond asserts that the Dakota mythology included four
"Wakinyan" or flyers — great birds that cause the thunder.
Minnesota Historical Collections, 2: 219–222, 228.

ning striking to the earth is when the air-deity strikes
the earth & water monster. The bones of the mam-
moth which are sometimes found on the praries, they
think are the conquered deities' remains & preserve
them a[s] "Wahkon".[6] The Oonctahee has a long
tail with which he sometimes catches the thunder
birds & drags them to the ground. Their contentions
cause the storms.][7]

Then there is Withokah the "fool-maker" or the
god who makes the game foolish that the Dacotah
may the more easily capture them. He is fre-
quent[l]y prayed to. The sun & moon are also deities
& there is a spirit of the earth & fire & the four winds.
The god of war is however chiefly worshipped. The
idea of the "great-spirit" is probably derived from
the whites.

[*Pallas.*

We-an-no-pa-pee, (two women,) preside over orna-
mental work &c & one skilful in such things has
dreamed of or is inspired by Weannopapee. Tah-
koo-shka-shka-shka (he who stirs) animates their
weapons & is the god of motion. His disposition is
peevish & he is easily displeased — he is therefore

[6] The Sioux "had seen bones of the mammoth, pieces of which
they had in their possession," according to Samuel Pond. They
thought that these were the bones of a huge buffalo or ox, and
since it exceeded other animals in size, it was "adopted as their
chief god." *Minnesota Historical Collections*, 12:403.

[7] The caption and the two paragraphs inclosed in brackets are
written on a left-hand page facing page 3 of diary E. The first
word, or heading, and the second paragraph are written in pencil.

treated with peculiar reverence. Their armor-feast is made to this god and are frequent. He also resides in boulders, & presides at the hot bath. The medicine men in some instances are under his influence.[8]

Their form of prayer is destitute of the usual appearance of reverence. As they proceed to the hunt, anything which is considered by them as a deity is offered the pipe & some trinket, feather or piece of tobacco or food is placed before it to secure it's good will & assistance. Their game is often a deity & if the opportunity permits, a prayer the burthen of which is that it may permit itself to be killed, is pronounced, the pipe & some sacrifice is offered to it & then it is slain. They speak of & address their gods as familia[r] acquaintances & look upon [them] rather as beings to be appeased than beloved.

After death they suppose their spirits to be rewarded or punished according to their behaviour in this world. After the soul leaves the body it journeys over, (some say an iron) road far to the south at last it reaches a wide lake or river, where the only crossing is by a long pole laid across it at the opposite end of which a goddess stands. The Sioux tattoo their bodies with various figures & these are their passports to the region of happiness beyound the river.[9] If they have been good men & can show

[8] Most of the Sioux gods mentioned by Mayer are described also by Pond, in *Minnesota Historical Collections*, 2: 219–255.

[9] Mayer seems to have confused the use of paint by the Sioux with the practice of tattooing, which was unknown by this tribe.

these marks, they are permitted to pass. If not the
goddess shakes the pole & they fall into the water.
Little children who have not been tattooed show the
veins on their hands & feet. Beyound the river are
fine hunting grounds & the *perfection* of all the pleas-
ures which they enjoyed in this life. They suppose
this region to be some place on Earth, far to the
South. The milky-way is called the road of spirits.][10]

An Indian stood before the commissioners clad with
the most ragged garments, his hair dishevelled & his
face blackened & wearing an expression of grief &
fatigue. His daughter with three others had been
murdered & scalped by some hostile war-party[11] — &
he had just arrived from the scene of slaughter, his
heart was sore, he said, & he could not rest until he
had told his father, (the commissioner). They had
been set upon by some ten men as they were travel-
ling in a hitherto safe country & fired upon from an
ambush. They at first ran & seeing no chance of
escaping they returned & instant[l]y the tomahawk
cleft their skulls. The wretches mutilated their
bodies & escaped with the scalps. A boy, the only
male with them, was closely pursued by them but

It is unlikely that any of the motifs with which they decorated
their bodies were looked upon as " passports to the region of hap-
piness." Miss Frances Densmore to the editor, October 9, 1931.

[10] The caption and the three paragraphs inclosed in brackets
are written in pencil on three left-hand pages facing pages 4, 5,
and 6 of diary E.

[11] Goodhue, in the *Pioneer* for July 24, also mentions the arrival
of the bereaved father, who he says was a Sisseton.

escaped by his speed & brought the news to the father who immediately set out on horseback with a fellow Sioux & found the bodies, which they collected together, threw a blanket over them & left them to the next comers, who were hourly expected, to bury them. He presented a picture of a down-stricken man as he sat on the ground, his head resting between his hands & his face half concealed by long black locks of disheveled hair, Grieved, starving & fatigued.

As I stood on the highest point of the prarie I observed at the farthest teepees two objects, apparently bipeds with enormous heads, dodgeing about & "progressing" thro' the villages, their nearer approach & constant motion evinced by the more distinct tinkling of the bells suspended about their persons. Viewed nearer, they were Indians with the skins of the head of the buffalo with the horns attached, placed upon their shoulders & used as a mask their bodies naked to the breech-cloth painted in stripes with a pendant ornament of a skunk tail tied to the right leg. In their hands they carried lances decorated with eagle feathers. These they grasped in both hands as the[y] went at a smart pace jumping about & imitating the motions & grunting of the newly arrived buffalo. It was believed to be the precursor of a greater display the following day — but we were disappointed. It is the buffalo dance & is performed, to induce that animal to appear

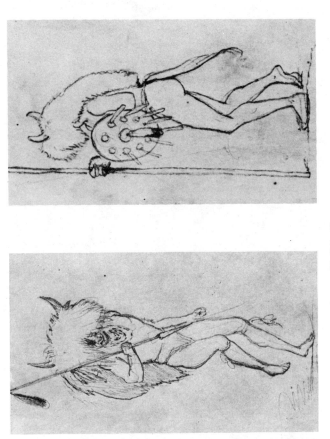

Buffalo Dancers

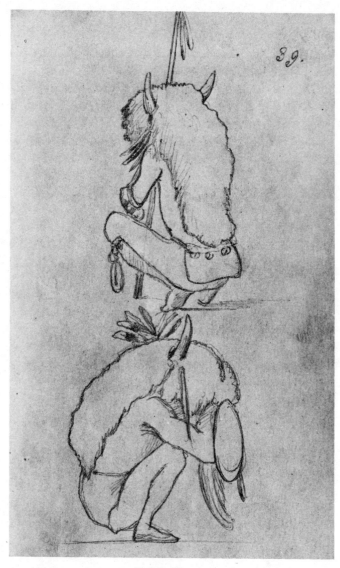

Buffalo Dancers

& furnish their food. As the buffalo appears at first
in small numbers & then gradually encreasing, so
they imitate its habits & send two or three at first
to dance & then a greater number. Buffalo are found
within sixty or a hundred miles of this point. They
formerly inhabited all parts of this vast country from
the Atlantic west.[12]

18. In an arbor formed of green boughs laid upon
a frame work of young trees the commissioners of
the U. S. & the chiefs of the Dacotahs met to treat.
At one end on a raised platform was placed a table
behind which sat the commissioners[,] the american
flag hoisted behind them a few feet from the arbor,
at the sides were the secretaries, reporters & to the
right & left stood & sat on the ground the traders
half-breed[s] & spectators. In a semicircle in front of
the commission, the chiefs were seated on benches,
& the intervening space was occupied by the inter-
preters, & a barrell of sugar & water a favorite bever-
age with the Indians during warm weather stood in
the midst. Behind the chiefs within & around the
arbour were grouped, on foot & on horseback, on the
ground & on their feet, the Dacotahs, young & old,
of inferior rank, men women & children, arrayed in
their best & eagerly watching the progress of the
negociation. Silence & dignified postures character-
ized the assembly as the pipe was lighted by Mr

[12] There seems to be no evidence that the buffalo ever was
found east of the Allegheny Mountains.

Alexis Bailly, the Master of ceremonies, & a few
whiffs having been smoked by the commissioners it
was held in succession to the mouth of each chief.
[Pioneer.] [13]

Mr. A. S. H. White had raised a kite greatly to
the amuse[ment] of the Indian children, a crowd of
whom collected around him to watch it as it soared
higher & higher into the pure ether. The half-grown
boys & the dogs of the Indian village are the greatest
pests it has been my fortune to meet in this tour.
Too old to attract by the grace & interest of child-
hood, they have its inquisitiveness, which uncurbed
by the sense of propriety of the adult becomes impu-
dence. They have not pride enough to cultivate
personal appearance & the cleanliness which they as-
sume with manhood is absent. Very dirty, very ugly
& very mischievous.

In every village there are a race of mongrel curs,
half terrier half wolf, who annoy ever[y] passer by
with a volley of barks, & endanger his heels, with
their teeth. By a singular contradiction the same
sound with which we "set a dog on" they use to
call him off from his attack. The Indian sluts during
"heat" are tied for nights on the prarie where the
wolves pass & the result of the intercourse is evident
in the sharp ears, bushy tails, & wild eyes of the
progeny.

After council a number of young men accompanied

[13] The word inclosed in brackets is written in pencil.

by three girls & carrying their musical instruments [drums, flutes, & rattles,] [14] came to dance the "prariewolf" dance. This is danced by young men who have not yet killed an enemy & who have vowed to cut the hair on the sides of their head about their temples short until they have fulfilled their vow. The dance is the usual jumping "shaker" motion with singing & beating on the drum & rattling, the girls assisting with their voices in the louder portions.

On the following day a "Mandan" dance was performed by some of the chief-men of the upper Sis-setons. In this, a large drum highly ornamented & supported on four sticks is beat upon by the dancers who sit in a circle around it, each one having a stick. Their voices kept time to the music & two boys of about twelve & three or four young girls sang with them during portions of the performance. After a preliminary overture on the drum the one arose related an exploit & then accompanied by two or three others danced somewhat in the style of a "ho-down" or hornpipe, minus the patting of the hands of the one & the variety & freedom of the latter. During his dancing the others beat & sang & when he sat down he joined in until another arose made his speech & danced. This was continued until all had spoken & they had succeeded in extorting a present of tobacco, when they retired leaving our tympanums to recover from the shock which they

[14] The words inclosed in brackets are written in pencil.

had sustained. A large crowd[,] horsemen & foot[,] surrounded the marquee & dancers, & the setting sun bea[u]tifully *gilded* the edges of the figures in the background.

[After leaving our camp they went to the tent of Little Crow before which they repeated the first performance. As a token of his appreciation of this honor Little crow presented his bea[u]tiful headdress of seventeen eagle-plumes to the principal chief & stated that he was sorry that it was incomplete the number of his scalps entitling him to twenty four feathers. Another Indian presented a horse to a dancer & for days after whenever the horse & his new rider approached the camp he was heard to chaunt the praises of the donor at the top of his voice.] [15]

The pipe of peace is the ordinary pipe of the Indian highly ornamented. A soldier's pipe is adorned with eagle plumes & the pipe smoked on a war party has the stem stained black or red.

[15] The paragraph inclosed in brackets is written in pencil on pages 5 and 6 of diary F. It is followed by four blank pages. The final paragraph, which follows here, appears at the foot of the page on the outside back cover of diary F.

Addenda[1]

Cincinnati	W[illiam] L. Sonntag.
"	J[oseph] O. Eaton.
Washington	Balentyne — Hall.
New York	C. Butler. No 20 Nassau Street.
"	Anna C. Lynch. 45. Ninth St
Phila	John C. Mitchell. Walnut below 8th St.
"	J. B. Cowperthwait. 253 Market.
"	Phineas Banning. 135. Market
Boston —	Geo. A. Richmond. 94 Staniford St or
	153 Main St St Louis.
"	W. P. W. Dana. No 7 Bulfinch pl.
Chicago.	W. B. Ogden.
St Louis	Thos Jackson.
	Lt Col. Bladen Dulany.[2]

St Louis — city hotel — Nashville. West Newton.
Alexandria — Hill Watson.

[1] Under this heading have been grouped lists of addresses and other notations that Mayer wrote at the beginning and end of the first two volumes of his diary. Since they do not form part of the diary proper, they have been separated from the text.

[2] This list of addresses is written on the inside front cover of the first volume of Mayer's diary. During his western travels the artist seems to have met some of the individuals listed: Sonntag and Eaton were Cincinnati artists; Butler, Miss Lynch, Banning,

Tully Martin's — Mrs M^c Lean.

Albany — Delavan.

I. S. M^c Culloh, 37 Wall St. N. Y.

Anderson, Dodge, Swartworst, Darling, Duggan.[3]

Balt[imore] to Pittsburg —		313.	12.00	
			3.50	
Cincinnatti —	(470)	500.	6.00	fare
			4.50	
Louisville —	(141)	150.	2.50	fare
Nashville —		190.	7.00	fare
			2.00	
Smithland		200	1.00	fare
Cairo —		63	7.00	
S^t Louis —		177	11.00	
Missouri —		180	10.00	fare
		30	4.00	
		30	8.50	fare
			10.00	[4]

F. B. Mayer S^t Paul, Minnesota. June 23rd 1851.[5]

Richmond, Jackson, and Dulany were among Mayer's fellow passengers on the "Excelsior"; he probably was with Balentyne on the stage between Cumberland and Brownsville, and with Hall in Louisville. See *ante*, p. 30, 44, 45, 52, 89. Dana was a well-known artist.

[3] The foregoing list is written in pencil on the final page of volume 1 of the diary.

[4] This table of expenses is on the inside back cover of volume 1 of the diary.

[5] This notation is on the inside front cover of volume 2 of the diary. The date corresponds with that of a notation on page 3 of

The raft. Ohio
The Island. Moonlight Mississippi
(The welcome.)
The departure.

Spanish — Texas.
The distant camp.
" deserted " .
" Shawnee woman — camp scene
The mission — Windriver Mts.
 " "
The caravan — prarie — Nebraska
The portage — Minnesota. Gabriel.
Winter The hunter's lodge " — "
 " Evangeline
The log-cabin. "
The sentinel.
The battle field.[6]

Daniels & Smith — N 6th St
Long's 2 Expdn
Stanwix hall, city hall. Albany.
plates of the vatican — " —
Schoolcrafts' Indian in his wigwam.
Tribune buildings New York.
A. S. Barnes & Co 51 John St make Journals &c

this volume. See *ante*, ch. 6, f.n. 13. The four lines that follow
are written upside-down in pencil at the foot of the page.

[6] This list is written upside-down on the first page of volume 2
of the diary, facing the inside front cover.

Brooch. P. Chouteau Jr & Co — N Y.

Lennox. N Y has a " Turner."

Phila — Bodmer's book & plates in Graham.

C. de Montréville, M D. 61 Fourth St St Louis Mo

Mrs N. S. Ruggles, Thames St New Port, Rhode
Island — Richmonds aunt.

[Thos Keeling — La Crosse.] [7]

Col. W. C. Henderson. Piquea, Lancaster county, Pa

Dr Thos Foster — St Paul. Minnta [8]

O my son, my son, he had pity on me
He fed me, he clothed me &, when I was sick he cured
me. [9]

[7] This name and address are written in pencil.

[8] The foregoing lists of addresses and notations appear on two
facing pages at the front of volume 2 of Mayer's diary. The right-
hand pages of this volume have been numbered in pencil; the last
five addresses listed here appear on page 2. The notations on the
left-hand page are written in pencil. Mayer's interest in art and
in western travel is reflected in some of the notations. The second
expedition into the Minnesota country of Stephen H. Long, in
1823, took that explorer up the Minnesota Valley, the region that
Mayer visited when he went to Traverse des Sioux. The expedi-
tion is the subject of a work by William H. Keating, entitled
Narrative of an Expedition to the Source of the St. Peter's River
(Philadelphia, 1824). Henry R. Schoolcraft, Indian agent, ex-
plorer, and student of Indian life, published *The Indian in His
Wigwam, or Characteristics of the Red Race of America* at Buffalo
in 1848. A folio of eighty-one plates by Charles Bodmer, repre-
senting Indian life, was issued with the London edition of 1843 of
Travels in the Interior of North America, 1832–1834, by Maxi-
milian, prince of Wied. Henderson and Dr. Foster were members
of the party that went to Traverse des Sioux. See *ante,* p. 145.

[9] This notation is written in pencil at the top of a page of

St Pauls to Galena — 5.00
Galena to Chicago —
Chicago to Buffalo — 18.
Buffalo to Albany — 10.
Albany to Saratoga — 2.
Albany to New York — 1.50
N. York to New Port — 4.4

Tahawatona, the young buck
Chiochincha — " grouse
Tiukata — the crooked horn
Ashton White —
Lahtonkahwahaghea, or the man who comes to see
the buffalo.
Henderson
[Quosta-washta — the batchelor] [10]
Tyler Wechasta washtag.
Tatonkawahaghee [11]

Indian prospects

volume 2 facing page 64, which is blank in the original diary.
Mayer quotes these remarks in his narrative, *ante*, p. 165. Some
notations in pencil on page 63 are so faint that they cannot be
read.

[10] This line is crossed out in the original diary.

[11] These accounts and names are written in pencil on a left-
hand page facing the inside back cover of volume 2 of the diary.
White, Henderson, and Tyler were present at the treaty negotia-
tions at Traverse des Sioux. According to Goodhue, Tyler was
known to the Indians as "Shasta Wasta." *Pioneer*, July 17, 1851.

Indian religion — the contrary god.
 " marriage —
 " meals —
 " names.[12]

 5
 10
 10
 10
 5
5 10
 ——
 50
 20
 ——
 70 – 85

[12] These notations and the figures that follow are written in pencil on the inside back cover of volume 2 of the diary.

Part 2

*Mayer and the
Treaties of 1851*

Introduction*

MORE THAN FOUR YEARS after the Minnesota Histori-
cal Society published Frank B. Mayer's diary and
sketches in 1932 under the title *With Pen and
Pencil on the Frontier in 1851*, a news release called atten-
tion to a manuscript diary in the possession of the Ameri-
can Museum of Natural History in New York City. Accord-
ing to this release, which was issued by "Science Service,"
the diary had been "pronounced one of the most valuable
records written about American Indians, by no less an
authority than Dr. Clark Wissler," curator of the muse-
um's department of anthropology. The writer of the rec-
ord, who told of "Minnesota Indians living in wild and
unsettled territory," was none other than Mayer. Here,
obviously, was another version of the diary published by
the society from the original in the Ayer Collection of the
Newberry Library in Chicago.

Correspondence with Dr. Wissler brought not only
information about the diary, but a generous loan of the
original manuscript. Its three volumes have been badly
damaged by fire, the first being charred to such an extent
that short extracts only can be deciphered. The manuscript
passed through the Baltimore fire in 1904, when it was
among the papers of the late Henry Walters. After his

*This piece was first published in *Minnesota History* 22 (June 1941):
133–156.

death in 1931, the contents of his office, including the diary, were purchased by Mr. Morgan Marshall, administrator of the Walters Art Gallery of Baltimore, who presented the Mayer manuscript to the American Museum in the spring of 1936.[1]

This new version of the Mayer diary proved to be a copy made by the artist himself, evidently with a view to publication. That Walters had owned such a copy was known in 1932, but at the time it could not be located.[2] The original journal in the Newberry Library is incomplete, ending abruptly with the entry for July 18, 1851, the day that the treaty negotiations opened at Traverse des Sioux. The copy now for the first time available continues to October 22, and includes accounts of the treaty negotiations at Traverse des Sioux and Mendota and of the author's return journey via Chicago, the Great Lakes, and the Hudson River to New York and Baltimore. Since these sections could not be included in the volume published in 1932, it seems appropriate to publish the portions relating to the treaties this year, for the ninetieth anniversary of the Indian land cessions of 1851 will be marked in the summer of 1941.

A careful comparison of the American Museum's copy with the published version reveals that the earlier sections are in most respects identical. These are the parts that were

[1]Dr. Clark Wissler to the writer, October 21, November 2, 1936; interview with Dr. Wissler, February 10, 1937; Miss Dorothy Miner, librarian of the Walters Art Gallery, to the writer, September 16, 1937.

[2]Bertha L. Heilbron, ed., *With Pen and Pencil on the Frontier in 1851: The Diary and Sketches of Frank Blackwell Mayer*, 20–22 (St. Paul, 1932). For a detailed description of the diary in the Newberry Library, see p. 24–26.

most seriously damaged, but enough of the text remains to establish the resemblance between the two versions. Certain sections of the newly discovered copy, which seems to have been prepared many years after the journey that it describes, have been expanded, and the author has added bits of information that are of interest and value.[3]

Probably with an eye to attracting readers in Minnesota, or even a publisher for his manuscript, Mayer worked into the narrative some comments on the climate, soil, and scenery of the state. He writes:

Th[e] soil and climate of Minnesota a[re] said to be well adapted to the production of [MS. burned] cerial grains an[d] [par]ticula[rly vege]tables. The climate is as healthy as any in America and this will always be a[n] attraction to the emigrant. The winters ar[e] long and dry, the temperature being low but equable. Mocassins are worn the whole winter, the snow soon becoming frozen and hard and dry. The summers are short and at midday very warm.

The praries, constitute a class of scenery peculiar to America, the term denotin[g] a large tract of country devoid of tim[ber] and covered with long wild grass, not necessarily level, yet, as a gener[al] rule, approaching that condition. Th[e] idea of space, an important elem[ent] of the sublime, is the poetic attrib[ute] of the prarie. That peculiar cha[rm] which the ocean exerts over th[e] mind is likewise felt on thes[e] land-seas. (If I may so speak) [of] the [end]less fields of waving grass. Her[e are] all the atmospheric "effects" of dista[nce] and the gorgeous tints

[3]Facing the entry for July 24, 1851, is a clipping about Riggs's *Dictionary of the Dakota Language*, from a newspaper of February 24, 1894. This may indicate that the American Museum's copy of the diary dates from the 1890's.

of the settin[g] sun are exhibited in perfection. . . . The
shadows of the passing clouds and gathering of the future
stor[m] gives a variety to the colour of the praries which
greatly redeems the monotony of perfectly equable
colour.[4]

A substantial addition to the entry for June 21 deals
with the Sioux medicine man and his method of adminis-
tering to a patient. Mayer relates that he "was a witness"
to the incident that he describes. "Hearing noise in a tee-
pee which was pitched near the house [of] the interpreter
at Fort Snelling, I cr[awled] cautiously to the spot, and
protecte[d] by the darkness, lay quietly agains[t] the side
of the tent and applying [an] eye to a small orifice, which
exis[ted] opportunely in the old skins, I h[ad] full view of
the transactions of t[he] interior unobserved," Mayer
writes. There he saw several natives "grouped aro[und] a
smouldering fire," with the "octogenarian mother-in[-law]
of my host stretched on a few s[kins] and covered by a
blanket." Attending the patient were her daughter, a
granddaughter, and "Hoosaneree, (Grey leg) the uncle of
'Little Crow.' " The latter's "hair was dishevelled and his
blanket was thrown over his shoulders, for he was divested
of his shirt and leggins and the night was not warm. A rat-
tle, m[ade] of a gourd with a few beads within and a bowl
apparently containing water were near him." Soon "he
began his incantations" with a long series of strange sounds
that Mayer attempts to record, "all the time using the rat-
tle to a certain extent in harmony with the measure and
sentiment of his song, now fast, now slow, now shakin[g]

[4]From the entry for June 27, 1851.

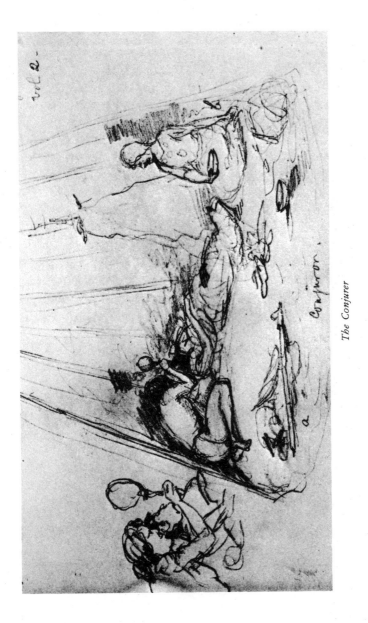

The Conjurer

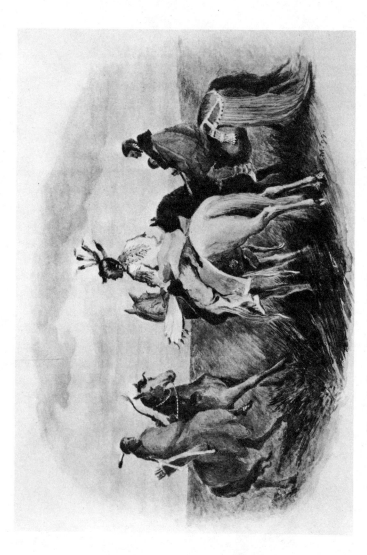

Sisseton Indians at Traverse des Sioux (Goucher College, Baltimore)

it and then giving it a rotary m[otion]."[5] At times he raised the cup to his lips and by "blowing into it, or by some other m[eans] produced a gurgling sound, nev[er] ceasing however to use the rattle." Once the medicine man "pronounced a short speech . . . addressed to the intruding spirit." He "applied his mouth and then his ear to her ear and temple and, as tho' endeavoring to scare away the animal within, he imitated the bark and grunt of a dog or some animal in pursuit." Mayer "never lear[ned] whether D[r] Hoosaneree's treatment w[as] successful in curing" the patient.

The excitement occasioned by the arrival of the Sisseton Sioux at Traverse des Sioux on the afternoon of July 4 is vividly pictured by Mayer.

> They had come from the neighborhood of "Lake Travers[e]" and "Lac-qui-parle" and were buffalo-hunters. The buffalo still vis[its] their country and they are there[fore] in a much better condition th[an] the Indians at this place who are probably the most degraded of the Dakota. These Indians of the plains possess more of their origi[nal] character and appearance than a[ny] I have yet seen. They are talle[r] more muscular and wilder in expression of their countenance [and] in their dress and habits. . . . They brought with them their wives, children, dogs, horses and lodges.

The picturesque costumes of these plains Indians, both men and women, and the trappings of their horses, with their elaborately ornamented saddles, are described. "On

[5]Mayer's sketch of this scene, which is in his Sketchbooks, 45:34, is reproduced herewith.

one of these horses the fringes of the saddle reached to the ground and concealed entirely the hindquarters and legs of the animal," writes Mayer.[6] Soon after their arrival, there was a "fine display of the costumes and appearance" of the Sisseton, for "they came in a body, mounted, and on foot, men, women, and children to be presented to the Commissioners by their trader *Laframboise*."[7] At their head was their young chief, the Male Raven, in full regalia. Among his followers "were several Indians of giant stature over six feet, muscular, robust, and straight. One of these" Mayer considered the "grandest Indian I have ever seen or expect to see. There were others who were nearly equal to him, and a large crowd but little inferior, who alighted i[n] our camp and in dignified silen[ce] shook hands with the commissioner[s]." They then "passed the pipe," listened to a speech of welcome, and were presented with "an ox that they might stay their voracious appetites, which they represented to be greatly aggrava[ted] by a long fast and tedious journey."

On the following day the Sisseton again visited the

[6]Sisseton horsemen are pictured by Mayer in a water color reproduced herewith. The Minnesota Historical Society has photographic copies of a collection made in the late 1890's and now owned by Goucher College, Baltimore. It is described *ante*, 13:408–414.

[7]At the time of the treaty, Joseph Laframboise had been trading among the Sioux of southwestern Minnesota for almost thirty years. In the 1850's, his post was at Little Rock on the Minnesota River near Fort Ridgely. See Willoughby M. Babcock, "Up the Minnesota Valley to Fort Ridgely in 1853," *ante*, 11:175. For an explanation of the role of the traders at Traverse des Sioux, see William W. Folwell, *A History of Minnesota*, 1:282–284 (St. Paul, 1921).

camp of the treaty makers. Mayer describes their arrival as follows:

> They were preceded by a rank of horsemen who advanced abreast beating their drums and singing a wild war-song as they approached our camp at a stately walk, the horses seeming nowise annoyed by the din which beset their ears. The effect was very wild, this cavalcade of savage musicians, in their wild dress and paint, mou[nted] on spirited horses and singing [a] loud shrill monotonous chaunt [as] they advanced abreast . . . appearing and then almost concealed as they rose and fell with the undulations of the surface.

When they reached the camp the musicians seated themselves on the ground and the others "joined in a grand 'hop-dance' or begging dance." After they had danced for some time, "the Governor presented a blanket to the chief's brother, who throwing it over his shoulder and holding it aloft, marched aroun[d] the camp singing the praises of [the] donor and his thanks for the g[ift.][8] Tobacco was also distributed and they returned to camp apparently plea[sed.]"

Camp life at Traverse des Sioux is the subject of some of Mayer's comments. "Our meals were prepared and eaten in a deserted trading house," he relates in the entry for June 30, "a few boards on tressels and rude benches covered with buffalo robes serving as table and chairs. Our fare, beef, pilot bread, and occasionally vegetables, i.e.

[8]This scene probably is the one pictured in Mayer's water color entitled " 'Singing a present' Sisseton Camp."

potatoe[s] and cabbage." He expands the entry for July 1 as follows:

> Many picturesque incidents occur during the evenings of our camp life. Our supper usually takes place about six o'-clock but by no means at dark for in this northern latitude the day lasts from three in the morning to nine at night. . . . Later as the twilight sinks into night and the prarie becomes alive with myriads of *fireflies*, the plaintive sounds of the flute are heard as some love-sick swain seeks to soften the heart of an obdurate maiden. (This is the only Indian instrument of music which has the least pretension to melody, all the others being as harsh and rude as can be imagined.)
>
> Then also the fires are lighted that the smoke may prevent a too near approach of the multiudes of musquitoes who wage a war agains[t] us, especially at night, tho' th[ey] never cease their attacks. . . . The fires scattered here and there ove[r] the prarie amidst the teepees and tents, surrounded by the picturesqu[e] figures of Indians and frontier life, presents examples of the striking in "chiaro oscuro" and "effects" which so delighted the minds of Rembrandt and his compeers. The "sharp" and massive effects of the centralization of light are here seen in perfection. A peculiar effect is presented by the transparancy of the skins of the teepees, the fire within rendering them luminous and the shadows of the inmates are seen as they sit aroun[d] the interior. . . . The same eff[ect is se]en in our own camp where the . . . tents are illuminated by the candl[es] that Mr So and So uses to write his wife by.

Songs, especially those of the French-Canadian voyageurs, resounded through the camp of an evening. "I was unsuccessful in procuring any comple[te] records of these musi-

cal rarities," writes Mayer, "the politeness of many of my French friends consisting rather in smiling promises than a conscientious fulfillment." A few snatches of a "Canadian Voyageur song" do, however, appear in one of Mayer's sketchbooks; it is followed by some bars of what he calls the "Chanson du Nord." Mayer comments that the "French is admirably adapted to songs of this class and indeed offe[red] a strong contrast to our sturdier tho harsher English."

The artist seems to have been on friendly terms with both Indians and whites in the camp. On one occasion, he notes, "an Indian came to me and led me to a group of his companions near by who directed my attention to the outline of a figure cut with a tomakawk [sic] in the sod of the prairie. It was intended as a representation of myself and a few tufts of grass were placed to represent my beard. They all enjoyed my surprise amazingly and consider'd it a capital joke. There were four occasions on which I found myself the subject of their pencils it seem'd a rataliation [sic] for my treatment of them, and a mode of expressing the similar power which they possessed." Mayer was among the "especial favourites" on whom the Indians conferred "Dakota names." He reports that "our Kaposia friends arranged feathers in the ha[t] of A. S. H. White and myself a[nd] named us respectively 'Tiukatah' 'the crooked horn' from the crooked plume he sported, and myself 'Tahay-o-wotana' or the 'young b[uck'] my feathers resembling the direct[ion] of the sprouting horns of the young deer. I had previously received t[he] name of 'Ishtamaza'

or 'm[any] eyes' from wearing spectacles, bu[t] I am now universally known as 'Tahayowotana'."[9]

Mayer makes no attempt to present a detailed report on the treaty proceedings—his interest is in the red men and their habits, rather than in their relations with the whites who wanted their lands. That he felt the need for some report of the proceedings is apparent, however, for to his entry for July 18 he adds a statement that the "speeches of the commissioners . . . are appended, correctly reported by the Editor of the Pioneer." It will be recalled that James M. Goodhue, who established the first Minnesota newspaper at St. Paul in April, 1849, attended the negotiations and reported them for his paper. His account appears in the *Minnesota Pioneer* from July 10 to August 7. Mayer must have obtained and preserved a file of the paper, for clippings of the report of the treaty negotiations published therein are pasted on pages facing his own manuscript narrative, beginning with the entry for June 30. It is followed by a report, also from the *Pioneer*, of the proceedings at Mendota. Mayer describes Goodhue as "our Fallstaff e[ditor] of the Pioneer" and speaks of his "enlive[ning] influence" in the camp at Traverse des Sioux.[10]

Mayer followed the account of the treaties and of his sojourn at Fort Snelling with a detailed description of the return journey to Baltimore. The end of his travels must

[9]These comments have been added to the entries for July 1 and 5.

[10]This is in the entry for July 11. Unfortunately this portion of the diary is almost completely obliterated, and most of Mayer's comments on the picturesque editor are lost.

have found him in a philosophical frame of mind, for he concludes his narrative as follows:

> In completing the memoranda of a journey which, I trust, has added to my experience of life, fostered a taste for the beautiful, and developed a stronger feeling of nationality, I have endeavoured to give an unexaggerated statement of the scenes I have witnessed and I hope I shall not be accused of having told "A Traveller's tale."

The spelling, punctuation, and capitalization used by the artist in his original manuscript have been followed. An effort has been made to supply within brackets words or parts of words that are missing in the burned pages. No attempt has been made to reproduce the many numerical notations that appear in the margins; they refer to volumes and pages in Mayer's sketchbooks, which he numbered with methodical care.[11] At the beginning of the third volume of the American Museum's manuscript, Mayer gives a list of seventy cuts to be used in illustrating his journal. It is gratifying to note that a large number of the drawings selected by the artist himself were reproduced in the volume published by the Minnesota Historical Society in 1932; others appear herewith.

The importance of the treaties of 1851 to the pioneer settlers of eastern Minnesota can hardly be overestimated. After their ratification in the following year, a vast empire embracing most of the present state south and west of the Mississippi River was thrown open to settlement. The

[11]For a description of the Mayer sketchbooks in the Newberry Library, see the published *Diary*, 23. Volume 45, which was in private hands in 1932, has since been added to the Newberry Library's collection.

treaties served as a prelude to the hordes of land seekers, town-site promoters, lumbermen, millers, homemakers, and the like, whose arrival on the upper Mississippi made possible Minnesota's admission to statehood before the end of the decade. One man who appreciated the significance of the acquisition of the Sioux lands was Goodhue. "The news of the Treaty exhilirates our town," he announced in the *Pioneer* after the conclusion of the negotiations at Traverse des Sioux. He then went on to predict what the treaty would mean to Minnesota and St. Paul in the future:

> It is the greatest event by far in the history of the Territory, since it was organized. It is the pillar of fire that lights us into a broad Canaan of fertile lands. We behold now, clearly, in no remote perspective, like an exhibition of dissolving views, the red savages, with their tepees, their horses, and their famished dogs, fading, vanishing, dissolving away; and in their places, a thousand farms, with their fences and white cottages, and waving wheat fields, and vast jungles of rustling maize, and villages and cities crowned with spires, and railroads with trains of cars rumbling afar off — and now nearer and nearer, the train comes thundering across the bridge into St. Paul, fifteen hours from St. Louis, on the way to Lake Superior.[12]

Mayer's interest in the negotiations of 1851 was of an entirely different kind; unlike Goodhue, he did not expect his own future to be identified with the great northern empire acquired on those summer days of 1851. He was an Easterner, an outsider who could take a purely objective

[12]*Pioneer*, July 31, 1851.

view of the epoch-making events he was witnessing. How he reacted to those events and what he thought of the proceedings at Traverse des Sioux and Mendota are revealed in the pages that follow.

BERTHA L. HEILBRON
MINNESOTA HISTORICAL SOCIETY
ST. PAUL

Frank B. Mayer
and the Treaties of 1851*

J ULY 23. *The Treaty signed.* This event was conducted with much dignity both on the part of the Indians and the commissioners. The commissioners having first signed the treaty, the chiefs stepped forward in rotation, and touched the pen which the secretary used to indite their names. This being their form of oath and acquiescence. Some few, who had been instructed by the missionaries, wrote their names, and many prefaced their signature with a short speech.

As they stood at the treaty table, their tall figures e[n]veloped in their buffalo robes, and conducting themselves with becoming dignity, they recalled the cope-clad presence of the functionaires of the Roman [c]hurch, or they reminded me of the classic creations of Raphael or [John] Flaxman as their blankets fell in massive or graceful drapery when they knelt to write their names, or awaited the withdrawal of their predecessors. One of the greatest advantages I have derived from my observation of the Indian costume is the power it has given me to realize or fully imagine the appearance and prevailing *sentiment* of costume among the Greeks and Romans, the costume best adapted to the highest class of art and susceptible of the most harmonious adaptation to any required circum-

* Reprinted courtesy American Museum of Natural History

226

stances. The ease and grace with which the Indian wears his blanket or robe is a constant study for the artist, often suggesting and realizing the most beautiful combinations of form and drapery..

As each chief signed the treaty, a medal, bearing the head of the president of the U. S., was placed around his neck by the commissione[r] and when all had signed, the commissioner addressed them in a valedictory of some length, and in the course of the afternoon a large amount of presents were distributed to them, consisting of blankets, cloth, powder, lead, tobacco, vermillion, beads[,] looking glasses, knives, trinkets &c.[13]

July 24. All were up "bright and early" to prepare for our departure and we were scarcely out before a large crowd of Indians made their appearance attired for the buffalo-dance. Large buffalo masks covered their heads and shoulders, giving them the wildest appearance imaginable, and they carried shields, spears, guns and fans. A number of old men and girls accompanied them, as musicians, and arranged themselves in two rows, while the others danced.

This dance was very similar to their former performance

[13]The United States acquired from the Sisseton and Wahpeton Indians all their lands east of the Bois des Sioux and Big Sioux rivers. On the east the boundary was the Mississippi north of Fort Snelling, the Minnesota, and the Blue Earth rivers. A tract "stretching from Lake Traverse down the Minnesota River to the Yellow Medicine and extending ten miles on each side of the former stream" was reserved for the use and occupation of the Indians. For this vast area in Minnesota and Iowa the government agreed to pay the Indians $1,665,000. Folwell, *Minnesota*, 1:281, and map, p. 324.

in the same character, except that their number were great-
er, and they confined their motions to a circl[e,] following
one another around, and then dancing opposite to each
other, occasionally resting thmselves on their haunches,
when they plied their *fans* vigorously. Whether this was an
imitation of the natural habits of buffalos, my knowledge
of natural history does not permit me to say, the effect of
a buffalo fanning himself was, at least, peculiar. Many of
the performers had shields of a circular form made of
buffalo hide, very white, and ornamented with pendant
feathers and paint. They were highly prized and "unpur-
chaseable". Having received presents, they departed. Our
last breakfast in the old house having been hastily
despatched all hands were soon engaged in striking the
tents, securing our baggage, packing up Indian curiosities,
and making all the arrangements necessary for our speedy
departure. By twelve o'clock the last waggon load of
"traps" had arrived from the camp and was stowed aboard
the "keel-boat" which was to convey us to Mendota, (the
meeting of the waters), at the junction of the Mississippi
and Minnesota.[14]

The passengers, numbering fifty and including the com-
missioners, traders[,] tourists, French voyageurs and half-
breeds, and an educated Indian and his wife, having col-
lected aboard, we took a last look at Traverse des Sioux,
the remains of our camp, and the distant tepees, and with
three good cheers pushed into the stream, with light hearts

[14]"The commisssioners came down from Traverse des Sioux, in a Dur-
ham boat, every man working the oars," according to the *Pioneer* for July
31. "They made the run down, of more than 100 miles, in 24 hours."

for we were "homeward bound" yet almost regretting the termination of our novel camp life of four weeks,[15] confident we should seldom if ever again encounter such scenes as had delighted us during our sojourn together. As we "got under way" four lusty voyageurs tugged at the oars, Belland, that voyag[eur] of voyageurs took the helm or stern oar, Mr [Henry H.] Sibley was our captain, and all united in the full chorus of a voyageur boat song, "their oars kept time and their voices kept tune", as we floated down the glassy river, the air clear and bracing, the day bright and joyous. As "Belland" threw all his strength and skill into the guidance of the ponderous oar and ever and anon expanded his manly chest to the chorus of the boat song, his face full of animation and his form a model of manly beauty, he was the ideal of a voyageur. "Henry Belland" is the son of Canadian parents who reside in Montreal, but for years he has roved the praries and woods of the Northwest, through the wilds of Canada, th[e] lake country of Minnesota, the frozen regions of Pembina, and the trackless plains of Nebraska He had visited the mouth of the Yellowstone, and on horseback, on foot, in the canoe, in winter or summer, he was at home in all situations of frontier life.[16]

[15]The treaty party arrived at Traverse des Sioux on June 30. See Mayer's *Diary*, 148.

[16]This probably was Henry Belland, Sr., who was killed at the lower Sioux agency on August 18, 1862, the day that the Sioux Outbreak began. See Folwell, *Minnesota*, 2:109. Evidence that Belland was at Lake Traverse in the late 1830's is to be found in a manuscript article by John H. Case, among the latter's papers in the possession of the Minnesota Historical Society. For a portrait of Belland, see the published *Diary*, 94.

The native politeness and good feeling of the French-
man had never forsaken him, but by his wild and adven-
turous life had acquired a fascinating frankness, cheerful-
ness and generosity. The energy which distinguishes the
American pioneer, was engrafted on the *elegance* of his
French nature and that roughness which generally accom-
panies the backwoodsman of American birth was replaced
by the ease, grace and animation of the French *gentle-
man*[,] for *gentleman* applies not only to the man of edu-
cation and rank, but is rather the attribute of "nature's
own nobleman, friendly and frank, the man with his heart
in his hand". Such was Belland, and I shall long remember
him as [one] of the few *ideals* I have me[t in] actual life.
I do not say he was without faults, but they were such as
were incident to his character, the energetic, gay "voya-
geur". His form was of the most manly beauty, a tall, lithe
active, graceful figure, in which strength had not produced
heaviness. His face was oval and not fat, but yet sufficiently
thin to render expression delicate. A clear blue eye, open
brow, aquiline nose of *elegant* size, not too large, light yet
decided, a mouth, determined yet amiable, a chin of that
massive form and decided character, without which his
face would have been too delicate and almost feminine.
His hair was light golden colour and in clusters of flaxen
curls was played with by every passing breeze. He was in
the prime of life and full enjoyment of physical health. He
was always ready with a kind word, a joke, and an act of
generosity.

Among the passengers was "Enoch" or "Hanoch" as he

was generally called by the Sioux, an intelligent Indian who had been educated by the missionaries, having been sent to Ohio where he received a good English education. He still wears the Indian dress and is mostly engaged in teaching his countrymen. His pronunciation of English, which he speaks fluently, is remarkably sweet and soft, more so than in any *foreigner* I've heard.

He was a valuable companion of my rambles among the Teepees.

At intervals during the day the boat-songs were renewed and as we collected in groups on the deck various amusements sufficed to while away the time—conversation, recitation and songs.

The day closed with one of those beautiful sunsets peculiar to this northern latitude. So *holy* was its hue and so *pure* its sentiment of colour, it recalled that sky with which Raphael, in the "Madonna of St Sixtus", has surrounded the holy mother, which at a casual glance, seems but the blue ether, but seen nearer, resolves itself into innumerable angelic countenances. The long vista of prairie was a fitting fore ground to this lovely sunset, and a deer, which was startled by the splash of our paddles and bounded far off into the distance, seemed a harmonious incident to the *poem*.

We observed a peculiar appearance produced by a swarm of insects which was poised, in pyramidal form, from the top of a tall tree, rising in a cloudy cone some feet to the apex.

As night fell we heard the bark of the prarie-wolves, and

passed some encampments of Indians who had stopped for the night in the woods which bordered the stream. The evening was spent in listening to song and recital. [L. J.] Boury gave us Ingoldsby's "Lord Tom Noddy" with great spirit. [A. S. H.] White, Sibley and others united in "Sparkling and bright" "Health dear woman", "Down East" "Farewell to Moore" "Star-spangled banner" "Landlord fill &c", while throughout the night the greatest variety of voyageur songs inspirited the oarsmen, who were unremitting in their labours.[17] They were determined to be awake themselves, and permitted no one to be otherwise, for, at the end of every song, they varied the monotony of the chorus with an Indian yell which fully succeeded in destroying the slumber which we were seeking on the deck, wrapped in our buffalo robes. Three Canoes, filled with Indians, accompanied us until late in the night, their presence evinced by their wild war songs and the dipping of their paddles, while, in the intervals of song, the glimmer of the flint and steel, as they lighted their pipes, now and then revealed them through the starlight.

The occasional bark of a wolf and the indistinct foliage which concealed the winding river, added to the *poetry* of the scene, and formed an appropriate finale to our Treaty trip. The next day, at noon, we arrived safely at the fort, our flag floating from the bow and all uniting in a full chorus of the "Chanson du Nord", (and the "beau porte de S^t Malo").[18]

[17]A picture of the interior of the keelboat crowded with singers appears in Mayer's Sketchbooks, 43:30. It is reproduced herewith.

[18]For a detailed discussion of voyaguer songs, see Grace Lee Nute, *The Voyageur*, 103–155 (New York, 1931).

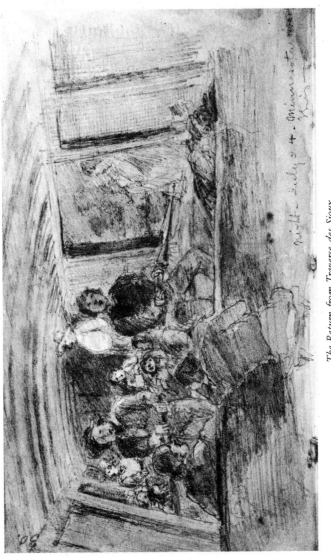

The Return from Traverse des Sioux

A Red River Half-breed

I shall long remember with pleasure my residence among the two thousand Dakotas assembled at Traverse des Sioux. Every day produced some novelty and enabled me to fill my sketch-book with many beautiful and interesting *hints* of savage life and appearance.

The great variety of *picturesque* subject rendered a choice difficult, and, for the first time in my life, I was nigh to be surfeited with the picturesque. Beside what my pen and pencil have preserved, my memory will long retain a deal which neither can represent. The delay which tired others was most fortunate for me and yet gave me no leisure moments. The treaty was concluded favourably to both parties, and is the first [since Penn's, it is said,][19] where no armed force has been in attendance. I have thus seen nearly as great a variety of Indian character as a journey of many hundred miles into the Indian country would have afforded me, and from what I have seen I can realize what *can* or *might* be seen. . . .

July 26. At Prescott's. Had an agreeable meeting with [George A.] Richmond, the Boston man I met on the Excelsior, a gentleman and talented. A parley with an old soldier of the garrison gave me many hints of frontier life—Texas and Mexico.

July 27. Attended drill of the troops in the morning. Two thirds of them are foreigners [and mere animals.][20] In the afternoon walked with B to S^t Paul. B is a very small man and a *Frenchman*, in its most peculiar signification.

[19]The words enclosed in brackets are written in pencil.
[20]The words enclosed in brackets have been crossed out with pencil in the original manuscript.

He cut a comical figure in trying to get through a swamp on the prarie. He was attired in sky-blue Paris pants and mocassin[s] and was very desirous to reach St Paul without wetting the last or soiling the first. In his perplexity he finally became transfix[ed] in the midst of the mire, (the prospect as discouraging as the retrospect), resting like a pair of three legged compasses on his pedestals and a large cane which he grasped in both hands, a perplexed brow and expanded eyes peering from among a long beard and a profusion of hair. Having got safely through, tho' with wet feet, I turned & beheld B in this attitude when I immediately lay on the prarie in a fit of immoderate laughter — my sense of compassion being destroyed by that of the ridiculous. B, however, at last made a desperate effort and emerged from the grass and mire.

July 29. Returned from St Paul, whither I went chiefly to see the "Red-rivermen", a caravan of whom had arrived with their skins and peltries. They were under the charge of Mr [Norman W.] Kittson, the trader at Pembina.[21] The Red-river half-breeds are descendants of the French,

[21]Opposite this point in the manuscript, Mayer gives the following reference: "vide. Congressional doct Ex. Doc. No 42. Senate. 31 congress. 1st Sessn." The document is Captain John Pope's *Report of an Exploration of the Territory of Minnesota* (serial 558). Pope, a member of an expedition under Major Samuel Woods that explored the region between Fort Snelling and Pembina in the summer of 1849, includes in his report descriptions of a Red River train and of the half-breeds and their settlements. For a detailed account of "Norman W. Kittson, A Fur-Trader at Pembina" by Clarence W. Rife, see *ante*, 6:225–252. Kittson, who was associated with Sibley in the fur trade, established a post at Pembina in 1844. "The annual caravan from the Selkirk Settlement arrived" at St. Paul about July 18, according to the *Pioneer* of July 24, 1851. Abundant evidence of Mayer's interest in the Red River train is to be found in his

Scotch, and English who constituted Lord Selkirk's settlement on the Red river, and who took to themselves wives of the neighboring Indians, Chippewas and Crees. A portion of these half-breeds have settled within the boundary of the U. S. at Pembina, a point on the "Red river of the North" a few miles south of our boundary. They are tall, fine looking men, generally, presenting a mingled resemblance to their ancestors. They are almost exclusively employed as hunters and trappers, the buffalo being the favourite object of their pursuit. The women produce the most beautiful garnished work of beads, porcupine quills and silk, with which they adorn leathern coats, mocassins, pouches, saddles &c. Until within a few years they have been entirely dependant on the "Hudson's bay Company" for their supplies and trade, but of late they have directed their attention to intercourse with the settlements here, and have found it greatly to their advantage to do so, for their caravans or trains have annually increased in number, and now two hundred carts make the yearly pilgrimage across the praries, six hundred and fifty miles, to St Paul.[22] Their carts are rudely made of wood, no iron being used in their construction, the fastenings and clamps being of raw-hide or pegs of wood. They are drawn by a single ox, or horse, in shafts and carry from eight hundred to a thousand pounds.

sketchbooks. Three sketches obviously made at the Red River camp in St. Paul are reproduced with his *Diary*, 57, 58; another appears herewith.

[22]The *Pioneer* of July 24 estimates that the Red River train of 1851 consisted of only about a hundred carts. Mayer also exaggerates the distance from St. Paul to Pembina, which according to Pope, was 446½ miles. The latter gives a table of distances in his *Report*, 42.

They are laden with buffalo hides[,] *pem[m]ican*, (which is the dried buffalo meat chopped fine and consolidated by putting it in a skin bag and pouring melted tallow over it, so that It constitutes a very compact and nutritious food to the hunter and traveller in these northern regions), peltries, fur, embroidered leather coats[,] mocassins, saddles, &c. These they sell or exchange at S[t] Paul[23] and return again to their secluded home where, nine months of the twelve, they experience the intense cold of a northern winter. The thermometer sinking often to 40° below 0. Pembina is the most northern settlement of any consequence in the United States.

They are a wild, picturesque race, and they are hardy and athletic. Their costume partakes of the character of their genealogy—*mixed*. The Scotch bonnet, adorned with plaid and ribbons, is much worn and the rest of the costume differs but little from the voyageur dress. Mr Belcour[t], the Catholic priest who resides among them, is an intelligent and affable gentleman.[24]

The Governor of Minnesota and suite, accompanied by the dragoons from F[t] Snelling, will leave here soon after

[23]The carts that arrived in 1851 were "not all heavy loaded," according to the *Pioneer* of July 24. The newspaper reports, however, "that a considerable sum of money came with the train, which is intended for the purchase of goods."

[24]For a sketch of the Reverend Georges A. Belcourt, see *Minnesota Historical Collections*, 1:240–244 (1872). Belcourt went to the Red River country in 1831 and he established the Pembina mission in 1849. Two letters by Father Belcourt are included in Major Samuel Woods's report on the *Pembina Settlement*, which is published as 31 Congress, 1 session, *House Executive Documents*, no. 51 (serial 577). Both deal with the Red River settlements and the people who lived there.

the treaty, at present being negociated at Mendota, is concluded, and proceed to Pembina for the purpose of effecting the purchase of the lands adjoining Pembina, and inducing the halfbreeds to become citizens of the United States.[25]

While at S[t] Paul I made the acquaintance of Jno. W. Quinney and two other chiefs or *sachems* of the Stockbridge Indians.[26] The Stockbridge Indians are the last remnant of the once powerful tribe of the *Muh-he-con-new* or Mohicans[27] who occupied the whole territory between the[28] Hudson and the Connecticut at the time of the discovery by Europeans of this country. A portion of this tribe congregated at Stockbridge [?Conn[t]],[29] about the year 1720 for the purpose of missionary instruction, and it is the descendants of those alone who embraced Christianity and civilization who endure to the present day. At the close of the Revolutionary war, they were

[25]The treaty that Ramsey negotiated with the Chippewa at Pembina was signed on September 20, 1851. The Senate, however, failed to ratify it in June, 1852, when the Sioux treaties of 1851 were approved. Folwell, *Minnesota*, 1:288, 291.

[26]An obituary sketch of John W. Quinney, who died at Stockbridge, Wisconsin, on July 21, 1855, appears in the *Wisconsin Historical Collections*, 4:309–311 (1859). A reference to "Cong[l] Doc. 1830," appearing on a page that faces this point in the original manuscript has not been located.

[27]Muheconew—i e good canoemen [*author's note*].

[28]Quinney said "southern New York and New [Eng]land" [*author's note*].

[29]The word enclosed in brackets has been added in pencil. It is, however, incorrect, for the original Stockbridge mission was in Berkshire County, Massachusetts. The Indians went there in 1736 and left in 1785. Frederick W. Hodge, ed., *Handbook of American Indians*, 2:637 (Washington, 1912).

removed to lands in Western New York, provided for
them by Government, they having assisted the colonists in
their struggle for independence. In 1820 they were again
removed to "Green-bay" and now are seeking a last resting
place in Minnesota, the government having promised
them a *permanent* home. I understand that a dispute hav-
ing arisen among them, a portion have determined to
remove hither, while the remainder retain a portion of
their possessions in Green-bay.[30] Those who are coming
here will become citizens of the U. S, the others refusing
to join with them in such a move, & hence the dispute

They are perfectly civilized, adopting civilized dress and
habits, and governed by a code of Laws and Sachems of
their own choosing. Their numbers do not exceed one
thousand. The Sachem, Quinney is an intelligent, gentle
and somewhat reserved man, with features strongly In-
dian, tho mild in expression.[31]

29 July. The Treaty with the lower bands of the Sioux
at Mendota, progresses but slowly. A faithful report of the
proceedings is appended.[32]

July 30. To day the Indians celebrated a "*brave-dance*"

[30]The removal to Green Bay took place in 1833. The plan for a settle-
ment in Minnesota does not seem to have materialized. Some of the
Stockbridge Indians were removed in 1856 to a reservation in Shawano
County, Wisconsin; those who desired to become citizens settled in the
town of Stockbridge. Quinney was among the latter. Hodge, *Handbook
of American Indians*, 2:638; *Wisconsin Historical Collections*, 4:309.

[31]On a page facing this point in the manuscript, Mayer notes a
"Sketch-portrait" of Quinney.

[32]On the left-hand pages throughout this portion of the diary are
pasted clippings of the detailed report of the negotiations at Mendota
that appears in the *Pioneer* for August 7 and 14, 1851.

before the commissioner None but Warriors can partici-
pate. They were all divested of clothing, with the excep-
tion of the usual covering of the loins which is never laid
aside, except in young children. Their he[a]ddresses and
ornaments were similar to those used in the ball-play, tho'
richer and more profuse probably more picturesque than
on any other occasion. Each one carried a weapon or bow
& arrows in one hand, and in the other, a rattle. They
formed a large ring, listened to speeches and danced. It
was a more symmetrical arrangement than any I have seen.
All stood in a ring for some time singing in chorus and rat-
tling and then, at a signal, all began to dance in a mingled
confusion, and then again returned to the ring, listened to
a speech, sang, &c. They received presents of tobacco &c
as usual.

The view from Pilot Knob, once a favourite burial place
of the Sioux, is very extensive, commanding the valley of
the St Peters, the Mississipp[i] Fort Snelling, St Paul and
St Ant[h]ony.

Sketch'd the view, and an Elk belonging to Mr Sibley[33]
and saw a *black* sq[u]irrel, a quadruped peculiar to the
West. Attended Treaty, virgin-feast, & sketched Odell's
wife—a very handsome graceful half-breed.[34]

[33]Mayer's sketch of the view from Pilot Knob is reproduced in his
Diary, 35. In the *Pioneer* for August 7, 1851, Sibley's captive elk is
described as a "very large fine animal, with a terrible weight of antlers
upon his head." It was "kept in a high enclosure, and tied with a halter."
[34]Mrs. Thomas S. Odell was the daughter of an army officer and a
native woman. Her husband went to Fort Snelling as a soldier in 1841,
settled in St. Paul in 1846, and built a trading store and house in West
St. Paul in 1850. See T. M. Newson, *Pen Pictures of St. Paul*, 51 (St.
Paul, 1886). Mayer's sketch of Mrs. Odell is in his Sketchbooks, 44:44.

The "half-breed" women are almost invariably comely, tall, and graceful.

August 5th The treaty was to day signed.[35]

Sketched Teepees at Mendota in company with Mr Geo. W. Woodward of New York, a gentlemanly fellow and fond of Art.

What was my surp[r]ise on examining a fine buffalo robe I had purchased of an Indian and left in the dingy office at the interpreter's, to find that the rats had made sad inroads in it. Several large holes now marred it's former beauty . . .

July [sic] 6–7. The two last days have been occupied in paying the Indians a large amount due to them, by the stipulations of the late treaty.[36] The amounts were distributed to heads of families in proportion to the number of persons in each. The distribution is made by the Indian agent, interpreter, and clerks, who sit at the long table in Prescott's hall, and the Indians and half-breeds crowd

[35]"The Treaty with the lower bands of Sioux, was signed at Mendota, last Tuesday afternoon," according to the *Pioneer* of Thursday, August 7, 1851. "Little Crow, who writes his own name, led off," the account continues. He was followed by Wabasha. In all, sixty-four chiefs and warriors signed the treaty. A detailed report of the speeches and proceedings of August 5 appears in the *Pioneer* for August 14.

[36]The terms of the Mendota treaty are given in Folwell, *Minnesota*, 1:284, and in the *Pioneer* of August 7. Much of the area west of the Mississippi and east of the Minnesota and Blue Earth rivers was ceded by the lower Sioux. The newspaper notes that on the day following the treaty, the "Indians were paid in cash $30,000, being part of the funds unpaid to them, and remaining due, as arrearages, by the terms of their treaty of 1837." Dr. Folwell relates that "not many days passed before substantially the whole amount was in the hands of the traders and the merchants of St. Paul." *Minnesota*, 1:287.

around. The house [in]side and out is swarming wit[h] red-men, squaws and papooses, who smoke, talk, sleep and squawl in every posture and tone.

In the evening I saw a fine display of that inexplainable phenomenon, the "Aurora Borealis". The rays shot upwards in sprays of vivid light and were distinct. This phenomenon and that of the "*double suns*" are witnesssed here in great perfection during the winter.

July [sic] 7. Rode to St Anthony. As we crossed the prarie a large wolf was seen sitting in the road immediately before us. As we approached, he walked deliberately to one side of the road and seated himself at a convenient distance, where he watched us complacently, as we stopped to look at him. Having no arms, we could not attack him. He is a well known prowler and his impudence is noted.

The falls of St Anthony extend, in a nearly strait line, across the Mississippi, being divided by an island which .extends about a mile and a half up the stream. The beauty of one portion of the fall has been almost entirely destroyed by the saw mill which has been built immediately above, and the other portion has lost much of its wildness & beauty by the lodgement of numbers of logs (upon the rocks and between the crevices) which have come over the falls during freshets, having escaped from the dam where they are collected to supply the Saw mills.[37]

[37]Franklin Steele built a dam across the east channel of the Mississippi at the Falls of St. Anthony in 1847, and in the next year he began operating a sawmill on the east bank. Settlement followed, and the village of St. Anthony, now a part of Minneapolis, developed. See Folwell, *Minnesota*, 1:229. On a page facing this part of his manuscript, Mayer gives

The height of the fall is not over twenty feet and the entire width of the river about half a mile.

The waters pour over in a flood of amber colour graduating into a snowy whiteness as it approaches the rocks beneath. The islands in the vicinity are covered with pine and other foliage, and below the falls their rocky sides present a picturesque appearance. The wester[n] side of the river has few trees and the country is prarie. To the East is the village of St Anthony with an elevated country at the back of it. It is destined to become a great manufacturing point, the water power being one of the finest in the world. This will be applied, however, at the expense of the beauty of the scenery of the Falls which, when first viewed by the whites, must have presented a beautiful appearance. The presence of saw mills, dams, races, and logs, will soon destroy its beauty entirely, I fear. The falls are over ledges of sand stone, the channel is level and of solid rock. The falls seem to have been gradually receding from the junction of the Minnesota to their present position.

Another fall called the Little Falls, formed by the descent of a small creek into the Mississippi, a few miles below St Antony, & near the [latter?] tho' of small size, is very beautiful. The stream is precipitated from the level of the prarie to the bottom of a ravine the distance of over fifty feet. Thence it flows through foliage and rock to the Mississippi. This beautiful fall is destined to meet the fate of its "big sister", the falls of St Antony (which the Indians

a reference to "Ex. Doc. 42 Senate, 1850." He doubtless had turned to Pope's *Report*, 14 (serial 558) for a description of the falls and an account of lumbering operations there.

call *Minne-ha-ha* "the laughing waters".),[38] for its advantages as a motive power will not permit it long to remain in idleness after our Government disposes of the military reserve on which it is situated. I regret that sickness prevented me from making a careful sketch of this beautiful spot before such a change takes place.

The inhabitants of the village of S[t] Antony present marked features and character which at once indicate their origin to be New England and especially "down East from the state of Maine", raftsmen & woodmen from the Kennebeck and Penobscot.[39]

I must surely be getting very *shabby*, for the hotel keeper told the servant to inform B that this "fellow" wanted to see him.

Fine clothes, I presume, are here considered indicative of gentility. Head ache at night, and next room very fond of the accordeon—trying—very. Saw the first specimen I have met of "Bloomerism". A very pretty girl with gipsy hat, short skirts and Turkish pants.[40] Can't fancy it.

[38]It was, of course, the Little Falls, not the Falls of St. Anthony, that the Indians called Minnehaha, the name that they still retain. Notwithstanding the remarks that follow, Mayer did sketch the Little Falls, for a view of them is included in his Sketchbooks, 44:27. He refers to it in the margin near this point in the manuscript.

[39]The lumber industry attracted to St. Anthony and to the St. Croix Valley a number of New Englanders. The role of the Mainite in the Minnesota lumber industry is discussed by Agnes M. Larson in an article entitled "On the Trail of the Woodsman in Minnesota," *ante*, 13:350, and by Richard G. Wood in a chapter on the "Emigration of Maine Lumbermen," appearing in his *History of Lumbering in Maine*, 233 (Orono, Maine, 1935).

[40]The bloomer costume for women was the subject of frequent comment in the *Pioneer* in the summer of 1851. "This is the prevailing cos-

The best writers on the "North West" are said to be McKenzie, Lewis & Clarke, Simpson (overland journey round the world) Fremont, Cha[s] A. Murray, Long's Exped[ns] Lanman & Catlin are considered *exceedingly* questionable authority.[41]

July [sic] 20. Having visited St Paul and transacted business there I returned to the Fort, my headache having increased and fever being thereunto added. The Doctor, McLaren, ascribes it to the miasmatic influence of the S[t] Peters and exposure to the Sun, which is intens[ely] hot at

tume for females at Traverse des Sioux," writes Goodhue in the *Pioneer* of July 24. "The costume may be seen daily in our streets worn by the natives. It is what Mrs. Bloomer claims for it . . . 'pre-eminently *American.*' " In the issue for July 31, the editor complains that "Every paper is filled with comments upon the Bloomer costume," adding that the "subject is worn to tatters."

[41]On a left-hand page facing this point in the manuscript Mayer wrote in pencil: "Artist-work on the Indians — Rindisbacher, ∠ Bodmer, ∠ A. J. Miller, Catlin, Stanley." Peter Rindisbacher, one of the earliest artists to picture the Minnesota country and its natives, is the subject of a sketch by Grace Lee Nute, *ante*, 20:54–57. Karl Bodmer was the artist who accompanied Maximilian, Prince of Wied, on his American travels and illustrated the latter's *Travels in the Interior of North America, 1832–1834.* Mayer studied with Alfred J. Miller; his work is discussed in the introduction to the published *Diary*, 6. George Catlin made two visits to the Minnesota country in the 1830's; he wrote and illustrated an extensive work entitled *Letters and Notes on the Manners, Customs, and Condition of the North American Indians.* More than a hundred and fifty pictures of western scenes and Indians were exhibited in various eastern cities by John M. Stanley in 1850 and 1851. In 1853 he accompanied I. I. Stevens on his Pacific railroad survey from St. Paul to Puget Sound. The writers mentioned in the text include Sir Alexander Mackenzie, Sir George Simpson, and John C. Frémont. The narrative of the Long expedition of 1823 was written by William H. Keating. This work and Charles Lanman's *Summer in the Wilderness* deal specifically with Minnesota. Mayer seems to have read widely in the field of western travel.

midday.[42] Twelve days sickn[ess in] such a place as Prescotts wa[s] calculated to induce a condition of "blueness" and "homesickness" unparalelled in my previous experience.[43] Without comfort, without sympathy, without friends, without amusement, with fever, with cold, with dirt, with disgust and with comparisons with home—I determined to stand it no longer, and as soon a[s] strength permitted me bid adieu to the worst quarters I ever occupied and took passage aboard the "Doctor Franklin N° 2" for S^t Louis.[44]

One of the last objects I saw as I left the Fort was "Gubbo", the half breed, mounted on a swift horse, with his blanket and buffalo robe on the saddle, his rifle across his

[42]In 1873 the Minnesota state board of health published a paper on the causes of "miasmatic diseases." "In marshy or miasmatic districts," according to this statement, "the disease cause . . . is liberated and disseminated by the heat of the sun in the spring." Ralph H. Brown, "Fact and Fancy in Early Accounts of Minnesota's Climate," *ante*, 17:257–259.

[43]For a description of Philander Prescott's house at Fort Snelling, where Mayer lived both before and after going to Traverse des Sioux, see his *Diary*, 136–141. In the unpublished version of the diary, under date of June 24, 1851, the artist gives a more detailed description of his quarters. "In harmony with the apartmen[t] was its furniture," writes Mayer. His own bed was very unsteady; beside it were a "chair, minus a back, and an adjoining bedstead, occupied by an individual who was subject to frequent attacks of lunacy & who talked in his sleep of incoherent horrors." The rafters were hung with "herbs, cast-away garme[nts,] old furs, and skins deserted by the moths for lack of nutriment. . . . The floor was of unplan[ed] boards and were not secured to the joists, so that many a trap was laid for the stranger's legs which might easily have pierced the ceiling beneath. The eaves were stowed with old boxes, trunks, &c which I never looked into; and the huge stack of two chimneys filled the centre of the loft."

[44]The "Dr. Franklin No. 2" arrived in St. Paul on the morning of August 23 and left the same evening. *Pioneer*, August 28, 1851.

knees, and waving me good bye, as he scampered over the prairie on his way to overtake the Governor and suite, who had left a few days before for Pembina and the Red river of the North.[45] Had I felt well I should have envied him the pleasure but as it was, I did not.

At S^t Paul we took on board a large number of furs which had been brought by the Red river men, and were the property of "Pierre Chouteau J^r & C°," who constitute the American Fur C°, & to whom almost all the Traders in our Indian country are more are [or] less subordinates.[46]

August 23. left S^t Paul and on the 27^th arrived in S^t Louis . . .

[45]Governor Ramsey left for Pembina on August 18. His party was accompanied by an escort of cavalry from Fort Snelling. *Pioneer*, August 21, 1851.

[46]Pierre Chouteau, Jr., and Company of St. Louis took over the business of the American Fur Company in the Northwest in 1843. The furs that Kittson and the Red River train carried to St. Paul were destined for the St. Louis market. Rife, *ante*, 6:234.

Index

256 INDEX